D0593227

PELICAN BOOKS

HENRY MOORE

342-6
28

John Russell was born in 1919 and educated at St Paul's School and Magdalen College, Oxford. He worked at the Tate Gallery as an honorary attaché in 1940–41. After war service in the Naval Intelligence Division of the Admiralty he became in 1945 a regular contributor to the *Sunday Times*. He has been its art critic since 1950 and on that account has travelled widely in the USA, the USSR, Africa and Australia. His books on art subjects include monographs on Seurat, Vuillard, Braque, Max Ernst, and Ben Nicholson. He was responsible for the Arts Council's exhibitions of Modigliani, Rouault, Balthus and (with Suzi Gablik) Pop Art. His other publications include *Shakespeare's Country*, *Switzerland*, *Paris*, and *Erich Kleiber: a memoir*.

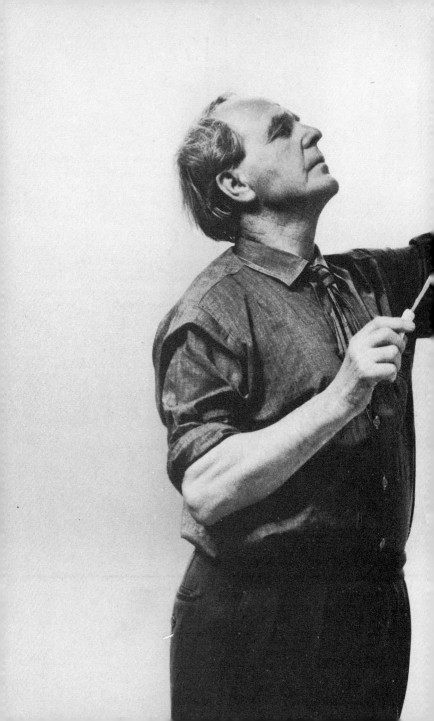

HENRY MOORE

BY JOHN RUSSELL PENGUIN BOOKS

DELTA COLLEGE
Learning Resources Center MAY - 1980

NB 497 .M6 R78 1973

Russell, John.

Henry Moore

Penguin Books Ltd, Harmondsworth,
Middlesex, England
Penguin Books Inc., 7110 Ambassador Road,
Baltimore, Maryland 21207, U.S.A.
Penguin Books Australia Ltd, Ringwood,
Victoria, Australia

First published by Allen Lane The Penguin Press 1968
Published with revisions in Pelican Books 1973

Copyright © John Russell, 1968, 1973

Made and printed in Great Britain by
Hazell Watson & Viney Ltd, Aylesbury, Bucks
Set in 'Monophoto' Ehrhardt

This book is sold subject to the condition that it
shall not, by way of trade or otherwise,
be lent, re-sold, hired out, or otherwise circulated without
the publisher's prior consent in any form of
binding or cover other than that in which it is published
and without a similar condition including
this condition being imposed on the subsequent purchaser

Designed by Gerald Cinamon
Photograph of Henry Moore on pages 2 and 3 courtesy Snowdon.

TO MARGARET SCOLARI BARR

Preface

Almost my first action on taking up an unpaid post at the Tate Gallery in June 1940 was to open a correspondence with Henry Moore. I did not then presume to take up much of his time, but I am conscious of having taken up a good deal of it over the last ten or fifteen years, not only in the studio but on licensed rampages in one or another part of the world. Whatever merits this book may have are owed to his kindness and friendly cooperation.

Where Henry Moore is quoted verbatim, the quotations come in many cases from tape-recordings of interviews with Vera Lindsay and myself which were commissioned by the *Sunday Times*. Other quotations come from *Henry Moore on Sculpture*, an anthology edited by Philip James and published by Macdonald.

I must acknowledge once again the hard and patient work put in by Mr Moore's secretary, Miss Betty Tinsley. This new edition has benefited, also, by the generosity of Mr David Mitchinson, who gave us the benefit of his close knowledge of an *œuvre* which becomes daily more difficult to keep track of. I am very grateful, finally, to Lord Snowdon for his photograph of Henry Moore at work.

J.R.

The Early Years
up to 1924

In the career of Henry Moore, legend must from the start be disentangled from fact.

How often, for instance, do we not read in exhibition catalogues that Moore was 'born on 30 July 1898, the son of a miner'? The date is incontrovertible: but 'the son of a miner' causes many people to picture for themselves a self-made genius with Lawrentian overtones, an unlettered giant powered by imperious instinct and ill at ease in the world of ideas. For that matter, Moore's open and easy address and unaffected habits of speech are in many ways misleading. Only on closer acquaintance is it apparent that he systematically underplays his own stature as a man who for half a century has kept in touch with the things that matter in many departments of human activity.

This was an inherited capacity. His father was not 'a miner', in the conventional sense of the word, but a thoughtful and tenacious individual who would have gone quickly to the top if he had had a chance of formal education. Nearer to H. G. Wells than to D. H. Lawrence in his orientation, he set great store by brains, and by the proper use of them. He had pulled himself out of the pits by mastering, unaided, the mathematical and technical knowledge which were needed to become a mining engineer. Three of his eight children became teachers, and when Henry was a boy his father gave him just the guidance which he needed. Both his parents set, in fact, an example of sustained conscientious exertion: his father in the grinding disciplines of

self-help, and his mother in the continuous hard labour of raising eight children.

She had tremendous physical stamina. She used to work from morning till night until she was over seventy. To be a sculptor, you have to have that sort of energy and that sort of stamina. Sculpture is of all the fine arts the one in which you have to have an absolute physical fitness. You can't – in the early stages at least – be tired or ill if you want to be a sculptor.

Moore was the seventh of eight children. When he was twelve or thirteen his younger sister died and he had, more than ever, the privileges of the youngest child in a large and well-knit family. 'There's no doubt that I had a very good time at home and took for granted the warmth and friendship and happiness of a large family.' When Moore speaks of his childhood he describes, above all, a situation. There is little of the atmospheric or anecdotal detail with which many people lard their first memories: what comes over is the sense of being at home in a manageable society. And, whereas the classic English childhood of the sensitive person is made up of distances suddenly beyond measurement, misjudgements of capacity, and social illusions which burst open and leave permanent wounds behind them, Moore progressed from stage to stage in orderly style. If he had extravagant ambitions, his father knew better than to damp them; and his schools were of the kind in which teachers took time out to foster an exceptional boy. If there were traumatic incidents, no one knows of them. If we compare the boyhood of Matthew Smith, for instance, who came from what could be called a more privileged milieu, we can only wonder at the maturing of great gifts which came, in the one case, from sustained agony of the nerves and spirit, and in the other from what now seems like an almost Biblical simplicity of life and an earnest, regular, high-souled will to succeed. It came naturally to Moore to be at one with his environment, and he was further helped in this by the

teachers whom he still names with gratitude and affection: T.R. Dawes, the headmaster of the local grammar school, and Miss Gostick the art mistress, and one or two others who put it about that there was more to education than passing examinations. Moore believes that 'Such people are there all the time, for everybody, if any one wants to find them.' But in the teacher/pupil relationship something was changed forever, surely, when radio and cinema and television broke into what had been a closed circuit between one mind and another. In terms of 'facilities' the years immediately before 1914 may now look almost medieval; but in human terms education still reached out beyond the medieval and had as its highest achievement something near to the Socratic ideal of teaching. And Moore was one of those who profited most by it.

It was Mr Dawes, for instance, who organized the school outings to Kirkstone Abbey and other points of consequence in the countryside, and it was on one of these that Moore had his first sight of the stone heads in Methley Church which came to mean so much to him. The region round Castleford gave him, also, an experience which marked him for the rest of his life, though it was only uncovered a year or two ago when a camera team from the Columbia Broadcasting System went up to Yorkshire in connection with a television programme on Moore and his career. While there, they took some shots of the Adle, a huge rock which Moore remembered going to see, at the age of nine or ten, with his father. Today the Adle is in part overgrown with trees, but in 1908 or thereabouts it was entirely bare; and one of the camera team noticed, and Moore later confirmed, that when photographed from a certain angle the Adle was remarkably like the leg-end of the *Two-piece Reclining Figure no. 1* [117], which Moore produced more than half a century after his first visit.

By the time Moore was ten or eleven he found that he was getting a great deal of pleasure from drawing classes, and from carving old bits of wood and stone, but nothing had happened to form within him the

sense of vocation. But then one day in Sunday school his teacher was pointing the moral that one should always listen to others and try to learn from them. As an example of this he described how when Michelangelo was carving his head of a faun, someone passed by and said, 'But that's an old faun. Surely an old faun would have lost some of his teeth?' And so Michelangelo took up his chisel and knocked out two of the faun's teeth. 'So there you are,' said the teacher, 'there's the greatest sculptor in the world ready to take advice from a stranger, just because he'd listened carefully and thought it made sense!'

Moore didn't take much to the moral, one way or the other, and as he had never seen a faun the point about the teeth went for nothing with him. What stuck was the phrase 'the greatest sculptor in the world'. Something about it sounded *right*, in the way that a phrase quite casually spoken, in a context of indifference, can sometimes carry a hidden message that changes a whole life. Thenceforward, if anyone asked what he wanted to be in life, Moore would say 'A sculptor'.

Now, it might seem that he was badly placed to further his ambition. Sculpture as a fine art could not be studied at first hand any nearer than London, and in Edwardian times there was really nothing in the way of accessible books on the subject, even if at the age of ten or eleven he had known how to get at them. There had never been an artist in the family. The prospects for a full-time sculptor were bleak in any event, and as far as the practicalities of a career were concerned he might as well have said 'I want to be a toreador' for all the hope he had of getting informed direction.

But this is not to say that in the long run, and as seen from today, the auguries were unfavourable. On the contrary: the auspices for Moore the sculptor were almost as good, for anyone who knows how to read them, as they were for Braque, who was born with a paint-brush more or less in his hand, or for Matisse

when at the end of his career he turned to the strips of cut-out paper which just happened to be the medium towards which his sixty years of experience had been tending.

Part of the Moore legend insists that he was born into a world which knew nothing of sculpture. This is untrue as a matter of observable fact, and it is untrue to Moore's own experience as he himself has recorded it. There is hardly a country church in England that did not acquire, between the Reformation and the deaths of Chantrey (1841) and Westmacott (1856) something of interest in the way of sculpture. 'Educated' people did not look at these things until a generation ago: but today anyone can make the connection between column and capital, or between the reclining Crusader, and the relevant pieces in Moore's *œuvre*. Of all the strains which go to make up that *œuvre*, this has been least subject to analysis; but Moore himself authorized us to go ahead when he wrote in 1941 of the eleventh-century carvings which he had seen, as a boy, on Yorkshire churches. *As a boy*: those are the words which count most. Moore has always refused to grope around among his earliest memories, and when a German scholar studied his work on psychoanalytical lines he refused even to read the book which resulted, for fear that it dragged into the open sources best left to work themselves out undisturbed; but there is no doubt that the observation of sculpture formed a part of his life as a boy, and that it was sculpture of a kind altogether grander, and less enfeebled by aestheticizing, than he would have met with at that date in a household where art was much talked of.

At that time it was quite possible to go to art school at the age of fourteen. But when Moore eventually got to Leeds School of Art in September 1919 as an accredited ex-service student, he could only congratulate himself on having missed the years of pointless drudgery which then did duty for art education. The vital thing for a would-be sculptor in Edwardian England was to stay clear of the academic ideal in sculpture and

keep alive the instinct of play and the power of unself-conscious invention. This Moore did, as a schoolboy, in circumstances best described in his own words:

Near where we lived in Castleford there was a quarry, and we used to play about with the clay and make what we called touchstone ovens, little square boxes with chimneys and a hole at the side, and we'd fill these with rotten wood and light it and blow on the fire to warm our hands in winter. And sometimes we'd decorate them with drawings. All our games had a seasonal rotation – whip-and-top time lasted three weeks, for instance – and one of the games that came round was called 'Piggie'. For this, you took a round piece of wood and shaped the ends of it till you could hit it with a stick and make it jump into the air. I very much enjoyed carving the piggie, and of course I was carving and modelling the clay all the time too.

From 'Piggie', the players later turned to a more highly developed game called 'Knurr and Spell'. This also involved wood-carving, in that the ball was first caught in, and later thrown from, an oblong container which ended in a tapering, oblique-angled hand-piece. Recently, when prompted by a biographer to look into the question of these games, Moore made what would in psychoanalytical terms be called a significant connection. He realized, that is to say, that in his middle thirties, when his work was apparently at its most hermetic, the image of 'Knurr and Spell' rose up from his unconscious and took a hand in the Cumberland alabaster *Bird and Egg* [1], which was one of the most mysterious of his inventions for the year 1934. Here, in fact, were the ball, and the tapering handle, and the oblique angle, and the egg-shaped hollow with the circular hole at the bottom of it in which the ball was to rest. There could hardly be a neater or a more exact illustration of the workings of the unconscious in art.

I doubt, for that matter, if anyone could invent, for that time and that place, a more auspicious beginning for a sculptor than this constant, spontaneous, and enjoyable contact both with the materials of his art and

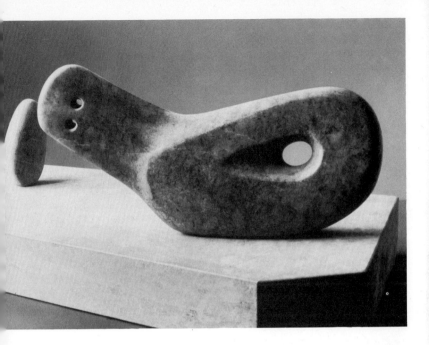

1. Bird and Egg, 1934

with its social function. Instead of the debased rituals of art school, Moore was occupied with something that fulfilled an immediate social need, however modest: looking for instance at a piece like the *Sculpture to Hold* in yew-wood of 1936, it seems to me that this work, though related to Giacometti's, must also have its source in the 'piggies' of Moore's boyhood. Equally, the mysterious block-like carvings of 1936 may relate in part to the early reliefs of Ben Nicholson, who was a close neighbour of Moore's at that time; but they are also, I think, a sublime variant of the touchstone ovens – square-cut, monolithic, incised and drawn-upon, and instinct with a magic in which 'fine art' has no part.

Moore's family greeted his decision to become a sculptor without even a mandatory minimum of discouragement. His father said no more than that it would be a good thing if he qualified as a teacher, in order to have something to fall back on, and Moore's mother made no comment at all, except to say later,

when she saw what gruelling physical work was involved, that she thought he 'might really have found an easier profession'. Moore became a student teacher in 1915, and in the following year he returned as a teacher to the elementary school which he had attended as a small boy. (Now that there were several teachers in the family, the Moores had moved from 36 Roundhill Road, the house in which he was born, to a larger house in a rather grander neighbourhood: the corner house, that is to say, in Smawthorne Lane.)

It seems, from this distance, as if nothing could break the ordered and smiling round of Castleford life. Moore himself goes so far as to say, in fact, that even the Army, which he joined in 1917, was 'just like a bigger family', in that at first he was the youngest member of his regiment, the Fifteenth London Regiment (Civil Service Rifles). Readers of *Her Privates We* and *Good-bye to All That* would find it difficult to recognize the war of 1914–18 as it appears in Moore's characteristically understated recollections.

For me, the war passed in a romantic haze of hoping to be a hero. Sometimes in France there were three or four days of great danger when you thought there wasn't a chance of getting through, and then all one felt was sadness at having taken so much trouble to no purpose; but on the whole I enjoyed the Army ... After I was gassed at Cambrai I was in hospital for three months and it still affects my voice at times, but as they made me a PT instructor afterwards I suppose I must have got pretty fit again.

These are not the words of one marked for life by experiences too dreadful to be set down. What they imply is not insensibility, but rather the armoured equilibrium of one who has already learnt to manage life, even in its more extravagant manifestations, and how to keep one distant aim consistently in mind.

In point of time, Moore's war service caused a minimum of delay, in that he was demobilized in February 1919, went back to teaching (at the same school) a month later, and in September 1919 was able at last to

get to Leeds School of Art on an ex-serviceman's grant. He was just twenty-one years old, therefore, when he reached that crucial phase at which a potential artist's ideas and inclinations and unformed devices come up against the System. That System may be draconic or permissive, deadening or inspired, rigid or improvisatory, but in any event it represents the formed as against the unformed world. Much depends on the student's ability to cope with it and make the most of it.

Moore is categorical in this respect. 'I was very lucky not to have gone to art school until I knew better than to believe what the teachers said.' Forty and fifty years ago there was nothing more dismal than the routines of a provincial art school. Hostility to living art was as intense in Leeds as it was anywhere in England – that is, very intense indeed – and there had lately been trouble about the War Memorial which had been commissioned from Eric Gill for the University, and trouble again about a projected series of decorations which were to have been commissioned for the Victoria Hall. In both these episodes the weight of the attacks bore heaviest upon the Vice-Chancellor of the University, Sir Michael Sadler. Sadler was a collector of quite exceptional discernment: he had bought Cézanne, Gauguin, Daumier, Courbet, and others before 1914, and already in 1912 he had visited Kandinsky in Bavaria and bought a number of his works. Later he turned also to the work of British artists, and from Wilson Steer onwards there were few artists of promise whom he did not go out of his way to help. (For John Piper, in 1925, he was 'the man on earth I most wanted to meet'.) From 1912 to 1924, Sadler gave himself unstintingly to Leeds, and it was Roger Fry who best summed up his achievement when he wrote:

Every time I came to Leeds I got more and more impressed with the work Sir Michael was doing. He had civilized a whole population. The entire spirit had changed from a rather sullen suspicion of ideas to a genuine enthusiastic intellectual and spiritual life. He showed what can *be done – but very rarely is – by education.*

Moore was old enough to pick and choose among what was on offer, and the thing that he chose at once, and held fast to, was the example of Sadler, and of Roger Fry and Clive Bell, and of the one or two other people who went adventuring without prejudice among art of all sorts and all periods. These adventures were still limited and imperfect, by comparison with those now available to the student of art, but they made up for their imperfection by an intensity of excitement not easily recaptured when all experience is to be had for the asking. Moore's consciousness was still in a phase of unbounded expansion in which every new experience was marked 'plus' and the problems of choice and co-ordination had yet to arise. The important thing was still (as Moore wrote in 1935) to get rid of the 'complete domination of later, decadent Greek art as the only standard of excellence'.

This state of affairs continued when Moore won a Royal Exhibition Scholarship in sculpture and went in September 1921 to the Royal College of Art in London. Even today, after nearly fifty years, something of the exhilaration of those first months in London comes without effort in Moore's conversation.

I was in a dream of excitement. When I rode on the open top of a bus I felt that I was travelling in Heaven almost, and that the bus was floating in the air. And it was Heaven all over again in the evening, in the little room that I had in Sydney Street. It was a dreadful room, the most horrible little room you could imagine, and the landlady gave me the most awful finnan haddock for breakfast every morning, but at night I had my books, and the coffee stall on the Embankment if I wanted to go out to eat, and I knew that not far away I had the National Gallery and British Museum and the Victoria & Albert with the reference library where I could get at any book I wanted. I could learn about all the sculptures that had ever been made in the world. With the £90 a year that I had in scholarships I was one of the real rich students at the College and I had no worries or problems at all except purely and simply my own development as a sculptor. As to that,

there were a whole lot of things that I found out for myself very simply and easily. Once you'd read Roger Fry, the whole thing was there. I went to the British Museum on Wednesday and Sunday afternoons and saw what I wanted to see. It was all quite straightforward.

The R.C.A. at that time had just acquired Sir William Rothenstein as its Principal. What had been primarily a teachers' training college took on quite another character under Rothenstein's directorate. There was, to begin with, a new emphasis on creativity among the students. Rothenstein discouraged the idea that art could be taught by people who had no first-hand experience of what it meant to try, at any rate, to produce a work of art. He was, secondly, a man who looked outwards and into the great world. He was not at all provincial, had known Degas and Rodin and many another great European figure, and kept up a large acquaintance among the *Prominenten* of his own day. He made a point of inviting one or two students up to his house on Sunday evenings: Walter de la Mare was one of many people whom Moore met in this way, and once in 1924, when still a student, Moore found himself standing on the hearth-rug with Ramsay Macdonald, who was then Prime Minister of England.

Rothenstein gave one the sense that there need be no barrier and no limit to what one can embark upon, and that is very important to a young student. Here was I, a student straight from Yorkshire, and it seemed perfectly natural for me to be standing in front of the fire and talking to the Prime Minister.

In this way Rothenstein carried on with a process and an idea which had begun, for Moore, at elementary school: the notion, in short, that a man was what he made himself.

One certain thing about art school is that students learn as much from contact with other students as they do from their teachers. Moore had very few fellow students in the sculpture school – at one time he had a studio and a model for his exclusive use for a whole

year – and most of his friends were in the painting school. In his first year he went to Paris with one of them, Raymond Coxon. They had had the idea that instead of reading and re-reading about Cézanne in Roger Fry it would be a good plan to go and see some originals. Rothenstein agreed that they could take off a whole week at Whitsuntide, and he also gave them two or three introductions. One of these was to Maillol. But when Moore got to Maillol's door he said to himself, 'Oh well – he'll be working and he won't want to see me,' and he turned and went away. But he did take up the introduction to the Pellerin family, and in this way he and Coxon saw the enormous *Grandes Baigneuses* of Cézanne which is now in the Art Gallery in Philadelphia. 'You know, the ones with the nudes in perspective, lying on the ground, that look as if they were cut out of mountain rock. Seeing that picture, for me, was like seeing Chartres Cathedral. It was one of the big impacts.'

This visit took place in the summer of 1922. Before long Moore began to be conscious for the first time of the tension in his activity which, once resolved, was to be his greatest single strength as an artist. This tension arose from the contrast – some would have said, the contradiction – in style and impetus between the work he was doing at the College and the work he was doing in his spare time in digs. He had gone to the College with what he now calls a 'silly and romantic idea' that art schools and their teaching were no good, anyway, and that the only sensible thing was to put in an appearance at the College and pursue his serious studies outside. After a month or two he realized that sculptors like Michelangelo and Rodin could draw as well as any of the great painters. He also realized that for practical reasons the only place in which he could learn to draw and model from life was an art school. In this way Moore began to lead what was, in effect, a double life: working from the model in the day-time, and struggling in the evening and at week-ends to develop his powers in an altogether different way.

The routine of the College had its afflictions. There was for instance the 'monthly comp.', in which the students' work was pinned up on the wall and was criticized freely and in public by a senior member of the staff. 'That young man has been feeding on garbage' was the verdict on an early drawing of Moore's which showed the influence of something – Negro or Etruscan art – which was not in the standard College curriculum. ('I'm sorry about that,' said Rothenstein to Moore afterwards, 'but it's bound to happen sometimes.') But none of this affected the central fact that he was learning, as he says,

to see form completely: and that's what a sculptor needs. You can draw a tree, or a bit of architecture, or a bit of landscape, or even an animal, and people don't notice – don't feel it, anyway – if you haven't got it quite right. But if you're drawing a human being it's quite different. Critical standards, your own and everyone else's, are infinitely keener. Even if you want to be an abstract sculptor, it's still invaluable to have had that training in drawing the figure. And it's not only training in the literal sense – one can't understand it without being emotionally involved. It is a deep, strong, fundamental struggle to understand oneself as much as to understand what one's drawing.

However much a European artist may talk, as Moore did later, about 'getting the Greek spectacles off one's nose', there is no doubt that the struggle which he was describing is a European struggle, and one which lies somewhere in the unconscious of everyone who has been brought up as a European and given even so much as wry, resentful attention to the established hierarchy of Western art. The balance of the erect human body, which Moore evokes as eloquently in conversation as in his life drawings of the 1920s, is reflected in the balance of the marks a Leonardo or a Michelangelo makes on the paper. There is, that is to say, a central tradition, and it can't but pull strongly at any student who gives all of himself to the task of drawing.

In the 1970s every sculpture-student has a built-in awareness of all the other elements which have contributed to the emancipation of sculpture. In the 1920s the situation was entirely different. Very few people had a clear grasp of what had been done by Brancusi, for instance, and although many young artists had a confused and partial idea of the sources of energy inherent in what was then called 'primitive' art it was quite another matter to incorporate these energies into work that made sense. There is no such thing as the painless incorporation within a work of art of elements taken whole from an alien culture. Yet the 1920s were the heyday of the mixed marriage of idiom and thought and intention in every department of the arts. What is *The Waste Land*, if not a multiple mixed marriage of this sort? By naming the greatest poem of the twentieth century I have, however, given a misleading impression of the degree of success to which such mixed marriages normally attained. Time has dealt severely with nearly all the 'experimental' work of the period. It would be embarrassing to list the casualties incurred in poetry, in the novel, in drama, in music, and in the fine arts by ventures which relied on the outward aspects of experiment, without corresponding to any profound emotional thrust and without having striven to assimilate and acclimatize modes of expression conceived elsewhere and, as often as not, at a great distance in time. But the year of Moore's first visit to Paris was, in spite of all this, the year in which *Ulysses* and *The Waste Land* were first published; Picasso had painted the *Three Musicians* the year before, Braque was perfecting his 'Chimneypiece' series, Brancusi had just finished his *Torso of a Young Man,* and Klee and Kandinsky were at the Weimar Bauhaus. There was enough of superlative merit in the output of the year to put any young man on his mettle. But equally evident was the ever-widening gap between the work of living art which came off and the work of living art which didn't. There was a topmost level of achievement, as there had always been: below that level there was only chaos and con-

fusion. The minor master or acceptable epigone, so common in earlier epochs, had been swept off the board altogether since the beginnings of analytical cubism. Till 1908 or thereabouts it was possible to make out a modest case for Trouillebert as against Corot, for Lebourg as against Monet, for Willy Finch even, as against Seurat: what they did was decent enough, provided that the claim was not set too high. But for Gleizes as against Picasso and Braque no case can be made, because the misunderstanding of the principles involved in the work of the major artists is total and irreparable. Nietzsche's remark that 'every great human being is a finale' is relevant, once again, to the major figures of the time. Attempts at resuscitation have proved again and again that there just is not, any longer, a level of acceptable minor achievement, some way below but within hailing distance of the giants. These giants have kicked down the ladder, once and for all, and it has to be set up somewhere else.

But if it is easy to tidy up, from a safe distance, the historical situation of the early 1920s, it was quite a different thing to live through it. The living artist is not primarily a historian, though he may have insights that a historian must envy, and it is not by thinking about history that he will win a place in it. Franz Kline put this point very well, not long before he died:

You don't paint the way someone, observing your life, thinks you have *to paint. You paint the way you have to in order to give. Someone will look at it and say it is the product of knowing, but it has nothing to do with knowing. It has to do with giving.*

How to give, and what to give, were the fundamental problems for Moore in his twenties.

Like every other young artist, gifted or not, he began by trying on other people's hats and seeing how well they fitted him.

When I first came to London I was aware of Brancusi, Gaudier-Brzeska, Modigliani and the early Epstein, and

of all that that direction in sculpture stood for. I couldn't
help – nobody can, after all – being a part of my own time.
But then I began to find my own direction, and one thing
that helped, I think, was the fact that Mexican sculpture

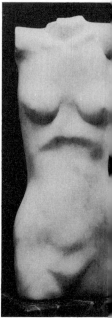

2 (*left*). *Torso*, 1925

3 (*above*). Gaudier-Brzeska
Torso

had more excitement for me than negro sculpture. As most of the other sculptors had been more moved by negro sculpture this gave me a feeling that I was striking out on my own.

4. *Suckling Child*, 1927

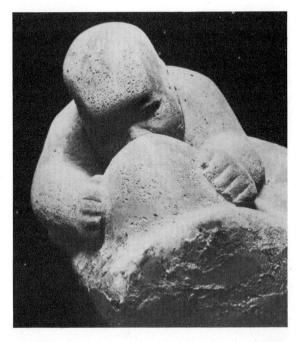

Among the European artists whom Moore names, Gaudier-Brzeska seems to me to have had an influence which is clear in the early carvings of animals and clearer still in the tender little *Torso* of 1925–6 [2] and the *Suckling Child* in cast concrete of 1927 [4], both of which can be related to known pieces by Gaudier [3]. Epstein can be detected in the flattened, frieze-like planes of more than one early composition, and when Moore was invited in 1926 to make some decorative compositions to go with a fountain the result had a certain kinship with Epstein. One or two very early pieces reveal that Moore had looked carefully at African sculpture – doubtless as a result of reading in Roger Fry that 'certain nameless savages' had produced 'great

29

sculpture – greater, I think, than anything England produced even in the Middle Ages'. But Africa left no lasting mark. Egypt stood for something, also, in the imposing *Seated Figure* [5] of 1924.

With Mexico, the case was quite different. And although Moore's remarks in 1941 on Mexican art have often been quoted I think that they must be set down again here.

Mexican sculpture, as soon as I found it seemed to me true and right, perhaps because I at once hit on similarities in it with some eleventh-century carvings I had seen as a boy on Yorkshire churches. Its 'stoniness', by which I mean its truth to material, its tremendous power without loss of sensitiveness, its astonishing variety and fertility of form-invention, and its approach to a full three-dimen-

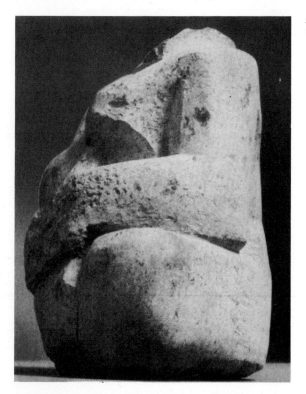

5. *Seated Figure,* 1924

sional conception of form, make it unsurpassed in my opinion by any other period of stone sculpture.

Given so strong a scent, even the most languid hound could hardly fail to see something of the chase. Moore's closest Mexican affinity, in most people's view, is with the reclining statue *Chacmool, the Rain Spirit*. This is in limestone, and life-size; it comes from Chichèn Itzà, and is now in Mexico City. The Chacmool statue can, in effect, be seen as the source of many of Moore's reclining figures, and as the source of what he has called his obsession with the subject in general. But an even closer, though short-lived, affinity might be traced between the Portland stone *Mother and Child* [6], which dates from the summer of 1922 and is Moore's earliest surviving independent carving, and the British Mu-

6. *Mother and Child*, 1922

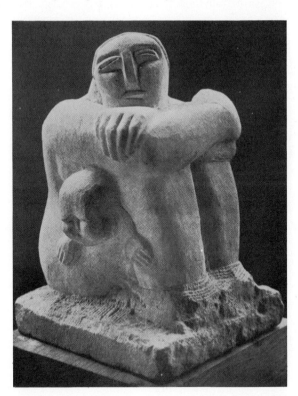

seum's figure of Xochipilli, the *Flower Prince of the Aztecs*. The Moore has a kind of edgy, irritable quality which I suspect has as much to do with the artist's state of mind, and with the still limited development of his gifts, as with any expressive intention. One has only to compare the relaxed eloquence of the pose in the Mexican figure, and the rich and confident handling of its lower legs, to see that Moore was still very much a student.

But, over and above the rude power which the Moore already gives off, there is a blockishness which was to characterize several important early carvings by Moore. He seems to have wanted to disturb the original character of the block as little as possible – partly, no doubt, in order to preserve its monumental quality, and partly from the feeling, now largely obsolete, that 'truth to the material' was one of the most important things about a sculpture. The forms seem almost to hug the block, as if to defend it against the sculptor's attack: there is, in fact, an almost palpable struggle between that sacred object, the block, and the image which the sculptor wishes to impose upon it. Today all this seems archaic: the idea of choosing a beautiful or an intrinsically rewarding material has been turned inside-out and the artist often aims either to deny, or to metamorphose, the nature of his materials, or to regenerate substances for which the world has no dignified name. But in the first quarter of this century a real moral superiority was ascribed to direct carving. (Carving was so rare in art schools that the examinations passed by Moore during his years in the sculpture schools in Leeds were specifically in 'modelling', it being taken for granted that this was the subject which would be presented.) Epstein and Eric Gill were both, in their different ways, champions of the idea that bronze-casting was an erratic and slightly discreditable short-cut to achievement, and that only the stone, marble, or wood which had been carved from start to finish by the sculptor's own hand could be ranked as true sculpture. One or two European artists – Brancusi, Modigliani,

Zadkine, Barlach – could be adduced in support of this, though it must sometimes have occurred to people that Rodin had hardly ever had a chisel in his hand. In England the point of view had overtones of our native Arts and Crafts movement; inherent in it, quite clearly, was the idea of 'truth to material'. Moore has since modified his opinions, realizing that the artist must set truth to himself higher than truth to his material, and that too great a love and respect for the material may inhibit and even stultify a sculptor at some vital stage in his work. But up till 1939 virtually all Moore's three-dimensional work was carved. Of the first two hundred items in the Sylvester catalogue, fewer than twenty have been cast in bronze: and of these several have only been cast since 1945. The act of carving has, in itself, a dramatic, all-risking irrevocable quality, and this gives it a dignity not quite to be rivalled by the act of modelling, where it is always possible to have, and to act upon, second thoughts. 'Truth to material', in those distant days, was the beginning of integrity in sculpture.

Moore had from the start, then, a certain attitude to his material. Each new piece, between 1922 and 1939, was to be an encounter with a particular substance: marble, Portland stone, Mansfield stone, Pynkado wood, Cumberland alabaster, ironstone, African wonderstone, Corsehill stone, Travertine marble, Ancaster stone, ebony, beechwood, Ham Hill stone, Hornton stone, Hoptonwood stone, verde di prato, walnut wood, serpentine, Bath stone, painted slate. Nothing in these encounters was taken for granted.

He also had a certain attitude to his sources. What mattered was not so much 'the Mexican inspiration', for instance, as Moore's awareness of what he later called 'the common world-language of forms'. What he needed was not so much the stimulus of alien imagery as the enfranchisement which comes from knowing that one's own earliest memories are part of the unity of all human experience. Any lively young person can run through the panorama of recorded art

and pick out the things which excite him: but what results, on that level, is a jumpy, un-ballasted art. What marks the serious artist for a lifetime is the authorization which comes from the knowledge that an illimitable repertory of images is within each of us, only asking to be brought upwards to consciousness.

Finally, Moore had, even as a student, the beginnings of a style. Whether the weight of the style would balance the weight of the self must have been continually in doubt. He had the material, he had the sources, and he had the beginnings of a style. But what to do with it all? What myths, legends, attitudes, and exorcisms to conjure forth? What to say, and how to say it? What, in a word – in Kline's word – what to *give*? That was still a problem, and it was hardly nearer to resolution in the experimental carvings of his student days than it was in the variant of a relief by Domenico Rosselli which he made in 1922. Before he could give himself entirely, and before he could even know what he wanted to give, the two sides of his life as a student must be drawn nearer together and the sedulous workman in the life-class be mated, somehow, with the investigator of 'the common world-language of forms'. This mating took place, slowly and painfully, as a result of the Travelling Scholarship which he was awarded in 1924, and which took him, in the first six months of 1925, to many places in northern and central Italy.

1924-31

The year 1924 was of cardinal importance to Moore. To begin with, it was the year in which he won the Travelling Scholarship which took him to Italy. It was also the year in which he first profited by that invaluable English institution, the part-time teaching job.

Without such a job, he might have been forced back into the provinces, with only intermittent access to the museums, the exhibitions, the libraries and the personal contacts which had brought him on, as they bring every young artist on, since he arrived in London in the autumn of 1921. The job was, moreover, in the Royal College itself. Derwent Wood, the Professor of Sculpture at the R.C.A., had resigned after a disagreement with the Principal, who later referred to him in his memoirs as 'an excellent modeller, the most scholarly of the academic sculptors'. Reading round this encomium, one might infer that Moore, an unacademic carver, cannot greatly have regretted the change. Rothenstein would have liked to appoint Epstein as his successor, but that idea was scotched by the Permanent Under-Secretary at the Board of Education, whose letter on the subject is a classic instance of Establishment attitudes. 'To appoint Epstein,' he wrote, 'would be a very perilous experiment and might cause us considerable embarrassment. For a Professor we would want not only a genius (as to which I am no authority) but also character; and I am not sure that character in a place of this kind is not of greater importance.' As Moore's genius was not yet in question, and his character appeared to be all that could be wished, no objection was raised to his appointment as Assistant in the Sculpture Department.

This stood for security of a kind which then seemed impregnable. Moore was paid £240 a year for a total of sixty-six days' teaching. He had, therefore, 299 days in which to get on with his own work in conditions of financial equilibrium. He did, in fact, devote himself to his students to the point of dreaming about them, night after night, and fretting continually as to whether he was or was not telling them the right things; and after ten years he was thoroughly tired of teaching. But meanwhile, and at a time when the people in England who owned a piece of modern sculpture could be numbered on one hand, there were still five days of every week, and nineteen complete weeks of every year, in which he had no obligation to anything except his own sculpture. To that extent the teaching job was an immediate and unmixed gain.

The Italian journey, which began in January 1925, was quite another matter. Moore had not in the first instance wanted to go to Italy at all. But the Travelling Scholarship was awarded 'for the study of the Old Masters', and not for the furtherance of the winner's own work, and it had always been taken for granted that the Italian Old Masters were the only Old Masters and that Italy was the only place to study them. If Moore's application to spend the time in Paris, or alternatively in Germany, was turned down it was partly for this reason and partly because there was no accepted means of paying the money in any country but Italy. 'Either I went to Italy,' Moore said later, 'or I didn't get the scholarship. So I went to Italy.'

He left behind him a piece half completed: the Hornton stone *Mother and Child* [7] which is now in Manchester. This redoubtable piece is the first to signal, on any substantial scale (it is $22\frac{1}{2}$ inches high), his preoccupation with forms of female beauty that are full, heavy, solid, and slow. He once said himself that 'There are specific kinds of sensibility, belonging to distinct psychological types': and he has followed this principle to the extent of not attempting subjects which lie outside his own kind of sensibility. The Manchester

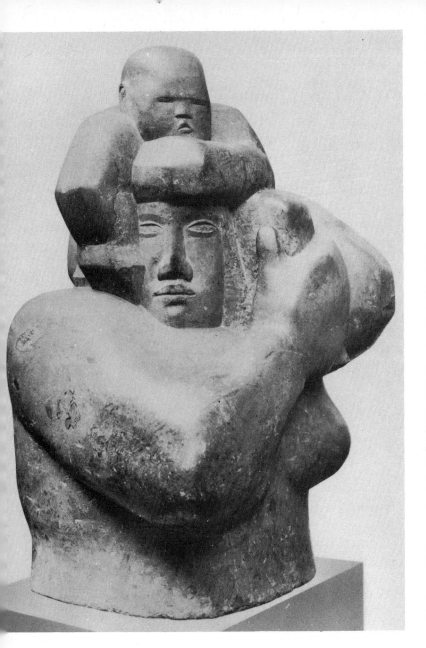

7. *Mother and Child*, 1924–5

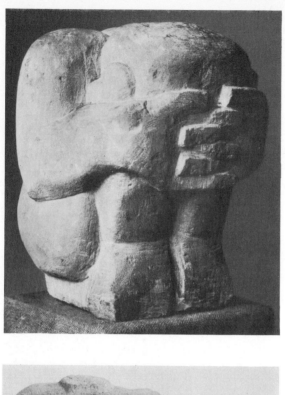

8. A. Derain:
Homme Accroupi, 1907

9. Frank Dobson:
Seated Torso, 1923

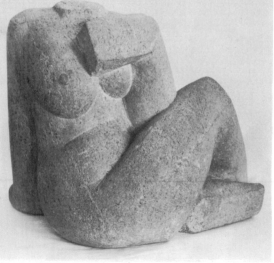

Mother and Child forecasts, already, that inimitable broody quality which finds its most majestic expression in the UNESCO carving [108]. But to Moore himself the Manchester piece now exemplifies the shortcomings of the doctrine of 'truth to material'. Essentially, he feels, it is still a block of stone with the corners sliced off, and the nature of that block is not so much set free as mutilated by the sculptor's activity. The forms now strike Moore as having been buried one within the other, the head and arm of the baby as having been stuck on, and the structure as a whole as being external, not internal. The necks are still packed away inside the stone. The faceting of the forms derives from Cubism, but the forms themselves hug the block. It is, in fact, as if the piece had turned out to symbolize the block's resistance to the artist. (Derain, working in stone as early as 1907, had met with the same difficulty [8].)

The Manchester *Mother and Child* would have been a difficult piece, in any circumstances, for a young artist in the early 1920s. Sculptures of that date by other and older 'advanced' artists – Frank Dobson, for instance – were usually made up of sharp-angled, jagged, abrupt planes that cut back and forth [9]. Moore's piece, on the contrary, is marked *maestoso*. It is midway – that much we can see now – between the aggressive and obviously 'experimental' pieces of 1923 and the suave utterance which he had mastered in the carving (done long before he saw Italy) after Domenico Rosselli. Eventually the tension between the two was happily resolved, but at the time it was torturous.

The first effect of Moore's Italian tour was to make it impossible for him to work at all. He could neither go on as before, nor start on a new tack that had any coherence. At a time when Moore's 'modernity' was his most obvious and controversial characteristic it was difficult to point to any palpable effect of the trip on his output. Today it seems to us one of the vital dates in his career.

Initially, in January 1924, he tried to act according to the view that the Renaissance, like the fifth century B.C.

in Greece, had been overplayed. But this could not work as a general proposition: no fair-minded and inquisitive person could live in Italy for four months and confine himself to the traces of Byzantium. His scholarship was intended, too, to provide a miscellaneous grounding in Italian art. Moore did what he now calls 'four months of taking off one's hat, as one had to, to Michelangelo and Donatello and Masaccio, and then going on to Venice and seeing Titian and Tintoretto and the others'. This did lasting damage to the idea that what mattered most was non-European art. Not that the idea was ever dropped, or has been dropped now: Moore knows the British Museum and the Musée de l'Homme in Paris as few people know them. But the two enthusiasms had somehow to be reconciled.

Simultaneously, the fact of being away from England for the first time caused him to think over what he missed, or didn't miss, and to formulate his ambitions for the future. He wrote back to Sir William Rothenstein that he aimed to be an artist in England and not outside it, 'working and carving in the big tradition of sculpture'. (Donatello the modeller seemed to him 'the beginning of the end'.)

I am beginning to get England into perspective – I think I shall return a violent patriot. If this scholarship does nothing else for me, it will have made me realize what treasures we have in England, and how inspiring is our English landscape. I do not wonder that the Italians have no landscape school – I have a great desire, almost an ache, for the sight of a tree that can be called a tree – for a tree with a trunk.

This feeling for home was a part of the general commotion of Moore's Italian journey.

I see now [he said in the late sixties] *that it's dangerous for young people to stop doing their own work and concentrate for a long period on other people's. In Italy there was just too much richness, too much to sort out all at once. I knew, even then, that it had to be done, and that the*

richer an artist's work was, the more he would turn out to have garnered from all over. If you take Cézanne for instance, you remember how much he owed to Tintoretto and El Greco and Daumier and Pissarro. And I believe that the bigger a person is, the more he will use his experience of other people's work when he comes to do his own. But at that time, in 1924, it was an ordeal.

It was an ordeal that began in Paris, with Moore's first sight of a Mexican reclining figure; and it went on, week after week, with the steady and painful reconstitution of one idea after another. Every morning for a month Moore would go to the Brancacci Chapel in Florence to get a hold on Masaccio before setting off to see anything else; and as he went on from one great Italian centre to another he faced something that grew steadily more baffling: the problem of how to get the

10. *Two Heads*, 1924–5

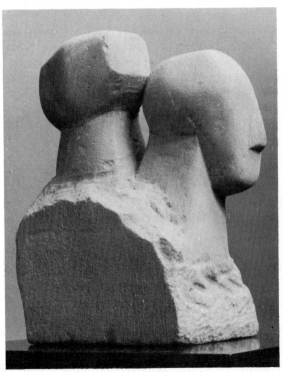

two great sculptural achievements, European and non-European, to coexist. His Italian experience was by no means comprehensive – several of the most powerful impacts, like that of the Rondanini *Pieta* and of the Giovanni Pisanos in Pisa, were to come in later years – but it was enough to bring him to an unexpected, complete, and agonizing halt.

When his own work did get going again it resulted, naturally enough, in pieces which have an uneasy and a transitional look. In the *Two Heads* [10] of 1924–5 the wind blows in strongly from the Cyclades. The chunky *Maternity* of 1924 has to do with the problem of the block. Other pieces relate to what was then called the 'modernistic' European idiom of the day. Two long-destroyed figures, the *Torso* of 1925 and a *Reclining Figure* of 1926, showed the tender side of Moore's nature for once uppermost: significantly, both were modelled and not carved. They also announced the two major themes of Moore's maturity, the vertical and the recumbent figure, in naturalistic and purely European terms. (Gaudier for the one, Maillol for the other, could have stood as godfathers.) What it is difficult to find, anywhere in these works, is the authentic Moore note.

But by 1926, and beyond a doubt by 1927, it begins to ring out: not interruptedly, but in one or two pieces of primordial importance. The little *Torso* in African wood, for instance, is the ancestor of all Moore's upright figures. During the autumn and winter of 1927, again, Moore was working on the verde di prato *Head and Shoulders* [11] which is to my mind the first outright masterpiece of his career. For the first time, he achieved fully three-dimensional forms which are consistently memorable: the piece is impossible to photograph, in that a photograph can isolate only one of its aspects. The organization of the forms is at once subtler, more delicate, and more radical than anything Moore had attempted before. But those forms were still, essentially, Cubist facets embedded in one another. It was as if Moore had made a drawing of the subject

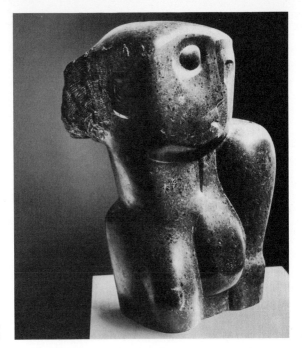

11. *Head and Shoulders,*
1928

in Cubist idiom, wrapped it round the block, and given an almighty squeeze. Beautiful as the result was (and the handling of nose, eye, mouth, brow, shoulder, and breast is one of the most tender of Moore's inspirations), it still lacked something of the realization-from-inwards at which he was aiming. (The piece is, by the way, infinitely more expressive, in human terms, than all but a very few of the paintings done in France, or anywhere else, in late Cubist idiom.) The forms were coaxed, not commanded: it may be significant, in this context, that Moore has a lifelong admiration for Seurat, who seems to him to have been the only artist since the Renaissance to have evolved a new and valid kind of drawing. Seurat perfected a way, when drawing, of cherishing the form continuously, coaxing it forward from darkness into light, never losing it for an instant as he lets the light reveal its fullness and roundness: in all this, there is something of the sculptural ideal.

43

Both the African wood *Torso* and the verde di prato *Head and Shoulders* were quintessentially human in their idiom: that is to say, everything in them can be traced to specific elements in the human body, and their areas of maximum tenderness correspond, equally, to our normal experience of the body. No violence is done, in either piece, and the body is not used metaphorically. This went on being true, right up to 1939, of quite a number of Moore's gentler and more obviously tender pieces. It was true of the single heads, and of the masks, and of the images of maternity, and of some of the most elegant of his standing and seated figures. But it is not with these that he broke through to the forefront of modern sculpture: for that, less comfortable pieces were needed.

Eventually the conflict between the European and non-European idioms was resolved. Moore went on, right through the 1930s, with pieces that owed allegiance to one side or the other, but it was in the long series of Reclining Figures that he first managed to reconcile the two. There, too, he developed an idea which helped to make him famous: the notion of the human body as a metaphor for landscape. (Many years later, as will be seen, he reversed this concept and began to work on landscape as a metaphor for the human body.) I suspect, though I have no grounds for asserting it, that one of the initial germs for the landscape idea was a passage in Roger Fry's early 'Essay in Aesthetics'. Talking of Michelangelo's *Tondo* in the Uffizi, Fry says:

When we find a group of figures so arranged that the planes have a sequence comparable in breadth and dignity to the mouldings of the earth mounting by clearly-felt gradations to an overtopping summit, innumerable instinctive reactions are brought into play.

'Innumerable instinctive reactions': the secret of Moore's command over a large public lies in his ability to release these reactions. And he does this by calling upon (to quote him verbatim) 'those universal shapes

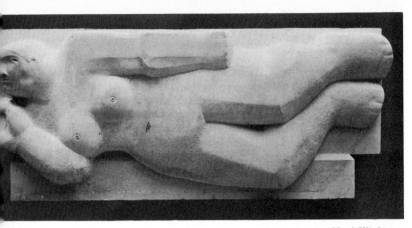

12. *North Wind*, 1929

13. *Reclining Figure*, 1929

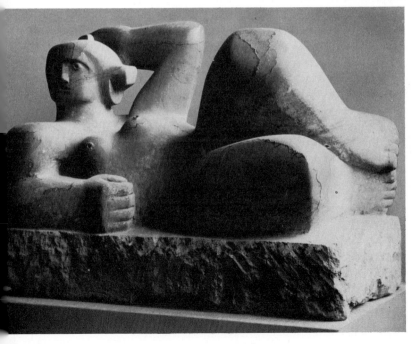

to which everybody is subconsciously conditioned and to which they can respond if their conscious control does not shut them off'. A phrase of Gaudier's about mountains being 'sculptural energy' had always seemed to Moore to be worth many an hour of drawing from casts, and by the spring of 1929 he was able to do something about it. From March until May of that year he was at work on the brown Hornton stone *Reclining Figure* [13] which is now in Leeds. It was not his biggest work to date: he had just finished an eight-foot-long decorative figure, more relief than sculpture, for the Underground building by St James's Park Station [12]; but it was his most ambitious attempt at a three-dimensional figure on what is – and this is too often forgotten – one of the standard themes of European art.

How, for instance, are we to look at the Leeds *Reclining Figure*? In some ways it marks a regression towards direct Mexican influence. In the tremendous heaviness of the right leg and foot, in the stiff and unarticulated right angles of the right shoulder and arm, in the failure of the figure to detach itself from the block, this is a backward-looking piece: in these respects the block has still the upper hand of the artist. But whereas the Mexican figure of Chacmool is basically a silhouette, and could from a plastic point of view be almost as imposing in low relief, the Leeds figure is designed quite differently, with the left arm standing free from the block and a cavernous opening between the knees to announce one of the artist's now most familiar themes. It is a piece which looks forward a very long way. If we jump ahead, for instance, as far as the post-war *Reclining Figure* in the same material [64] we shall find that although in 1946-7 Moore brought the whole of the left side of the body clear of the ground, turned the right arm and the right leg into a single and continuous form, and in general avoided all naturalistic emphasis, he kept, in essentials, the pose and the general feeling of 1929.

With the Leeds piece, and those which followed it on the same theme, Moore attached himself to a great

European tradition. That tradition is exemplified by the Bernini fountain in the Piazza Navona in Rome, the Donner fountain of river-goddesses in the Mehlmarkt in Vienna, Coysevox's Dordogne at Versailles, Canova's *Pauline Borghese as Venus*, Ingres's *Grande Odalisque* and, more recently, Picasso's *Le Printemps*. Prop the human body up on one elbow and you simply can't fail to get a composition that rises and falls in a continuously exciting line: that is the lesson of these works, for all the diversity of intent and occasion and style which distinguishes them one from the other. The Picasso, in particular, comes from a moment in his career which was particularly rich in sculptural suggestion: in 1920 and 1921, while preoccupied with the theme of women bathers, he struck off image after image which was to turn up again not long afterwards in the work of others. Two paintings, especially, seem to me to relate to transitional work by Moore: the *Deux Baigneuses*, dated 28 April 1920, and *Le Printemps* of 1920. Echoes of *Le Printemps* can, in fact, be found in Moore's work as late as the Dartington *Memorial Figure* of 1945 [60]; and, in general, Picasso's preoccupation in the early 1920s with heavy-limbed female nudes is one which exactly fitted Moore's needs at the time.

From time to time throughout his career Moore has had temporary obsessions: periods, that is to say, during which one particular subject was explored over and over again.

One has obsessions of that sort. You don't ever want to repeat an experience that you've had once while making a sculpture, but yet the idea keeps coming back and back at you and you have to do something about it. And if you're keyed up as you ought to be when you're doing sculpture you get into such a state of comprehension, or appreciation, of everything around you that the only way is to concentrate on that one idea. If you don't do that, it is almost impossible to go on living. If you let everything in, and if you try to follow up all the ideas for sculpture that come flooding in at such times, you'd just burst. You know how when

47

Mondrian had a wonderful studio in Paris, overlooking the Seine, he had the windows boarded up so that he wouldn't get ideas that distracted him from what he was doing? Well, I couldn't do that, but I understood why he had to do it.

The period of 1929–39 is rich, as will be seen, in brief obsessions of the kind that had to be worked through and got out of the way. But the obsession with the Reclining Figure has stayed with Moore for ever. As I have already indicated, he is not all given to auto-analysis and likes, on the contrary, to allow the unconscious to get on with its work without intrusion. To this end, few things are more helpful than subject-matter which allows of unlimited forays from a given and permanent base.

I want to be quite free of having to find a 'reason' for doing the Reclining Figures, and freer still of having to find a 'meaning' for them. The vital thing for an artist is to have a subject that allows to try out all kinds of formal ideas – things that he doesn't yet know about for certain but wants to experiment with, as Cézanne did in his 'Bathers' series. In my case the reclining figure provides chances of that sort. The subject-matter is given. It's settled for you, and you know it and like it, so that within it, within the subject that you've done a dozen times before, you are free to invent a completely new form-idea.

After completing the Leeds figure in May 1929, Moore embarked upon a period of tremendous fertility, in which carving after carving came from the studio – Sylvester catalogues more than twenty for the year 1930 – and the long blockage occasioned by the Italian journey was cleared away once and for all. Moore clearly felt free to experiment in any way he liked. Something in this may have been due to the enthusiasm of the fellow artists who had supported him, most notably, at his first one-man show in 1928 at Dorothy Warren's gallery. Epstein, Augustus John, and Henry Lamb were among those who bought from this show,

and the fact of being presented by the vivid and venturesome Miss Warren (who was responsible, around the same time, for showing D. H. Lawrence's paintings) must also have helped to place Moore as an artist of consequence. Many people, in any case, were glad to buy Moore drawings from Miss Warren at the asking price of £1 net.

During this period of intense stylistic activity Moore seems at first sight to have been jumping all over the place and trying his hand at everything from the cast concrete Masks of 1929 [14], in which there lingers

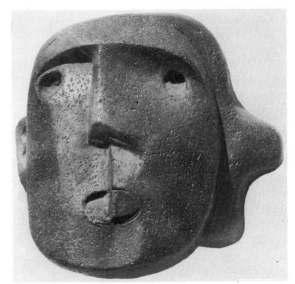

14. *Mask,* 1929

something of the grand frontal approach of Easter Island, to pieces like the Birley half-length of 1931 in veined alabaster, where an extreme sweetness and evident 'beauty' represent Moore's love of fine material at its most voluptuous. These were trends never to be repeated, like that of the lead Seated Figure of 1930, since destroyed, which is the only instance of his having made a sculpture in a style directly parallel to that of his drawings from life. In 1929–30 there were curious Profiled Heads and a whole group of Maternities.

In one and the same year, 1931, half-length figures naturalistically modelled, with even some attempt at characterization, contrasted with a figure in which the head was a tapered oval with two white circles incised upon it, one inside the other. Looking back at twenty-five years' distance, it is of course easy to see which of these was central, and which was peripheral, to Moore's ambition: at the time they seemed to balance one another. And if in time the naturalistic element dropped out almost entirely, it is also possible to see, from to-day's point of vantage, that the ironstone *Mother and Child* (a mere five inches in height) is the precursor of the Stringed Basket Figures of 1939, which at the time seemed so hermetic. For what is at stake, in both cases, if not the notion of a single flowing and coherent form, roughly ovoid in shape and resting as lightly as possible upon its base?

One or two portrait drawings by Moore exist, and in one or two sculptures dated *c.* 1929–31 there is, as I have said, something like a shot at characterization. Early reclining figures give the head a degree of natural-istic definition which later dropped away from Moore's intentions, and there is among most of Moore's heads a shared wary alertness, a suggestion of ears cocked and eyes turned in vigilance. But in general it is of Moore, as much as of his great predecessor, that we are re-minded when we read in Adrian Stokes's book on Michelangelo that 'faces are of much less significance to him than torsoes' and that 'the human frame, rather than the features, represents the person'. This being so, a naturalistic head like the one on the Ottawa *Re-clining Woman* of 1930 [15] has an effect of noble in-congruity: it is as if one of the Masks of the previous year or two had jumped down off the wall and got itself into the sculpture when no one was looking. Similarly, the powerfully-modelled breasts and hands of the Ottawa figure contrast with the single scooped-out form that stands for legs and feet, and with the sum-mary incisions that hesitate on the edge of indicating toes.

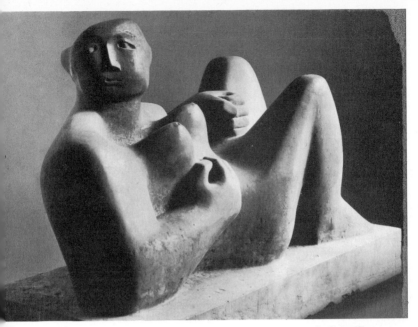

15. *Reclining Woman*, 1930
16. *Reclining Figure*, 1930

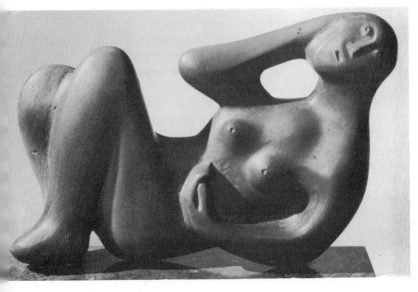

A reclining figure in Corsehill stone of the same year, now lost and probably destroyed, demonstrated even more clearly the transitional stage at which Moore then was: the breasts stood erect in a manner to which Nature could never aspire, but the right hand had sunk into the form that ran uninterruptedly from the elbow to the top of the breast and manifested itself by five grooved incisions like pencils laid flat in wet sand. A third reclining figure of 1930 [16] is of especial interest in that it shows Moore experimenting with an arabesque-form that embraces the whole figure, as if drawn almost with a single movement of the pencil. It includes, also, the first of the eloquent holes in his Reclining Figure series: and although it is a hole formed quite naturally by the crooking of the right arm it is a speaking hole, as opposed to an anatomical incident: a hole, that is to say, which rhymes with the other ovals in the composition. This piece is of interest, thirdly, for the fact that Moore was trying to get the figure free of the base: there is an elasticity in the woman's body, and an eloquence which is not at all (as it is in some earlier figures) the eloquence of an unusually dramatic sack of coals.

The lesson of a piece such as this must have been, I think, that it was by granting his sculptures the broadest possible independence that Moore was likely to get what he wanted. In the half-length semi-naturalistic figures of 1930–31, for instance, there are always beautiful passages in which Moore redistributes the relative importance of one part of the anatomy as against another and achieves, by doing so, a new kind of monumentality. But there is usually, also, a region at the bottom of the piece where the body ceases to be carved and just comes to an end, like a clothes-peg stuck into the earth. Moore would have found a way out of this impasse in the end, but meanwhile these were sculptures in which the plastic interest gave out an inch or two before the eye got down to the base; greater satisfaction was to be had where Nature had solved the problem: in full-length figures like the

Seated Girl of 1931 in anhydrite stone, for instance.

This problem was not resolved in the beechwood *Figure* [17] of 1931, but this figure is of great historical interest on more than one ground. It is, to begin with, one of the last small wooden sculptures in which the eloquence of the graining and the eloquence of the formal idea are one. Next, it introduces, in the terraced form of the breasts, a plastic idea which was to come out to royal effect in the Northampton *Madonna* of 1943–4 [59]. Thirdly, in giving a Romanesque arch-form to the diaphragm, Moore looked forward even further to the great Standing Reliefs of the 1950s whose most stirring feature is the enormous commotion, as-

17. *Figure,* 1931

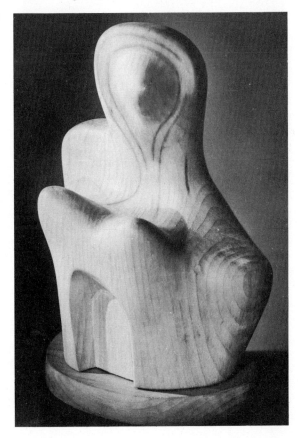

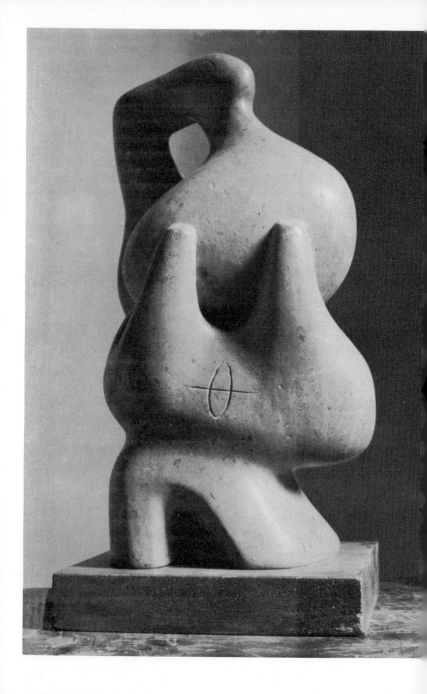

sociated in life with a supreme degree of sexual fulfilment, in precisely this region of the body.

Another feature of 1931 – the most fruitful year to date in Moore's career – is the arrival of themes metamorphosed successfully from Picasso. I stress 'successfully' because most English borrowings from this source have a look of absurdity. Like everyone else who wanted to know what was going on in modern art at that time, Moore went to Paris as often as he could. There, and from such French art magazines as reached London, he knew more or less what Picasso was up to. He owned, for example, a copy of the Picasso number of *Documents* (1930) in which the work of the previous few years was well illustrated; and the Hornton stone *Composition* of 1931 [18] was undoubtedly provoked by Picasso's beach scenes of the late 1920s. But although

18 (*opposite*).
Composition, 1931

19. Picasso:
Head, 1929

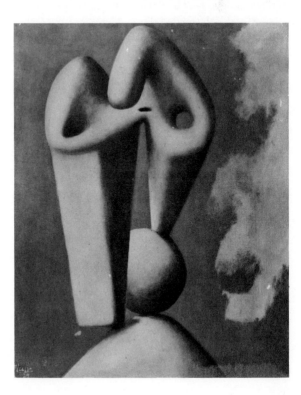

there can be no doubt of the source of the motif, the interest of the piece for Moore lay rather, as he says, 'in the attempt to get one round form to exist inside another, in stone, and stay alive'. Moore was now a grown artist, and an emancipated one, and the attitude to the block which had satisfied him in the early 1920s did not satisfy him now. In this *Composition* he aimed to get clear of the tyranny of the block and to turn the solid square stone into something that existed in independent reality. Picasso's many bathers have a grotesque, elephantine quality: dancing on the beach, identified with the ball that they toss skywards, they have themselves an inflated, rubbery, balloonish appearance; and this Moore has most ingeniously carried over into the stone by constantly varying the axes of his composition, splaying and tilting his feet and arms and retaining only that constant sign of the period, the crooked and right-angled elbow. Elements from earlier sculptures remain here and there: vestigial toes, breast-forms that stand erect, tender rounded back-forms that could be those of mother and high-held child. But this is a piece, and a coherent form, that exists in its own right. For the first time, too, Moore has managed to get the sculpture itself almost free of the base, suggesting by the shadowed hollow at its foot that it had come to rest momentarily, much as a thrown ball pauses for an instant in the sand. This is the piece, as it seems to me, in which Moore for the first time found the vein of meaningful ambiguity which has been the source of all that is finest in his later *œuvre*. The little *Double Head* of 1928 had been a ranging shot for something of this sort, in that it presented an image which carries imaginative conviction, even if nothing in Nature corresponds to it; but Moore was not then quite able to deal arbitrarily with Nature's *données*. The solemn, corporeal quality of his life drawings [47] was carried over into the sculptures. By 1931 he could do what he liked, provided always that he knew what it was.

The Reclining Figure benefited also from the climate of assurance which comes over Moore's work in 1931.

20. Reclining Figure, 1931

The most curious of the series to date, if not the most homogeneous, is the Zimmerman *Reclining Figure* in lead of that year [20]. As David Sylvester pointed out in his notes to the Tate Gallery exhibition of Henry Moore in 1951, this figure is less audacious, less constantly radical, than at least one drawing of the period; but it is, even so, a notably venturesome piece. Behind the dinosaur-like head the rear arm has the form of an eighteenth-century chair-leg. The chest is opened up and traversed by what could be either a preliminary draft for the stringed figures of the later 1930s or an afterglow of the guitar-form which dominates so much of Cubist painting. The figure has flipper-like lower legs and feet, and its stance is at a far remove from the slumped, inert, monolithic posture of the earlier Reclining Figures. Consistent it is not: but it crackles with confident invention.

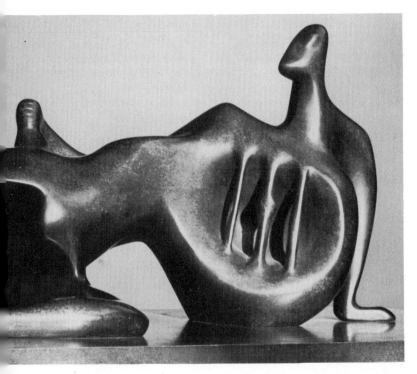

1931-39

Moore in his twenties had to puzzle things out more or less by himself, and to that extent it is reasonable to study him in isolation. But art is in the last resort a social activity, and no great work of art was ever produced in a social vacuum. There is no such thing as a masterpiece that was executed without regard for what other artists were doing and had already done: or even, to a lesser extent, without regard for what other human beings might one day want to see. The repercussions and reverberations may be too slight for our consciousness to take note of them; they may, equally, be prime facts of existence. But just as every human being has to adjust to other human beings, so every work of art has to adjust to other works of art. It can be done at a distance, but most of the great advances in modern art have been made by small groups of relatively young people who knew each other very well. This is true of the Nabis, the Fauves, the Cubists, the German Expressionists, the Dadaists, the Surrealists, the Constructivists, the first and second New York schools: and if there are apparent exceptions – if Seurat, Klee, Arp, Duchamp, Brancusi, and Giacometti seem to have been quite alone at vital moments in their evolution – they too were supremely aware of the general situation of art, and of the points at which they could press their gifts home. And the crucial moment in the development of any artist, great or small, is the moment at which the private world of the studio must be adjusted to the world outside.

Another general point that should be made at this stage is that very few young artists, and very few of their supporters, can distinguish between the relatively

and the absolutely good. To mistake the one for the other leads to unfounded assumptions: the artist gets stuck with himself, and with a limited idea of modernity, and his admirers in time take their bemusement elsewhere. Cruelty can result: it did no one any good to call Frank Dobson, in the 1920s, the best sculptor England had produced 'for about six hundred years'. To avoid misapprehensions of this sort an artist needs two things: friends and colleagues of real size, and an integrated idea of what is being done abroad. The carver's task does of course involve long periods of concentration, during which it may actually be harmful for him to become too involved with the outer world or too aware of what others are doing. Every large carving is an ordeal of steadiness and self-confidence, and one way of getting through that ordeal is not to look up from the job in hand. But ideally this absorption should be balanced by an easy and pointful sociability at other times. Moore in the early 1930s had the benefit of a social context very different from that of his earlier years. His working conditions at that time were just about ideal: the balance between innocence and experience was more or less right, and he had for the first time the advantage of working as the friend and neighbour of people who were tunnelling in the same direction as himself.

By 'the balance between innocence and experience' I mean something quite specific. 'Experience' means an awareness of the ways in which sculpture had been emancipated since – well, since 1912, the year in which Boccioni had envisaged 'a complete renewal of this mummified art'. 'Innocence' means the capacity to let one's profoundest instincts override ideas taken ready-made from others. Experience without innocence leads to work that is feeble, imitative, and mannered; innocence without experience, to work that is provincial and unresonant. Just occasionally Moore had grazed the one, as in the awkward and inconclusive plaster *Relief* of 1931; just occasionally, in some of the naturalistic carvings of the same year, he had grazed the other.

In the work with which we shall now deal both dangers were avoided.

This avoidance has a lot to do, as will be seen, with what was then called 'the modern movement'; but it also has something to do with Moore's own origins. I derided the use of the word 'miner' in connection with Moore's father; and it may seem illogical if, having outlawed it in relation to someone who had once worked in the pit, I use it in relation to someone who has been down the pit only as an observer in the 1940s. But Moore's is fundamentally an art of *burrowing*, and as the miner is pre-eminently a man who burrows I don't see how we can fail to make the connection, however lightly. Something in the inherited experience of the pit must be involved in Moore's lifelong preference for forms which have been opened out from within. (Just how strong that preference is, we may judge from the astonishment with which people received the *Standing Figure: Knife-edge* of 1961 [134].) Moore admits to enjoying the sensation of 'nibbling like a mouse' at the interior of a block of wood or stone, but the metaphor of the miner at the pit-face is, surely, just as exact. And if Moore has never been tempted by the slender, aerial forms and the incorporeal structures which have preoccupied other sculptors we need look no further for the reason.

Moore began, then, with a basic predisposition towards massive forms that could be opened out from within. Where was he to go from there? The British Museum could prompt part of the way, and the Italian old masters likewise: but although Moore has always aimed at qualities which are both universal and timeless he has done so as an artist identified with his own time and with his own particular place in it. No artist who is any good can stand apart from the attitudes of his time, any more than by an effort of will he can reject the vocabulary of form which is current at that time. That vocabulary has a way of asserting itself at just the moment when an artist thinks to have got free of it. This is true of the Nabis' attempt to import the idiom of

Japanese prints into French painting, and of the German Expressionists' borrowings from primitive art, and of every English painter's attempt to come to terms with Cézanne: what resulted is stamped inexpugnably with the date and the place of its origin.

So it is that, if some of Moore's early naturalistic carvings do not quite come off, even the novice can date them 'late 1920s'. Similarly, it is easy to spot points of resemblance between the more experimental pieces of that date and work which had been done, or was about to be done, overseas. But there is a great difference between an influence that is profoundly felt and an accidental likeness, due as much to the mere fact of contemporaneity as to any fundamental kinship.

If pressed, nowadays, to define his allegiances in 'the modern movement', Moore is likely to give a characteristically equable and simplified account in which everybody comes out well and there is no mention of the dilemmas in which he made the right choice. But the truth is, of course, that every artist has to make decisions all the time. If he makes the wrong ones, there's no disguising the fact. And Moore grew to maturity at a moment when it was impracticable to postpone those decisions. Today the repertory of living art is so wide, and so widely accepted, that an artist can go on redistributing the ideas of others for a lifetime without having to add anything much of his own. But in 1932 nothing had caught on, in this way: the *avant-garde* artist was in the position of a man who might or might not tap a vein of some unheard-of mineral, and in either case was risking his life. Today he can go through the same motions and risk no more than the man who telephones his broker to make an investment.

Duchamp-Villon, the sculptor-brother of Marcel Duchamp and Jacques Villon, died in 1918. But in 1932 what he had said in 1915 was still valid:

We cannot fulfil the needs of art in the idiom of bygone times. The things which we want to embrace in sculpture are things with which sculpture has never before been involved. Which is right? Ourselves, or sculpture?

Moore in his middle thirties had decided opinions about the new idiom, and about the ways in which people had tried to carry out Duchamp-Villon's mandate. He regarded Brancusi, for instance, as someone whose historical mission was now fulfilled.

Since the Gothic [Moore wrote in 1937], *European sculpture had been overgrown with moss, weeds – all sorts of surface excrescences which completely concealed shape. It had been Brancusi's special mission to get rid of this undergrowth, and to make us once again more shape-conscious. To do this he had to concentrate on very simple direct shapes, to keep his structure, as it were, one-cylindered, to refine and polish a single shape to a degree almost too precious . . . But it may no longer be necessary to close down and restrict sculpture to the single (static) form unit. We can now begin to open out, to relate and combine together several forms of varied sizes, sections and directions into one organic whole.*

The point could hardly have been put more clearly. Remembering, too, the lack of fuss which distinguishes Moore's carvings of the middle and late 1930s, we could pick one of Brancusi's own sayings: 'Simplicity is not a thing to be aimed at. It is something one arrives at in spite of oneself, as one draws near to the real meaning of things.'

In his preference for forms that are massive and full, Moore could count on an intuition which Rodin had, but never followed through, when he spoke of 'the human body conceived as an urn, tapering to the waist, widening at the hips, and forming a vase with an outline of astonishing perfection – the amphora, which holds in its flanks the life of the future . . .' Moore in the middle 1930s used over and over again a form, half urn, half basket, which had just these implications. Someone who had got on to the ambiguity of near-human forms, and who had always been splendidly radical in his attitude to the future of sculpture, was Arp: and in one or two pieces of *c.* 1932 Moore draws near to the squidgy, all-purpose, sea-lion-like forms of

63

Arp [24]. Moore is not a whole-hearted admirer of Arp, and I think that he finds Arp's idiom too suave, too supple in a slithery way, and too lacking in rugged incident. Where the forms in Arp have an intrinsic tension it is more, as he sees it, the tension of a balloon blown tight than the tension of an articulated structure in which rounded forms press outward. But he is too fair-minded to discount Arp's position as a man who has been fundamentally on the right side since well before 1914. Time and again, Arp's voice has been heard in terms that Moore could echo: 'Bourgeois art is licensed lunacy . . . It should no longer be allowed to sully nature. Like the early Christians, we must go back to essentials.' And again: 'Art is a fruit born of man, just as a fruit grows on a tree. But whereas all fruits have forms that are intrinsically their own, the human fruit which we call "art" nearly always embodies an absurd resemblance to something else . . . I love nature, but not its substitutes.' Arp pushed this belief to the point of wanting his sculpture to merge into Nature and become indistinguishable from it. But of course this has never been the case; Arp's hand is unmistakable. And Moore likes, moreover, to get altogether closer to the origins of his imagery; to worry them, in a word. But there will remain certain kindred manifestations: among them, the piece dated 1932 in which Arp set three movable forms on one large form, and the *Concrétion Humaine* of 1936.

Not much has been written about Moore's contacts with the Surrealist movement. Most English critics dislike Surrealism, dismiss it almost *a priori*, and are embarrassed to think that Moore was once involved with what seems to them a whimsical and literary digression from the main purpose of art. It is true that a great deal of execrable work was done in the name of Surrealism, and it is also true that although England fathered several of Surrealism's ancestors (William Blake, Lewis Carroll, and Edward Lear) our contribution to the movement in its heyday has not always lasted very well. But Moore's sympathy with the move-

ment was firm enough for him to contribute to the major Surrealist exhibitions which were held in 1936 in both London and New York. And even if he had not done so his sculptures of the 1930s would bear witness to the role played by Surrealism in liberating his imagination. For that imagination does, beyond a doubt, assert itself with a new boldness from about the time (in July 1930) when a new magazine, *Le Surréalisme au Service de la Révolution*, began to appear in Paris.

Moore was neither a whole-hearted Surrealist nor a convinced revolutionary, and he had no interest in either the para-literary conceits of Surrealism or the up-ended anecdotal paintings to which these gave rise. What moved him profoundly, as it has continued ever since to move anyone with the slightest feeling for poetic statement in art, was the series of early works by Giacometti which were reproduced, sometimes with an accompanying text by the artist, in *Le Surréalisme au Service de la Révolution* and other reviews. More important even than certain physical parallels (see Giacometti's skeletal *Reclining Woman* of 1929 and his *Project for a Square*) was the attitude of mind which Giacometti defined in a famous essay in *Minotaure* in 1933.

Once the object [a generic name that he gave to all the sculptures of this period] *is constructed I tend to see in it, metamorphosed and displaced, facts which have moved me deeply without my realizing it, and forms which I feel to be close to me – though (which makes them all the more disquieting) I often cannot identify them.*

These lines could stand as the charter behind Moore's more enigmatic works in the 1930s. Moore has always worked in precisely this way – with facts that have moved him deeply without him realizing it, and forms which he feels to be close to him even if he cannot, and usually does not want to, identify them. Before 1931 his imagination was not free enough, nor his technique assured enough, to give them full scope: an exceptional

excitement attaches, therefore, to the long series of works, many of them now unfamiliar to the English public, which he produced between 1931 and the outbreak of war in 1939.

One last environmental point. In the 1920s, as I have said, Moore had no companion of his own size. After 1939, he was of an age, and was working in an area of achievement, where artists no longer had close associates. But in the 1930s he did have, in Ben Nicholson and Barbara Hepworth, friends and neighbours who were close to him in age and in ambition. It would not do to exaggerate the intimacy which reigned, in working terms, between three artists, each of whom had a powerful individuality; Moore was essentially a thrusting and a solitary force. The inspired advocacy of Herbert Read soon put it about all over the world that a group of youngish artists was revitalizing British art; but although Moore enjoyed the friendliest of relations with his neighbours and was glad of the advantages of a close-knit society (through Geoffrey Grigson, for instance, he came to know much of poets and poetry) he did not see art-life in terms of organization and campaigning. Many artists take a legitimate pleasure in the politics of art, and the 1930s were a great period for the manifesto and the statement of policy and the grouping and regrouping of like-minded individuals. Moore believes that people should be ready to fight for what they believe in, and he was a member of Unit One from 1933 onwards, and of the Seven and Five Society from 1934, just as he contributed to *Circle* in 1937. But whereas Paul Nash and Ben Nicholson regarded these activities as part of a holy war, Moore believed that the work would eventually make its own way and that political activity was tangential: valid and stimulating for some, dissipating and irrelevant for others.

Architecturally there is nothing special about Parkhill Road; socially it leans as much towards Kentish Town as towards Hampstead. No. 60, where Mondrian came to live in 1938, might be a trial run for a penitentiary, and the Mall Studios, in which Moore, Nicholson,

Hepworth, and Herbert Read came to live five or six years earlier, have none of the grand Bohemianism of the London studios of late Victorian and Edwardian times. They are just cabins, a little apart from the life of London, in which people could get on with their work. Braque and Léger were occasional visitors; and after Hitler came to power, the original group were joined by Gabo, by Marcel Breuer, by Walter Gropius, and eventually by Mondrian; this did a great deal to de-provincialize what would have been, in any case, as powerful a concentration of younger talent as British art could show at that time. In 1933, Nicholson was thirty-nine, Moore thirty-five, Hepworth thirty: Hepworth had gone to Leeds School of Art at the age of seventeen and had therefore overlapped with Moore both there and at the Royal College of Art, where both were students from 1921 until 1924. Like Moore, she went to Italy at the end of her time at the R. C. A.; and, again like Moore, she found that it was all she could do to adjust her Italian experience to the idea of sculpture which she had brought with her from her early days in Yorkshire and from her years as a student in London. She went, however, at a substantially earlier phase in her development; and this is what she said later about it.

The Travelling Scholarship provided my most forma-tive years by far. There had been something lacking in my childhood in Yorkshire, and that was light. *In my early experience the sun never shone enough, the atmosphere rarely cleared, shadows were never sharp, surfaces never brilliant. Italy opened for me the wonderful realm of light – which transforms and reveals, which intensifies the subtleties of form and contours and colour, and in which darkness – the darkness of window, door, or arch – is set as an altogether new and tangible object.*

Read today, these remarks might seem to apply as much to drawings and reliefs made many years later by Ben Nicholson as to the naturalistic carvings of the human figure which Hepworth produced in her middle

and late twenties. The key to much of Nicholson's grandest work is in the architecture of the Ducal Palace at Urbino; but in the case of Hepworth Italian influence asserts itself above all in the lyrical ease and tenderness and fluency, so different from the basic awkwardness of so much English sculpture, of the carvings which she produced on her return from Italy. Looking at her Hoptonwood stone *Torso* of 1928 we at once remember Moore's clay *Torso* of 1925–6 [2], just as her ivory wood *Torso* of 1929 subtly echoes Moore's African wood *Torso* of 1927. What is remarkable here is not that she should have followed the lead of an exceptionally powerful and substantially maturer personality, but that her contribution has already something that is her own.

Hepworth's original achievement as a sculptor can best be dated, however, from 1931. In 1930 she had seen paintings by Ben Nicholson for the first time, and as a result of this her work ceased to be concerned with an Anglo-Italian compromise: in her own words 'the exploration of free sculptural form' became its object. In carvings like the alabaster *Pierced Form* of 1931 and the green marble *Profile* of 1932 she was 'seeking a free assembly of certain formal elements, including space and calligraphy as well as weight and texture'. 'Space', here, may now be interpreted as putting a hole where no nineteenth-century sculptor would have thought of putting one, and 'calligraphy' as the notion of incising an otherwise flawless smooth surface. 'I had felt,' she wrote later of the *Pierced Form*, 'the most intense pleasure in piercing the stone in order to make an abstract form and space'; and when she and Ben Nicholson visited Brancusi and Arp in 1932 she was able to go not as a sightseer but as someone with something to show. The two visits had above all a disinhibiting effect. In Brancusi's studio she got rid once and for all of the northern convention that sculpture is in some way 'fretted by the gravity of monuments to the dead'; and in the train on the way south to Avignon she 'stood in the corridor almost all the way

looking out on to the superb Rhône Valley and thinking of the way Arp had fused landscape with the human form in so extraordinary a manner'. The instantaneous liberation indicated in these lines is as characteristic of Hepworth's nature and gifts as is the thorough-minded inner debate which has made Moore's career one of continual combat. The work itself did not become any easier, but the attitude of mind behind it became firmer, easier, and more assured.

Both Moore and Hepworth were still, in fundamental terms, young people up from the provinces. People had been kind to them, but their conquests were their own, and they had started towards them from nothing at all. With Ben Nicholson the case was quite different. As the son of William and Mabel Nicholson and the nephew of James Pryde he had been born into the purple of the Edwardian art world. Every door in High Bohemia was open to his parents, and he might have evolved into one of those aimless, bereft, and insubstantial beings who go through life as 'So-and-so's son'. But, as everyone knows, he didn't. Absenting himself from every milieu in which his parentage could have been of use to him, he set himself to excel in, and indeed to discover, an entirely different sort of painting. No one, in reality, is more delicately aware of the qualities of William Nicholson's painting; but to the outsider Ben Nicholson's career is one long act of rebellion against the upholstered art of Edwardian England.

At the time now under discussion, that rebellion was approaching one of its most decisive phases: Nicholson was shaping up for his first reliefs. The paintings done in France in 1932, during the journey which had so great an effect on Barbara Hepworth, include some of his most delicious and original creations: pictures in which he is manifestly having great fun with the apparatus of representation, looking back to Braque's up-tilted table-tops, looking forward to the jumps and contradictions of style which young painters were to discover in the 1960s, pitting one kind of statement against

another, and counting as plus what had once been counted as minus – accidents and contradictions of texture. The 'free assembly of certain formal elements' of which Barbara Hepworth spoke was there already in these paintings.

21. *Mother and Child,* 1932

Very broadly, therefore, one could say that 1932–3 was for all three artists a time of decision, during which they allied themselves once and for all with 'the modern movement' in Europe, and in particular with an activity that overran all the conventional frontiers. Nicholson's reliefs took something from sculpture; Moore and Hepworth raided calligraphy in many of their carvings. Idiom in both cases was exploratory, unprejudiced, epigrammatic, and free. Discussion and the interchange of ideas went on more or less continuously, and from April 1933 onwards the group had a gifted and tireless commentator in the person of Herbert Read, who had come to live only a yard or two away. While all this lasted – till the outbreak of war – Henry Moore was for the first and only time in contact with a coherent group of like-minded colleagues.

By 1932 Moore had discarded nearly all his naturalistic ambitions, but he did give them one last tremendous throw in the Sainsbury *Mother and Child* [21]. This has the alertness, the emotional tension, of the early Pre-Colombian influence. It has the shifts and anomalies of scale which had begun in the previous year. It has the variety of axes which allows the sculptor to shift the interest continually within a basically simple design. And it has the swelling-from-within which Moore had developed in, for instance, the Clark *Composition* of dark African wood in the same year. Here the shoulder, elsewhere the knees and the breast, were the points at which Moore was managing to give his carvings a new counter-movement, an expansion from within outwards, that was the very reverse of the tightened, constricted, block-hugging movement of 1924–5.

This was the last occasion for ten years and more on which Moore was to show identifiable human beings in

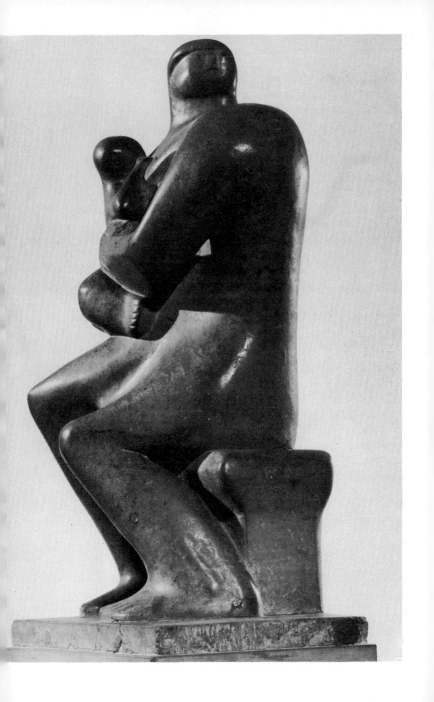

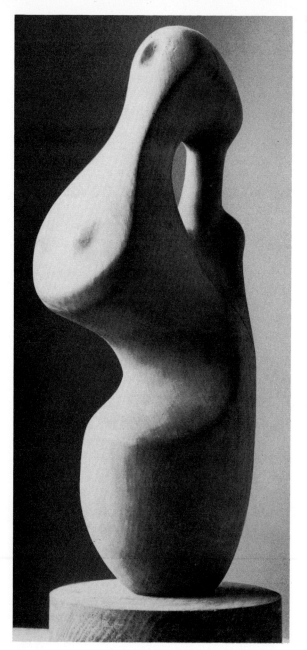

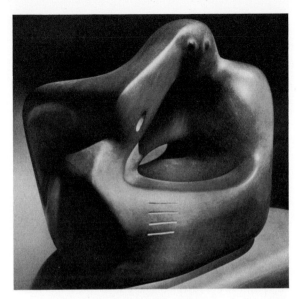

23. *Composition*, 1933

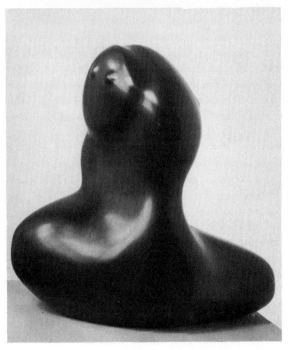

24. *Composition*, 1932

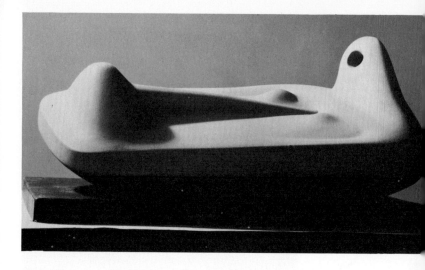

an identifiable situation. The pull of pure sculptural
invention was strengthened around this time by the
example of continental colleagues, and the human com-
ponent in his sculptures began to be treated in an ever
more radical way. Occasional echoes of recent paintings
by Picasso, or of sculpture by Archipenko, or of Pre-
Colombian art, do not affect, here or elsewhere, the
basic individuality of Moore's work. One or two pieces
(notably the Tate *Composition* of 1932 in African won-
derstone [24]) reflected a wish to adapt the formal
language of Arp to purely human preoccupations. A
piece like the British Council's *Composition* of 1933 is
like a comment, again, on Rodin's view of the urn and
the amphora as metaphors for the human body. But
Moore was pushing out – literally, in some cases –
towards formal inventions which had nothing to do
with anyone but himself. Two examples of this are the
figures carved in Corsehill stone; time has conferred a
strange immunity on these mysterious works. Faced,
for instance, with the *Figure* of 1933–4 [26] and even
more so with *Reclining Figure* of a year later [25] it
would be difficult for anyone not forewarned to name
their date, origins, and function. The *Figure* is the

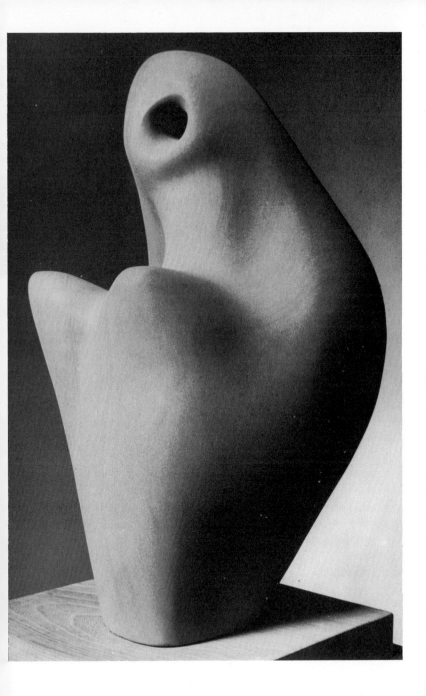

apotheosis of the swelling, outward-thrusting movement on which Moore had been working. It is a piece in which the swelling *is* the subject, to a degree not paralleled elsewhere, and all other themes and incidents are subordinated to it. There is no trace, in this figure, of the violated block: all accords with the mysterious, even, powerful and yet perfectly contained swelling of the stone, which seems, however irrationally, to have been modelled from within. In the colossal strength of throat, neck, back, shoulders, and breast, the figure also looks forward to the more than life-size figures of the late 1950s. The *Reclining Figure* is, on the other hand, an isolated and hermetic piece to which nothing in the later work corresponds. At once bather and bath, coffin and swathed corpse, Libyan sand-formation and early racing motor-car complete with helmeted driver, it belongs to past, present, and future impartially.

In 1933, when working for his second show at the Leicester Galleries, Moore turned to carved and reinforced concrete for a *Reclining Figure* now in the Washington University, St Louis, which harked back to the strutted, opened-out structure of the Zimmerman figure [20], made use of incised lines to focus certain points of interest, and for the arms and legs exploited thinnesses impossible in stone. Adrian Stokes was the first to see that this seemingly ruthless refashioning of the human frame was not, as it seemed to many, a complete violation of the European tradition:

Here are the peaks of the feminine form, realized at last freely, with the aid of mere connecting rods; here as twin summits stand the tall cylindrical knees; here as dolmens are the breasts; here the topmost plateau of the head; while so uniform and simple are the links between these forms that the composition as a whole may suggest an image of Cleopatra reclining in the stern of an Egyptian barge, her long body in such unison with the boat that her propped-up head, as though the topmost section of a rudder oar, guides, steers, and governs . . .

Many artists, having struck a vein of effort which could call forth so apt and so poetical a tribute, would have kept on at it. But 1933 was not, in fact, a very fertile year for Moore (the Sylvester catalogue notes only six items) and the pieces that he did get down to were quite different in character. Some of them had to do with the new dynamic element of the hole [27]. One

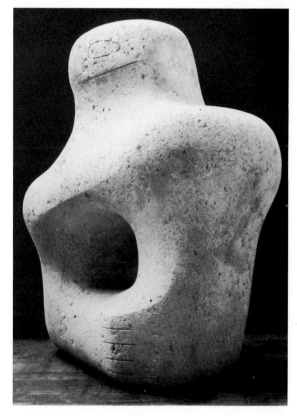

27. *Figure*, 1933

(S137) has striking parallels with the Barbara Hepworth grey alabaster *Figure* (1933): but the differences (his shoulder-form thrust out from within, hers tenderly smoothed down into place) are as striking as the likenesses. In one little-known piece, the African wonderstone *Composition* [24], Moore effected a compromise

77

or middle-ground between the opened-out forms of the St Louis *Reclining Figure* and the closed, fortress-like forms towards which he was also tending. This piece serves, in fact, as a marker-buoy for today's student, who can steer by the flattened oval of the hole, the face-form held over from the *Double Head* of 1928, and the new sophistication in Moore's handling of areas which in former days might have been left more or less as the block provided them.

The point is that at this stage in his development idea and execution were one; the hesitations of the 1920s were gone for ever. If his early pieces are occasionally cryptic, it is because the idea has not quite been dragged out of the block: but from 1933 onwards if a piece is cryptic it is because it is meant to be so. The female human body was still Moore's chief subject, but henceforward it is not merely opened up, but broken first into two pieces, then into four. It was also closed down, on occasion, into an object, at first sight inscrutable, which revealed on inspection all the attributes of the human frame. It was slotted, grooved, hollowed out, shored up, incised, and knobbed.

These mysterious carvings are among Moore's most substantial and enduring contributions to living art. But it would be naïve to suppose that they did not draw to a limited extent on an idiom that was already in the air. Moore has none of the mischief, and still less of the whimsicality, of Arp's reliefs, that delight some people and exasperate others; but a relief like Arp's *Torso with Flower Head* of 1924 opens up a mode of expression that both Moore and Hepworth were to carry several stages further. Nor do the jokey titles of works like Arp's *Head with Annoying Objects* (1930) obscure the fact that these were pioneer attempts to make sculptures in several movable pieces which would hold up as absolute works of art.

Potent, also, was the anti-rational imagery of European Surrealism. In a Dali or Tanguy of 1929 the forms may look totally wilful; but if we break them down objectively an element of unconscious conformity can

often be detected – and what they conform to is an idea of closed-or-open form that reappears four and five years later in Moore and Hepworth. What we are talking about is not the deliberate appropriation by one artist of another's formal vocabulary: it is the universal presence of forms which belong to a particular moment in the history of art and force themselves upon artists whose conscious intentions have nothing in common. Nothing could be further from the aspirations of Parkhill Road than a painting like Dali's *Birth of Liquid Desires* (1932) [28], but the foreground form is, none the

28. Salvador Dali:
The Birth of Liquid Desires,
1932

less, midway between Arp's reliefs of the 1920s and certain pierced and tunnelled forms in Moore. The metamorphoses to which the human body is subject in Moore's figures of the 1930s could never have come about in quite the same way if the arbitrary revision of natural form had not been one of the fundamentals of Surrealism. It cannot be quite coincidental, for example, that in May 1933 *Le Surréalisme au Service de la Révolution* published an illustrated article by Tanguy in which re-invented objects turn out to be related sometimes to human, sometimes to botanical, sometimes to mineral form. Re-invention was in the air:

once again, it cannot be altogether an accident that 1936, a year of outstanding importance to Moore's *œuvre*, was marked also by the Exhibition of Surrealist Objects at the house of Charles Ratton in the rue de Marignan in Paris. Those who did not actually see this show, which appears to have run for a week only, could pick up many of its ideas from a special issue of *Cahiers d'Art* in which were illustrated (I quote from Marcel Jean's *History of Surrealist Painting*) 'stibnites from Transylvania which looked like hedgehogs, a lump of bismuth of which the surface looked to have been set up in printing-type, limonites that had the look of exotic tubers, and a calcite formation that looked just like a snowman'. Equally potent at this time was the idea of the 'perturbed object', typified by the household objects which had been completely transmogrified by the eruption of Mont Pelé, in Martinique, in 1902: any number of analogies could be found between the frantic deformations to which these had been subjected and the revision of the human body, for expressive purposes, of which Picasso was later the pioneer.

This was the heyday also of the interpreted object: the pebble or rock structure which could be grouped, incised, painted, or re-arranged to make an unexpected and poetical impact. This was the year, finally, in which Max Ernst came upon the mathematical constructions in the Institut Henri Poincaré which were then photographed for *Cahiers d'Art* by Man Ray. In these constructions, the formulae of space geometry were put into concrete form. For generations they had fulfilled merely a specific didactic function. But then, on the intervention of a major artist, they suddenly assumed a whole range of auxiliary meanings and gave added authority to researches which had got under way quite independently. Once again, it might be too much to trace a direct line between this incident and the activities of Parkhill Road. But, as will shortly be seen, Moore drew a year or two later on comparable constructions in the Science Museum in London which he

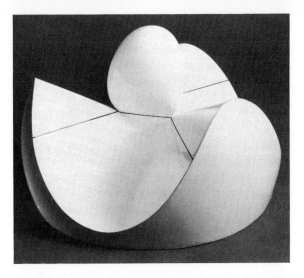

29. H. Henrici:
Algebraic Formula,
1876

had known since student days: Henrici's (1876) visu-
alizations of algebraic formulae [29] added something,
beyond a doubt, to the vocabulary of Moore in the late
1930s.

Above all, Picasso had proved by the end of 1930
that the human figure, broken up and remade in radical
style, could manifest a heightened expressiveness.
Picasso's heavy-limbed neo-Classical figures of 1920–22
lie behind the St Louis *Reclining Figure* of 1932, just as
the aggressive distortions and enclosed hollow spaces
of Picasso's *Seated Bather* of 1930 clearly prefigure
elements in later reclining figures by Moore. But the
message as received in Parkhill Road was not 'Do it
like this!': it was 'Go ahead!' Ben Nicholson once said
to me, 'Courage is the first thing I think of when I think
of Picasso': and what Picasso did at this time was to
give courage to people who lacked it, and to reinforce
it when they had it already.

Moore went ahead, therefore, with redoubled energy:
and that energy multiplied within itself instead of being
spread laterally over a wide area. I would rank very
high in his *œuvre* pieces like the shoe-like African won-
derstone *Reclining Figure* of 1934 and the two-, three-,

81

and four-piece compositions of the same year. Once again, an instructive comparison can be drawn between the African wonderstone figure and a Barbara Hepworth of the previous year, the *Reclining Figure* in white alabaster. Of the two, the Hepworth keeps closer to the facts of human anatomy: shoulder, pelvis, head, and hip vary mainly in scale from the *données* of Nature, even if the clog-form of the whole is clearly marked '1933'. The Moore, by contrast, is the first in a series that extends over the years 1934–7 and grows progressively more enigmatic. In carvings like the *Square Form* of 1934 Moore sometimes ran parallel to paintings and reliefs of the period by Nicholson; but in such cases the circles and the rectangular incisions occurred unexpectedly on the flanks, or on the topmost surfaces, of monumental and disquieting structures in which were fused all the things that Moore had learned from the past and all the things that he had learned from the present, and from his own instinctual drives. Moore *is* Moore, in these pieces, with an intensity not excelled anywhere in his work.

Moore's art at its best is, to my mind, an inclusive art. It allows, that is to say, of the inclusion of elements which in another artist's work might seem incongruous or mutually contradictory, and is the stronger for their presence. In a Barbara Hepworth like the alabaster *Two Forms With Sphere* of 1934 or the white marble *Two Forms* of the following year we see, by contrast, an exclusive art: an art which, like Brancusi's, proceeds by excluding what is irrelevant to the formal proposition that is being stated. All gross matter is purged; what remains has an absolute purity and an ideal simplicity of statement. In Moore's pieces of the same date the experience on offer is radically different. If the Hepworths are sacred places, the Moores are architectural environments long worn and weathered by human use. There are shifts of idiom and scale, deliberate antitheses of weight and proportion, points of high drama and points of repose. The whole bent and character of a piece like Moore's destroyed *Three Forms* of 1934

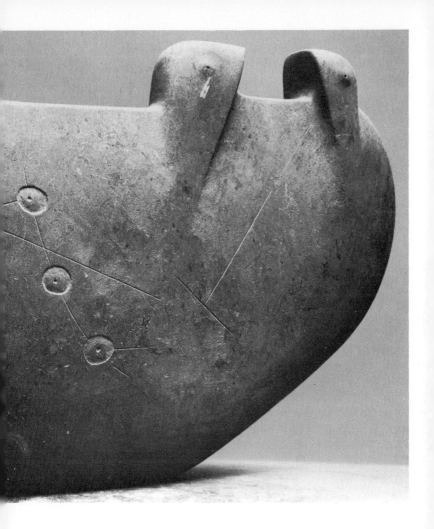

30. *Carving*, 1936

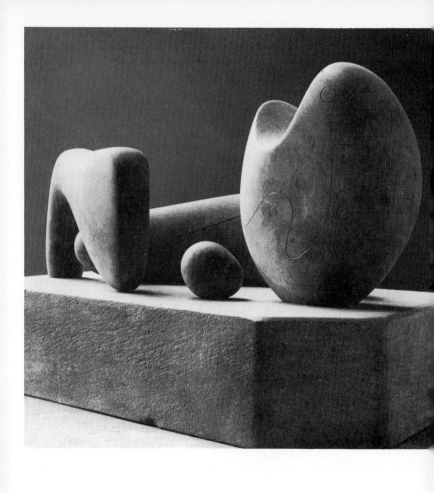

31. *Four-piece Composition: Reclining Figure,* 1934

varied according to the place and the angle from which it was looked at: Moore was all the time *adding*, that is to say, taking in more and more potential experiences and getting them to live together, where a Brancusi or a Hepworth would have subtracted and gone on subtracting till the final piece offered one single experience that was, in intention, the sum of all other possible experiences. But Moore himself defined his attitude when, not long ago, he said roundly that 'Great sculpture is not about perfection.'

The notion of inclusiveness, in Moore, applied also to other aspects of his work. In the 1920s his sculptures had to do, broadly speaking, with the cross-breeding of direct observation of the human figure with inferences drawn either from 'primitive' or from Italian sources. From about 1931 onwards he began to admit source-material of quite another kind. This was due in part to the example of continental Surrealism and in part to the notion, then newly formed, that anything can be the point of departure for a work of art if it is made use of in the right way. This notion has been of cardinal importance to Moore's work ever since: it first got under way in the drawn studies of bone-form, dated 1932, and in sculptures dated 1934 which are really found-and-altered objects in the pure tradition of continental Surrealism. The notion of the accidental in art, and of the object found and altered, is taken for granted in post-war painting and sculpture, but in the early 1930s it came as an immense revelation. Paul Nash at that time was a neighbour and friend of the Parkhill Road group, and no one was quicker than he, in paintings like *Earth Home* or *Landscape of the Megaliths*, to grasp what it meant to form an alliance with prehistory. What Adrian Stokes called 'the lapsed movement of the centuries' turned out to be on the side of living art; and Henry Moore began to work on meteoric stones at just the time when Giacometti and Max Ernst were hauling huge boulders from the bed of a glacier in the Engadine. With increasing years and increasing confidence he has begun to turn the tables on

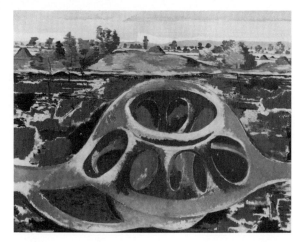

Nature; it is a curious fact about the glade which he uses as a mortuary for old plasters that the tree-forms which mark its boundaries do on occasion echo earlier sculptures by Moore. But in the 1930s, when living art was still the concern of an isolated few, there was reassurance in the idea that what seemed to many people outrageous and wilful practices were paralleled by phenomena which predated the very notion of art. And, concurrently, the everyday world was revising all our ideas of scale and 'importance'. Nobody, for instance, was more whole-heartedly a man of the present than Fernand Léger, and it would never have occurred to him to enlist prehistory as his ally. But he knew what was happening to the nature of imagery in art. 'A quite novel poetry,' he said, 'the poetry of the *transformed object*, is coming into the world, and a new art will be built up on these new discoveries, this new truth.' The object could, of course, be transformed in innumerable ways; and one of them was exemplified by the re-invented forms with which Henry Moore was working all through the 1930s.

Among these, the closed and cryptic forms to which I have already referred have few parallels in Moore's later work. The sculptures in two, three, or four pieces have, on the other hand, their counterpart in many

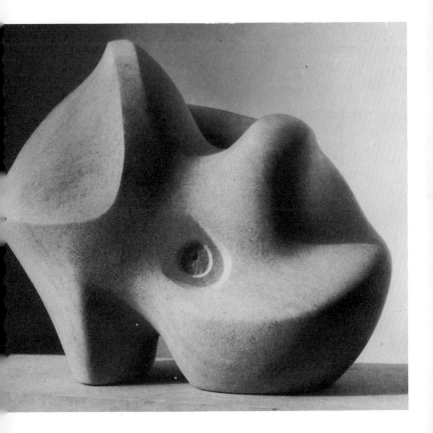

34. *Carving,* 1936

large post-war sculptures. Some observers have likened them to pieces by Giacometti, dated 1931, but even if the initial push may have come from this direction Moore rapidly made the idea his own. Nothing could be more characteristic of him, for instance, than the *Two Forms* in Pynkado wood of 1934. The basic formal idea, here, is that of the sheltering mother: part shoulder, part pelvis, the larger form bends over and nurtures the other in just the attitude that would earlier have served a naturalistic end, and was later carried over into the *Reclining Mother and Child* of 1960–61 [121, 122]. The monumental two- and three-piece Reclining Figures of the early 1960s are not so far, for that matter, from the *Four-piece Composition: Reclining Figure* of 1934 [31]. Moore was still working as much as possible on the principle of the altered object, and in the 1934 piece there are traces of Surrealist idiom which later gave place to altogether more magniloquent procedures. But the fundamental idea is there: that of breaking up the human body to make an image that was truly three-dimensional and could be explored exhaustively from every angle. After completing an experimental four-part piece in 1936 Moore seems, however, to have laid the idea aside for the best part of twenty-five years.

It was not the only idea to be so treated. The white marble *Sculpture* of 1935 [37] looked till recently like an isolated attempt with a material which, more than any other, has emotional connotations for the layman. For how many generations was it not accepted that a sculpture which was not in white marble was not really a sculpture at all? Cathedral and cemetery alike bear out the belief, and the sculptor is rare who is not in some way conditioned by the built-in suavity of the material. By cutting into the block and creating an effect of deep shadow and architectural contrast Moore was able to beat off the dangers of sentimentality: and, thirty years later, the formal idea of this piece was revived, toughened, and given an unforced majesty in the *Archer* of 1965 [136]. In bronze, this is one of the most cogent of Moore's later works; but in the dead white cast which

was prepared for *Homage to T. S. Eliot* at the Globe Theatre in June 1965 it made an impression of other-worldly magnificence. Somewhere within every member of the audience there stirred the ancient idea of white as the embodiment of all that is grandest and most solemn in human experience: that Moore could in this way renew an idea long dragged in the dust was one more proof of his stature.

An idea characteristic of the later 1930s, and not renewed since, is that of the stringed figure. Moore developed this while exploring the notion of the opened-out, as opposed to the closed and hermetic, figure. The initial idea came from didactic models [29] in the Science Museum, London, and in 1937 Moore produced a *String Relief* which is basically a Surrealist interpretation of the human body with string drawn taut between one and another of the three components. David Sylvester defined the threefold function of the string as follows:

It contrasts, in its tautness, with the curvilinear contours of the mass. It establishes a barrier between the space enclosed by the sculpture's mass and the space which surrounds the sculpture – only a barrier which, being a cage and not a wall, can contain the space on its open side while allowing it to remain visible. Above all, the string provokes movement of the spectator's eye along its length and thereby increases his awareness of the space within the sculpture – especially when, as in the Bird Basket *of 1939, one set of taut strings can be seen through another, so creating a counterpoint of movement which brings to life the space around and within which the strings operate.*

The stringed element was used in 1938–9 to emphasize and define the openness of abstract sculptures which were, in effect, standing figures or Mothers and Children under another name [40]. Eventually one of them was flatly called *Mother and Child*, and in the same year, 1939, a *Stringed Reclining Figure* [42] made the point even clearer. Moore's formal experiments

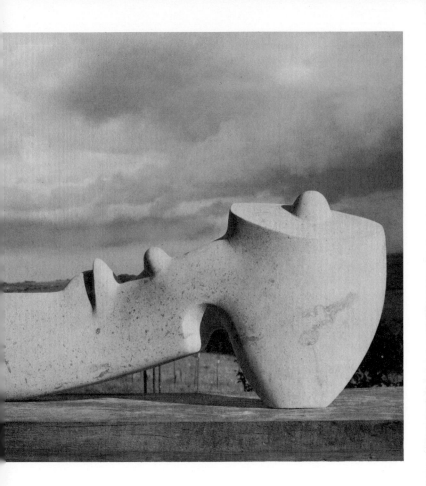

35. *Reclining Figure*, 1937

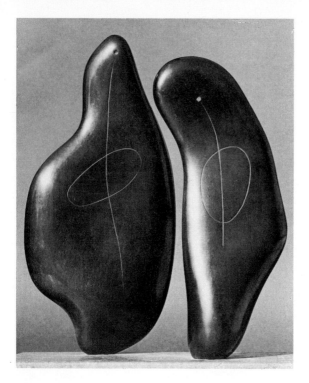

36 (*above*). *Two Forms*, 1934

37 (*opposite above*). *Sculpture*, 1935

38. *Four Forms*, 1936

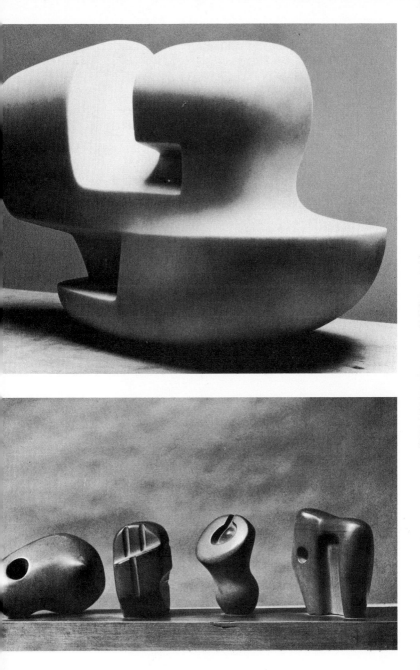

have always been made, in the last resort, in the interests of some new exploration of the human figure, and in the Reclining Figure in question the string contrasts with the easy, wave-like movement of the rest of the piece and literally pulls together what would otherwise be a group of disconnected episodes.

In so far as Moore was widely known at the outbreak of war, he was known for his major Reclining Figures: and in this country above all for the one [43] bought by the Tate Gallery in 1939, shortly after John Rothenstein became Director. This differs from his earlier reclining figures in that the inspiration of primitive art has given place to the inspiration of landscape; and, in particular, of the rolling, undulatory, and predominantly pacific landscape of England. Not the Alps, but downland; not the fjord, but the Seven Sisters; not the

39. *Head,* 1938

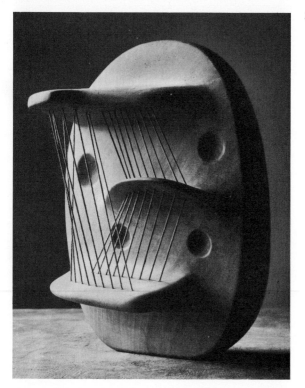

94

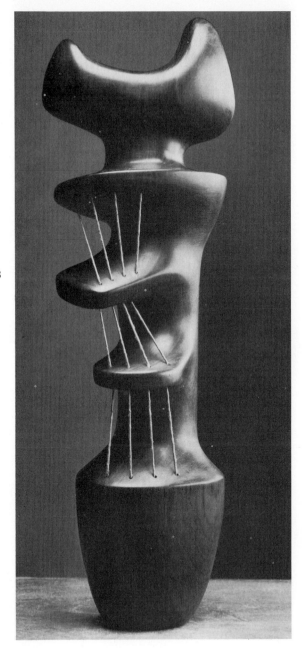

40. *Stringed Figure*, 1938

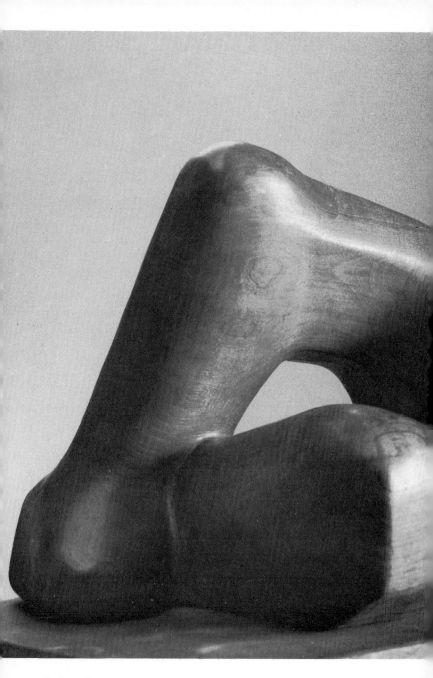

41. *Reclining Figure*, 1936

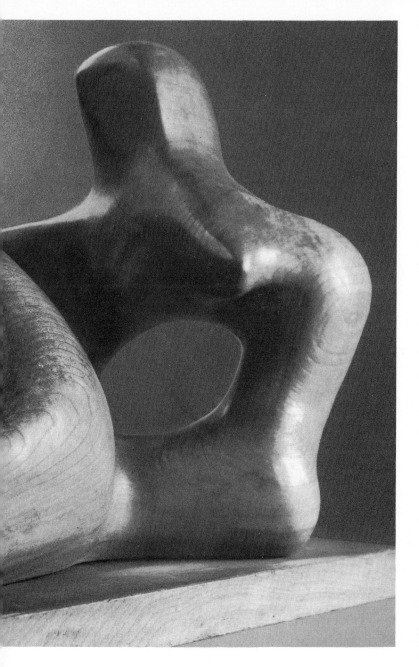

moraine, but the moors – these would define, within the limits of language, the tone of Moore's human landscape. The mountains above Carrara are to this day a holy place in Moore's eyes, but I doubt if it would occur to him to take them bodily into his work, whereas with the broody, unemphatic, heavy-shouldered near-mountains of England he feels free to manoeuvre as he pleases.

The 1939 pieces have in common, also, a new homogeneity of idiom. An incision or two on the Wakefield piece of 1936 [41] may look back a year or two, and the enormous clubbed right foot harks back to the late 1920s. But in general the 1939 pieces get clear away from the jumps and incongruities of Surrealist idiom; clear away, too, from the note of panicky awareness which was part of the Mexican legacy. The whole body now speaks, instead of the eyes or the set of the head. The auxiliary hole is much in evidence, adding an echo to the caverns and tunnels which Nature has provided. The body's own axes are countered by others inherent in the sculpture itself; and to vacancies not in Nature Moore has joined links and embankments and great swooping, swinging formal gestures for which there is, once again, no warrant in our anatomy. In the Onslow Ford figure [44] not only the chest but the head, the breast, and several re-invented areas are pierced, so that the piece echoes along all its length with tunnels and entrances. But all four pieces demonstrated an idea formulated by Moore himself: that 'sculpture in air is possible, where the stone contains only the hole, which is the intended and considered form'.

Architecture played a part, also, when Moore incorporated the notion of an arch within the notion of a hill. And if we remember the awkwardness and incongruities of the work done in the 1920s we shall see at once that in these four pieces the pressures, outward and inward, are in perfect equilibrium. Moore has both respected and fought against the material's own nature. And the sculpture is opened out not merely in a physical sense but morally also, in that nothing is hidden away, counterfeited, or protected by the block. No one can

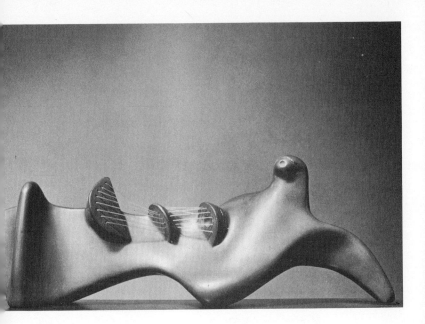

42. *Stringed Reclining Figure*, 1939

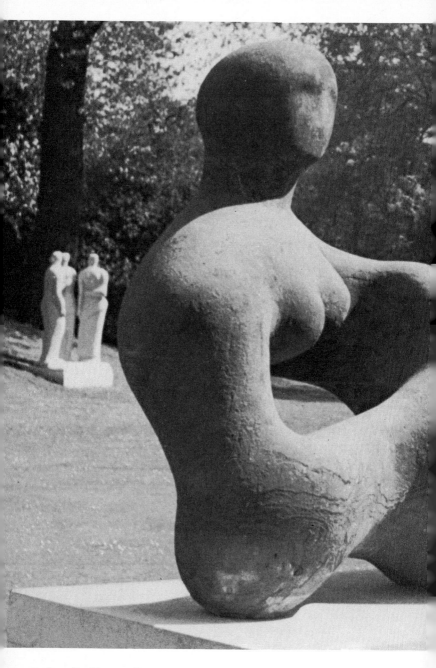

43. *Recumbent Figure,* 1938

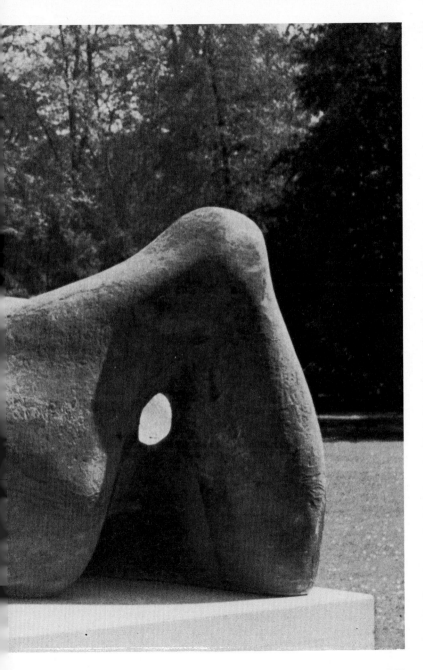

gainsay, in this context, the virtuosity of the Onslow
Ford figure; but the other three seem to me superior,
because Moore went all out to establish, not a chain of
holes, but one single hole so large, so complete, so ob-
viously 'important', that it became the sculpture's prin-
cipal subject. Initially he did it in elmwood, a material
unpopular with some because of its powerful, coffin-
recalling smell, but a great favourite with Moore [41].
Two years later he brought it off in the less tractable
medium of green Hornton stone: the Tate *Recumbent
Figure* [43] is one of the grandest of all Moore's achieve-
ments, and it would form an ideal full close to this
chapter, before the artificial close enforced by the out-
break of war, if it were not that in the six small Re-
clining Figures dated 1939, which measure between
five and thirteen inches apiece, there are ideas which,
as we shall see, he took up again on a larger scale in the
1950s.

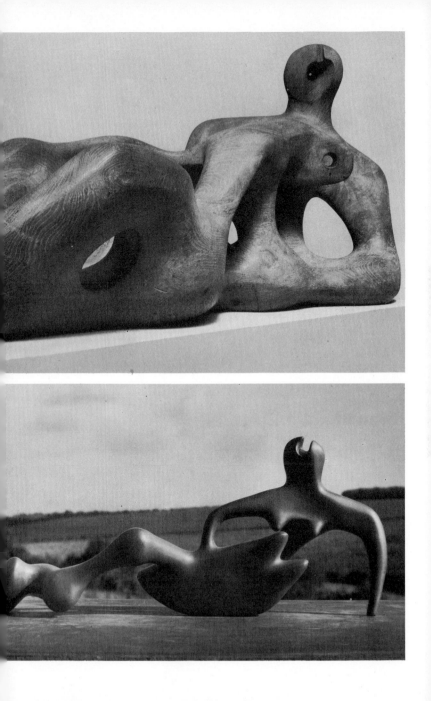

1939-45

Moore had always made drawings, and even where they seem least related to his mature work in sculpture they often turn out in the end to have a kinship the stronger, perhaps, for remaining so long a secret. In the Tate *Recumbent Figure* [43], for instance, which has just been discussed, there are echoes of more than one of the seated life-drawings of 1928 [47]: that majestic poise of the head did not have to be invented.

Life-drawing, Moore said recently, 'is the most exacting form of concentrated activity that exists. Carving is like digging up the garden by comparison.' The relationship between drawing and sculpture is, moreover, one of the aspects of his work about which Moore allows himself a certain degree of self-consciousness. He knows that for a young artist whose sculptures may take weeks or even months to complete there is a valuable freedom in the ability to make a drawing in an hour or so, if necessary by artificial light, and without the feeling that a false move may be fatal, as it may be in the case of a carving. He can even afford to work, as Moore did sometimes in the 1930s, in quasi-unthinking style, allowing the instinct of the moment to guide his hand. He can grope around among ideas that he may never want to carry further, and if he is a sculptor he can invent natural or architectural settings for his work and see how it stands up to them.

These are examples of creative drawing. Some sculptors, by contrast, turn out drawings which are no better than souvenirs of their sculptures, and there are others whose draughtsmanship is so feeble as to make one wonder that they ever let the sheets out of the studio. With Moore, the worked-up 'exhibition drawing' is

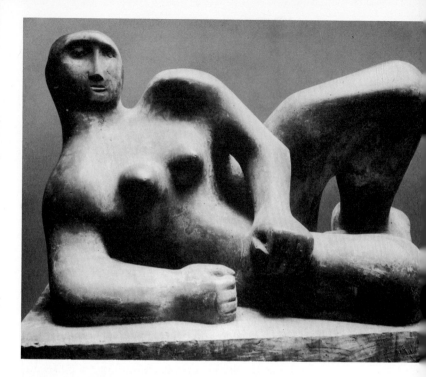

46. *Reclining Figure,*
1932

47 (*opposite*). *Seated Woma
Drawing from Life,* 1928

rare, and in nearly every case his drawings are genuine explorations of ideas. This was the case, especially, in the 1930s, when he was constantly running on ahead in his drawings and trying out ideas which for technical and other reasons he was not yet ready to put into sculpture. One instance already quoted is that of the bone-drawings of 1933; another, the drawings for strutted reclining figures, dated 1931, which were well ahead of the strutted sculpture of that kind which is now in St Louis; a third, the drawings (1936) of sculpture against a wall; a fourth, the coloured drawing of 1939 in which the idea of the internal and external form was first demonstrated.

But as far as Moore's popularity was concerned, the most pregnant of all the drawings of the 1930s was the *Figures in a Cave* of 1936 [48]. Moore did not often define the space in which his figures appeared: more

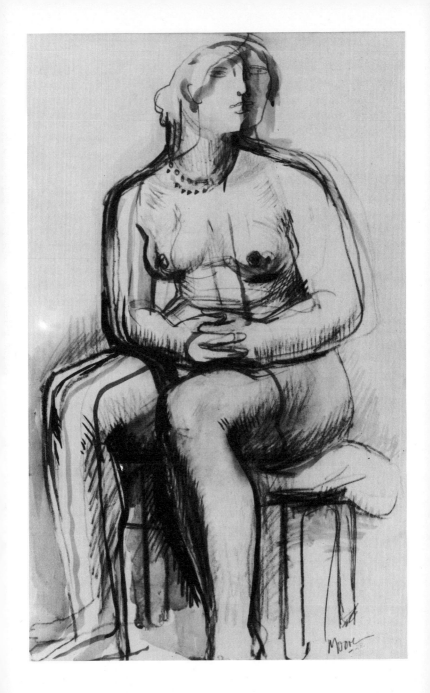

commonly they perched in mid-page and with no attempt at localization. But here for once were human beings wearing ankle-length robes in what was unmistakably a cave. Now the symbolic cave or Virgilian *antrum* has always played a large part in Moore's idiom, but this was the first time that an inhabited cave had been treated naturalistically. It had no successors,

48. *Figures in a Cave,* 1936

though from time to time projects for sculpture were set in a cabin-like environment from which claustrophobia was never far absent. In the spring of 1940 Moore produced, too, a whole group of Ideas for Sculpture, in which figures were piled one on top of another, heaped in a shallow picture-space and against a background which, when defined at all, was dark and prison-like. In the autumn of the same year life caught up with art when Moore, as an Official War Artist, began to study the underground shelters, and in particular the shelters improvised in the Underground, where thousands of people passed the night at the time of the Blitz. The drawings which resulted were made from memory, not on the spot, and they have as much a visonary as a documentary significance. Moore was spellbound by the fact that these thousands of people were lying helpless, deep in the earth, while things were done to them. The dreadful passivity of the scene was

50 (*above*). *Tilbury Shelter. Page from Shelter Sketchbook*, 1941

51 (*opposite above*). *Morning after an Air-Raid. Page from Shelter Sketchbook*, 1941

52. *At the Coal-Face*, 1942

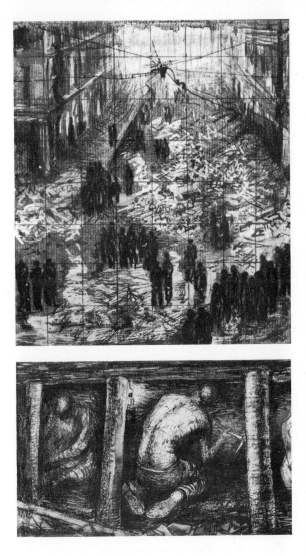

what lingered in his mind, and when he came to make the drawings the people in them looked as if each had a winding-sheet, not a blanket. Seen in close-up, individual heads were nearer to Géricault's mortuary studies for the *Radeau de la Méduse*, or to Giacometti's sculpture of a dying man (*Head on a Stalk*, 1947), than

to the stylized cheerfulness which was current form at the time and did, in reality, survive in even the most gruesome conditions. As a document of the times the Shelter drawings strike me as haunting but incomplete. They bring out the nightmarish, slave-ship quality which Moore can so well evoke to this day in conversation, and in some of the more crowded scenes there is even a foretaste of what Belsen and Buchenwald would look like on the day of liberation. The drawings are unforgettable; but their unforgettableness does not spring from the nature of the scene portrayed. It springs from the alliance of certain elements in that scene with certain basic preoccupations in Moore. For what is man, in these drawings, but a burrowing animal, far from the surface, filled with strange terrors, weirdly accoutred and uneasily reclining? What had been exceptional – a private nightmare – was suddenly the lot of everyone: to poses and postures which had been prompted by the instincts of art there was suddenly no alternative. (In one shelter drawing, for instance [49], nature fell in with art as one of the sleepers raised her right leg in precisely the posture which Moore has used over and over again in his reclining figures.) History put in Moore's way precisely those images of envelopment and protectiveness which had been thrust on him in earlier years by the shape of the block, or by tendencies implicit in art history, or by his own unconscious memories. People lived out, on the platform of the Underground, rituals normally reserved for the healing quiet of the hearth; and if Moore, in these drawings, is nowhere concerned with circumstantial detail of the kind which at the time made the whole thing bearable, he managed to hoist a petty and comfortless existence on to the level of symbolic adventure.

With the Shelter drawings, Moore became what he has been ever since: one of the keepers of the public conscience. People were persuaded, when they saw these drawings, that a certain dogged grandeur attached to the life they were leading. The squalid and self-preservatory elements in that life dropped away, and

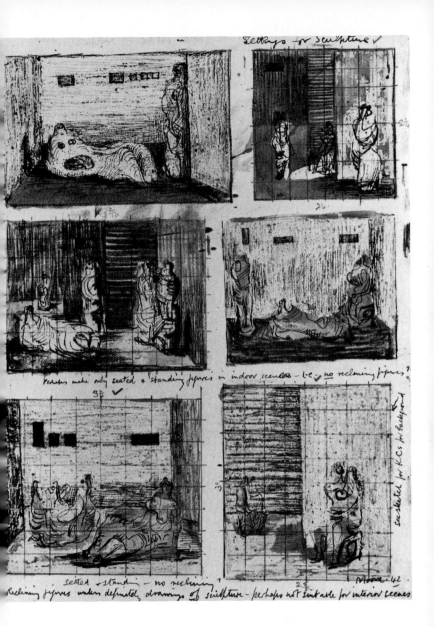

53. *Figures in a Setting*, 1942

what remained behind was on the scale of epic. (What epic, after all, is without its *longueurs*?) And as Moore is not at all a hermetic or cerebral artist there is no doubt that he, likewise, was sustained and encouraged by this sudden contact with a large public. It came at the right moment: teaching had come to an end with the outbreak of war, it was out of the question to get a man-size block of stone or a chunk of the right sort of tree, his London studio was damaged by bombing, and his

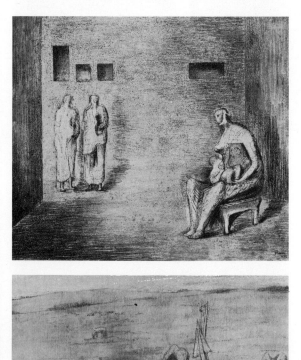

54. *Figures in a Setting*, 1942

55 (*below*). *Sculpture in Landscape*, 1940

56 (*opposite*). *Girl Reading to a Woman Holding a Child*, 1946

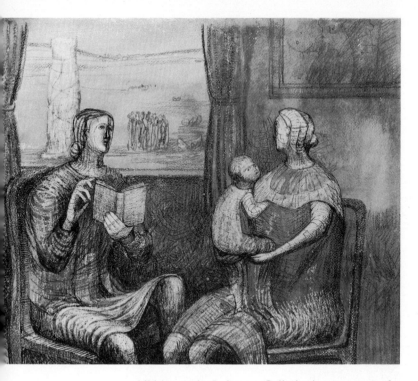

exhibition at the Leicester Galleries in 1940 was to be
the last for five years. It was a difficult time.

The Shelter drawings were followed in 1942 by a
series of drawings of miners at the coal-face. Once again
the motif of burrowing, the claustrophobic shallowness
of the picture-space, and the primary activity of the
bent and twisted human body were ideally adjusted to
the idiom; but as most people prefer to avert their
attention from the realities of the coal-face these draw-
ings have never enjoyed anything like the popularity of
the others. But there is very little else in Moore's work
to compare with them for directness and intensity of
observation – or, for that matter, for power and econ-
omy of design. And when the whiteness of a human
body is coaxed forth from the environing dark, there
comes to mind Moore's favourite among the draughts-
men of the last hundred years: Seurat.

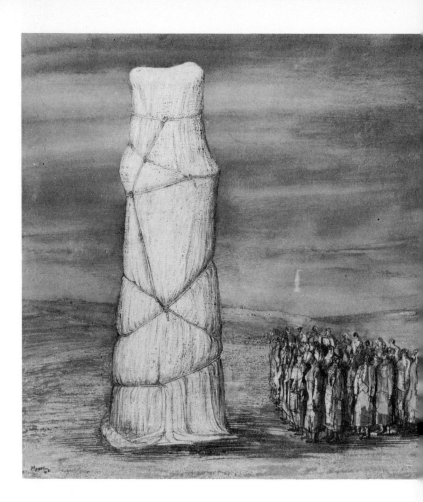

57. *Crowd Looking at a Tied-Up Object,* 1942

Between 1940 and 1943 there is nothing at all in the way of sculpture in the Sylvester catalogue. Large worked-up drawings alone mark the period; but they mark it in ways which now seem to have a note of prophecy. Nothing came, admittedly, of the projects in which whole groups of figures were disposed in an enclosed area, half-palace, half-prison, as if waiting around for some classic drama to get under way. Nor did anything follow from that last fling of the Surrealist in Moore, the *Crowd Looking at a Tied-Up Object* of 1942 [57]: but this is in its own right one of the most haunting and enigmatic of his inventions. (Watching, in later years, Moore's Upright Motives being swathed in readiness for a journey, a visitor to his studio could remember this drawing and find it re-enacted exactly before him.)

A drawing like the *Crowd Looking at a Tied-Up Object* prompts the idea, so often mooted by admirers of Moore, that he should have worked for the stage. Invitations to design scenery for Wagner's *Ring*, and for *King Lear*, and for one or two heavyweight theatrical ventures, did in fact come his way, but he always refused them. During the war, when sculpture was a practical impossibility, he might have been open to the idea, but in normal times he has always dreaded the interruptions which anything of the sort would entail.

I was frightened of it. If I got my coat-tails into the mangle of the theatre I'd be drawn in bodily. The first thing I should do would not be as good as I should like it to be, and I'd have to try again to prove that I could really do it, or to find out what was wrong the first time, and so on. Sculpture takes up so much of one's time, and it would be the simplest thing in the world to have one's energies dissipated in other ways.

But I think that the fundamental answer is that in Moore's best sculptures idea and action are one, whereas in a stage-set, however distinguished, action has to be added to idea. A great figure by Moore doesn't have to move, or talk, or do anything to round off and fulfil its

58. *Drawing*, 1942

existence. It *is* drama: condensed, caught up, con-
centrated. But in wartime, when figures of this kind
could not be made, Moore did experiment with what
were, in effect, stage-settings; and after the war –
sometimes ten or more years later – he realized some
of these notions in bronze. In 1952, for instance, he
wrapped two figures round the outer edge of a right-
angled projection which jutted out, as if into the middle
of a stage. Sometimes the human figure was seated, in
1956–7, against a wall, or on a flight of steps, as if in the
open-air theatre of the Greeks. A year or more later,
'motives' of a quasi-animal sort were set in front of a
wall into which rectangular openings had been let.
Eventually, in 1962, the cycle was completed and the
wall itself became the whole subject of the sculpture.

In all this, the polarity of Moore the sculptor and
Moore the draughtsman is made unusually clear. As if
in some classic textbook of war, two possible attitudes

are exemplified and made visible: the one darting ahead on reconnaissance, the other trundling behind with the heavy equipment that wins the final battle. Poring over the wartime drawings, we sometimes find a detailed forecast of a sculpture which would be carried out as soon as conditions allowed: a sheet of 1942, for example, foretells exactly the look of the elmwood figure [62] of 1945–6 which was for many years in the Cranbrook Academy. In others, a naturalistic drawing of the female nude appears side by side with intermediary sketches in which that nude is partly opened up, partly left as it is in life. Long after Moore had ceased to go to either shelter or mine, certain figures were enclosed in coffin-like areas which derive from the experience of Underground and coal-face. Some of these were later worked up as sculptures, but there are others which got no further: notably a very curious invention of 1944, which looks like a double-bass half in and half out of its case. There are indications, too, of the preoccupation with drapery which developed fully after Moore's first visit to Greece, in 1951.

Altogether, then, Moore in the middle years of the war was thrashing around like some powerful mechanism that had somehow got disconnected from its proper function: like a locomotive in a ploughed field, one might say. In 1943 this was put partly to rights when he was commissioned to carve a 'Madonna and Child' for St Matthew's Church, Northampton [59]. Fiftynine inches high, and in his favourite Hornton stone, this was to occupy him for the best part of a year. Once again, premonitory drawings can be found (dated 1942); but it is clear from the twelve small maquettes which have survived that in the preliminary stages Moore was, as it were, negotiating between his own previous practice and his recollections of Florentine sculpture. A Florentine sweetness and tenderness are uppermost in the final work, but it would be a mistake to underestimate the element of toughness in what is probably the most immediately and universally attractive of all Moore's sculptures.

One early maquette keeps close to the Sainsbury 59. *Madonna and Child,* 1943–4
Mother and Child of 1932 [21]. Another looks forward
to the crowned Madonna which Moore was to realize
for Claydon, in Suffolk, several years later. A third
harks back to the profiled, relief-like sculptures of the
late 1920s. A fourth, to the elongated frontage figures of
1931–2. Two others incorporate the wartime wall in
the form of a summary throne. (The throne idea was,
for that matter, already sketched out in a seated figure
of 1928.) From the pre-war reclining figures Moore
lifted an idea of drapery that served to mark off the
area between the legs and give even the most naturalistic
figure a formal interest, below the knee, that matched
the charm and eloquence of the contrasted heads. For
the heads themselves, a whole gamut of formulae was
tried out, from the pin-pierced hominoid forms of the
pre-war reclining figures to the mask-forms of 1928–9
and, in the final maquette, something not far from a
naturalistic English-rose ideal of the Madonna. In all
this, Moore was faced with one of the cardinal diffi-
culties of the figure-subject in twentieth-century paint-
ing and sculpture. Ever since Gauguin, that is to say,
eloquence in the figure-subject has been a matter not of
circumstantial detail but of the purity and intensity of
the emotional gesture which is involved. In a painting
like Gauguin's *Te Rerioa – The Dream* in the Courtauld
Galleries there is an incongruity between the treatment
of the girls' faces, which approximates to orthodox
portrait-style, and the treatment of the rest of their
bodies, which aims at an entirely different kind of
eloquence; and this incongruity jars more and more, as
we become more and more accustomed to kinds of
painting in which old-style 'accuracy' plays no part. It
is partly for this reason that paintings like Picasso's
Ambroise Vollard of 1910 now seem to us much more
'like' than portraits by Mancini or Orpen: the imagin-
ative thrust is what counts. Moore in general has allowed
the body to define the character of his figures, where
character enters into them at all. It is mistaken policy
to give one part, the head, references of a sort which

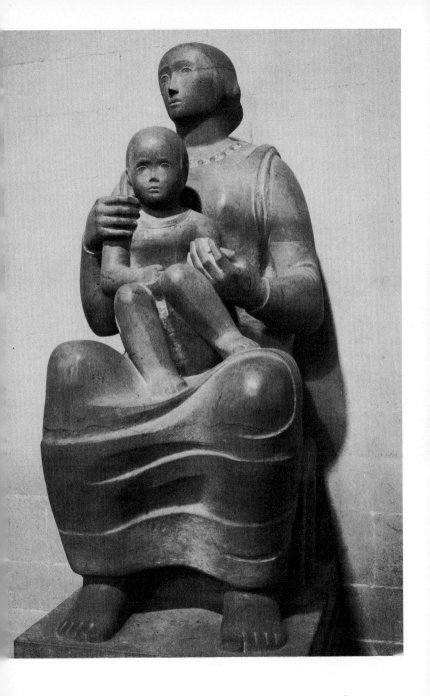

are denied to the others and are in any case irrelevant to the kind of work of art which the artist is aiming at. But in this instance, and in that of the Claydon *Madonna and Child*, Moore risks a naturalistic approach.

There were two main difficulties in this. One is that every naturalistic idiom dates: the other, that there might be an unmeaningful jump of style between the face of the Madonna and the rest of the piece. In the Northampton Madonna, both difficulties were averted. Neither face has dated: and Moore contrived to carry over from the faces to the rest of the sculpture, and back again, the same slow, grand, unaccented rhythms. Detail-photographs bring this out very well, for if we look at them as notations of form, and without trying to identify the passage in question in the general context of the piece, we shall find that a kindred swell and flow characterize every one of its areas: brow rhymes with shoulder, cheek with knee, chin with elbow, neck with ankle. So compelling is the basic rhythm of the piece that even where incongruities occur they pass unnoticed. How many people notice, or care, that the feet of the Madonna are the feet of the Leeds *Reclining Figure* of 1929 [13], or that the draperies are a filled-in version of some of the Stringed Figures of 1937–8? What matters is that the feet have just that minimum of characterization which prevents the sculpture from coming to a full stop at its base; similarly the horizontal, deeply indented line of the draperies offsets the vertical line of the forelegs and prevents the sculpture from being, at that point, all leg.

To the layman, the astonishing thing at the time was that an *avant-garde* sculptor like Moore could produce something with such immediate human appeal. To those who had followed his career, however, the astonishing thing was that he should have employed within the naturalistic idiom of the piece as a whole so many of the formal devices which he had developed in sculptures generally held to be entirely hermetic. The 'life-like' modelling of the hands and the inimitably 'suitable' neckline of the Madonna's dress were not what

some people took them to be: gestures of reassurance on the part of a reformed revolutionary. Their function is to keep the observer busy and interested at crucial points in the general design. Imagine those hands as flat pads of unworked stone, or that area between neck and breast as perfectly smooth, and you will see that something altogether more crude would have resulted. The point of the Northampton *Madonna and Child* is that the observer shifts back and forth, unwittingly, between the idiom of Easter Island and the idiom of George Eliot, and that the two are made to blend without incongruity. We end up by not quite knowing whether what we are looking at is an abstract composition in three perfectly-judged dimensions or a straight portrait of a well-built young Yorkshire mother with a commendably sober taste in embroidery. (One would say of her, as George Eliot says of Dorothea Brooke in *Middlemarch*, that she has 'that kind of beauty which seems to be thrown into relief by poor dress'.)

It was an achievement not easy to repeat, even if Moore's inclinations had been towards repetition. But he did make several attempts in 1944 at family groups – father, mother, and either one or two children – and these eventually served for the Stevenage *Family Group* of 1948–9. When compared, however, with the elaborate terraced construction of the Northampton group these early sketches for a family group tend to look forlorn and stilted: the nobility of the initial gesture is not quite carried through, and the individual figures in each group remain undeniably apart. The undifferentiated bare surfaces of their bodies cause the eye to slide this way and that, nowhere finding either the fastidious detail of the Northampton group or the unifying rhythm which gives that group its tranquil majesty. And when he came, in 1947, to make a 'Family Group' on a slightly larger scale (sixteen inches high) he produced one that combined a rather more naturalistic treatment of the parents' torsos with an altogether new invention, by which the two children were turned into a single basket-like form. Once again, a simultaneous approach

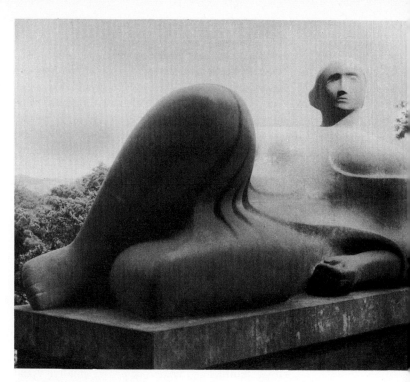

from both extremes of the sculptor's idiom turned out
to be imaginatively right.

Only once did Moore return to the untroubled
majesty of the Northampton Madonna. This was the
Memorial Figure [60] which he completed in 1945–6 in
memory of Christopher Martin. Once or twice – in the
feet, for instance, and in the emblematic treatment of
the right ear – this looks back to the 'progressive' idiom
of the 1930s, and of course the upraised right knee is a
survival from an even earlier idiom: that of the Leeds
Reclining Figure of 1929 [13]. What Moore would not
have aimed at, at any earlier time, is the gentle flowing
movement of the whole piece and the dialogue between
the simplified draperies and the monumental forms
beneath. Once again the head and the hands are just
sufficiently characterized to quicken our interest just
when the piece might have begun to seem too uniformly

general in tone: a pin-pricked turret and a pair of incised pads would not have served. (A seven-inch terracotta *modello* for the *Memorial Figure* makes relatively little effect in these and other respects: Moore had reached a stage in his career at which he could pick out, one by one, the points at which a piece needed to be simplified and accentuated.)

The *Memorial Figure* brings to an appropriately elegiac close the series of swathed human figures, drawn or carved, which derive in part from the experience of the shelter and in part from the investigation of pure sculptural form. Like the Northampton Madonna, it presents the experience of the shelter in sublimated state; as for the investigation of form, it is carried on discreetly and in such a way as to frighten no one. One might also infer, and some people did infer, that Moore by 1945 was like Prospero in Act V, scene 1: a once-terrifying figure who had abjured his rough magic. In no two pieces, certainly, is Moore's tender side so much in evidence. But Moore would cease to exist, as an artist, if either 'the tough' or 'the tender' were to get the upper hand for long and it was only a matter of time (and of transport, at the end of the war) before he could say, with Prospero:

60. *Memorial Figure*, 1945–6

> *the strong based promontory*
> *Have I made shake and by the spurs pluck'd up*
> *The pine and cedar: graves at my command*
> *Have waked their sleepers, oped, and let 'em forth*
> *By my so potent art.*

1945-54

It was in 1945, after the end of the war in Europe, that Henry Moore took up the position which he has held ever since: that of the Englishman who comes top of the list when living art is in question. Older people then, and younger people now, could command private loyalties no less intense; but Moore's particular position springs from the fact that in life, as in art, he can move easily and unaffectedly from the private to the public role (and back again). He is a natural ambassador. At home in all societies, he has kept something within him of the young man from Yorkshire who thought that nothing in the world could be more wonderful than riding on top of a London bus; and this sense of wonder and fun communicates itself whenever he undertakes what, to other artists, might seem a ceremonious chore.

By the end of 1945, therefore, he was a Trustee of the Tate Gallery, a member of the Arts Council's Art Panel, and an Honorary Doctor of Literature in the University of Leeds: these were prototypes of the honours which were to come to him more profusely than to any English artist since the days of Leighton and Poynter. When he went back to Paris, in November 1945, it was almost as an official visitor; and whereas twenty years earlier he had turned away in timidity from Maillol's door, Brancusi himself now bothered to come in from the Impasse Ronsin to see him. In 1946 he paid his first visit to New York, where the Museum of Modern Art gave him a major retrospective exhibition, and in 1948 he made the decisive breakthrough to international status when he was awarded the Grand Prize for Sculpture at the Twenty-fourth Venice Biennale. From this point onwards he was an accepted

public figure, with all the acclaim, and much also of the consecrated boredom, which that phrase implies. Not to have called on Henry Moore came to be the equivalent of 'miss three turns' in snakes and ladders for foreign collectors, museum directors, and miscellaneous enthusiasts when they visited England. Not to have Moore on a committee meant, in official art circles, the loss of a leaven of good nature and good sense. And Moore's journeys abroad took on, in spite of himself, the character of an official progress, in which every remark was noted down by the local Eckermann and every invitation had overtones of Old Diplomacy.

All this meant a radical change, not in Moore himself, but in his relations with the outer world. If we rule out the interval of war, it was only six working years since a historian of English sculpture had felt it necessary to say that Moore should not be confused with Henry Moore, R.A., an eminent Victorian amply represented in Sir Henry Tate's initial gift to his eponymous Gallery. Nor had he moved far, in financial terms, from the days in which five pounds had to see him through for a week's sojourn in Paris: fifty shillings for a return fare by night boat from Newhaven to Dieppe, and fifty shillings for board and lodging and incidental expenses in Paris itself. Doubtless it was pleasant to be acknowledged, but the Parkhill Road group had never lacked confidence, any more than they had worried about money. By 1930 Moore had, after all, been on terms of personal acquaintance with the nine or ten people who counted in the world of *avant-garde* sculpture. In 1929, for instance, the Leeds *Reclining Figure* [13] had been sent to an international exhibition of sculpture in Zürich, where it was shown with work by Lipchitz and others. Lipchitz had singled out the piece at once, and when the two met in Paris in 1930 he was outstandingly generous about it and about Moore's potentialities as an international figure.

The world of sculpture was very small [Moore said recently], *and even as a young man from England you*

could get to know all the people who counted. I knew Lipchitz and Zadkine and Giacometti by 1933, and Arp from about 1933 onwards, and I was really rather glad not to have an English 'tradition of sculpture' behind me. Paris was never really sculpture-minded, of course, and there was no such thing as an Ecole de Paris in sculpture as there was in painting. There were just a few individuals, whom one got to know. And the French critics didn't know the British Museum, or the Musée de l'Homme, let alone the whole history of sculpture, so they didn't realize what was happening when Gonzalez, for instance, got hold of the statue of the war-god Gou from Dahomey in the Musée de l'Homme. But I'd known since 1921, from what I'd seen in the British Museum, that the whole repertory of form-ideas was there, waiting to be picked up. Picasso and the British Museum were the only sources that I ever really needed.

With Picasso Moore has never had more than a minimal direct contact, and of course there comes a time in the life of every major artist when he no longer needs the kind of stimulation which can be given by such contacts in his twenties and thirties. Moore remembers very well, however, an occasion in 1937 when he and Mrs Moore were in Paris and they happened to go and call on Picasso.

It was at the time of the Spanish War. A whole party of us had hoped to go to Spain – Auden and Spender and Blackett and Bernal and people like that – and Alexander Calder wanted to go along too, but at the last moment we weren't allowed to. Anyway, there we were in Paris, and there was a big lunch with Giacometti, Max Ernst, Paul Eluard, André Breton, and Irina and me, and it was all tremendously lively and I think that even Picasso was excited by the idea of our going to his studio. But when we got there he lightened the mood of the whole thing, as he loved to do. Guernica was still a long way from being finished. It was like a cartoon just laid in black and grey, and he could have coloured it as he coloured the sketches. You know the woman who comes running out of the cabin

*on the right with one hand held in front of her? Well,
Picasso told us that there was something missing there,
and he went and fetched a roll of paper and stuck it in
the woman's hand, as much as to say that she'd been
caught in the bathroom when the bombs came. That was
just like him – to be so tremendously moved about Spain
and yet turn it aside as a joke.*

That had been in 1937: and now, only a year or two
later (in working terms), Moore was an international
figure. Not everyone survives a change of this sort, but
Moore has used money and fame primarily as a way of
cutting down on wasted effort and time. He still has the
house near Much Hadham which he took in October
1940, after his studio in London had been bombed: it is
a little bigger now, and a shade more comfortable, but
fundamentally his way of life is what it always was. Nor
did his habits of work change with success, though
some of his friends regretted, then as now, the time
that he gave and still gives to public duties. In the con-
text of those duties it is worth recalling Moore's de-
scription of his working day in the early 1930s, when he
had a cottage near Canterbury and Bernard Meadows
was his assistant.

*We'd all get up at 5.30 and throw a bucket of water
over each other to make sure that we were thoroughly
awake, and then we'd go on with whatever work we'd
been doing the day before. Irina got our breakfast at 6.30
and by 7 o'clock we'd be at work in the open – I had five
acres of shelving ground that ran down into a valley with
hills on the other side. Any bit of stone stuck down in that
field looked marvellous – like a bit of Stonehenge, but
not so big. About 11.30 we'd get into our little Standard
coupé and go down to the sea and bathe and eat our sand-
wiches, be back by 1.30 or 2, go on working till tea at 5
and then on again till dark. It made a 14-hour day, right
through the summer, but it was like a holiday, compared
with London.*

The sea is a long way from Much Hadham, and I
wouldn't put money on the continuance of the bucket-

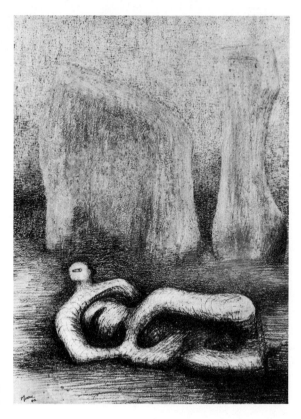

61. *Reclining Figure and Pink Rocks*, 1942

of-water reveille, but basically this is the kind of life that produced, within a year of the armistice in western Europe, both the *Memorial Figure* [60] which has just been discussed and the even larger *Reclining Figure* in elmwood of 1945–6 [62] which was, until 1972, in the Cranbrook Academy of Art in Bloomfield Hills, Michigan. The *Reclining Figure* is one of the high points of Moore's *œuvre*. It was forecast in detail in a drawing of 1942, and when Moore came to carve it there was very little to be experimented with in the terracotta maquettes. The case for adumbrated breasts could be set against the case for the kind of pectoral shelf which was used in the huge reliefs of 1959, but beyond that the

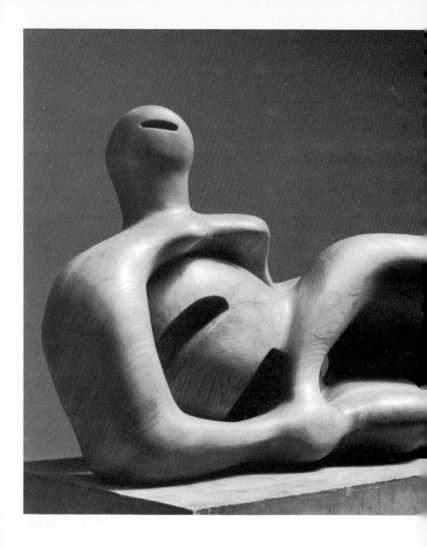

62. *Reclining Figure*, 1945–6

idea-structure was already in existence and could be drawn complete on the flat side of the block.

There is a basic difference, as I see it, between post-war figures such as this one and the Reclining Figures of the 1930s. Moore had learnt from the experience of carving the Northampton *Madonna and Child* [59] that if the basic rhythms were broad and firm enough the sculpture could combine the thrust of pure three-dimensional idea with direct naturalistic reference. In the 1930s one or the other was predominant: if the idea was uppermost, as in the Corsehill stone *Reclining Figure* [25] of 1934–5, then the human references were inscrutable. If truth to everyday experience came first, as in the Sainsbury *Mother and Child* of 1932 [21], then the sculptural idea took second place: the Sainsbury piece could be an illustration to Chateaubriand's *Atala* with no more than superficial adjustment. But in the Cranbrook Academy figure the two things exist side by side: or, more exactly, end to end, for whereas the legs and feet are related to those of the Onslow Ford figure of 1939 [44] the torso is based, as Sir Kenneth Clark was the first to point out, on one of the classic themes of Western sculpture. After twenty and more years of determinedly not using the 'Greek spectacles' to which academic sculpture had been subject, Moore suddenly slipped them back on again in order to adapt to his own purposes a theme mooted in the Parthenon frieze and thereafter constantly recurrent in Western art: the figure, as Sir Kenneth put it, 'with averted thorax and open legs, struggling out of the earth like a tree, not without a powerful suggestion of sexual readiness'. The relevant passage in *The Nude* also speaks of 'the pulsation of the wooden heart, like a crusader's head, burrowing in the hollow breast', and goes on to take the Cranbrook Academy figure as an instance of the way in which in modern art 'the nude does not simply represent the body, but relates it, by analogy, to all other structures that have become part of our imaginative experience'. And the particular point, here, is that in the 1930s Moore's sculptures either did or did

not appeal unequivocally to universal conscious experience. In this piece, Moore jumps from one position to the other with no sense of strain, and we move without incongruity from the very beautiful nuzzling form, which could stand for lover, son, heart, or child unborn, to the turret-like head and the cavernous leg-forms of Moore's practice in the 1930s.

This was, even so, an isolated occasion. In Moore's other work during the immediate post-war era there is an eddying back and forth between experimental, opened-out, and naturalistic, neo-Classical draped figures. In the small bronze *Reclining Figure* of 1945 the human figure is seen as a steep-pitched catchment-area, but in some of the small family groups there are echoes of the Promised-Land atmosphere which descended on England as the war came to an end. An idealized wholesomeness comes over the notion of the family, which Moore knows as well as anyone to be fraught, in reality, with potential tension and stress. This was one of the moments in history when people believed that it was possible to make a new start in human affairs. And where better to make that new start than with the family?

The New Town was, in this context, the predestined setting for the New Family, and in 1948 Moore was commissioned to make a large group of mother, father, and child for Barclay School in Stevenage. There was about the commission, if not about the finished group, something of the generalized uplift of electioneering. Moore is a man with a highly developed sense of social duty, but I myself find the *Family Group* less successful than the Northampton *Madonna and Child* in negotiating the dangerous ground between simplicity and flatness. More precisely, I feel that so large and elaborate a piece needs a little more of the tough side of Moore's nature. The Northampton Madonna is tender to the point of sweetness; but this quality is offset by an implied ferocity in the radical treatment of the lower limbs. (Some years after the family group commissions had been completed, Moore returned to the theme of

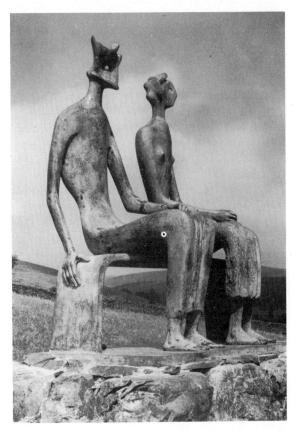

63. *King and Queen*,
1952–3

the two seated figures in the *King and Queen* of 1952
[63].)

Moore's basic gift, as it seems to me, is more for the
telling analogy and the multiple reference than for the
identifiable human situation. A significant piece, in this
context, is the *Three Standing Figures* of 1947–8, which
is now in Battersea Park. In many ways this derives
from the imaginary figure groups of the wartime draw-
ings; but it also relates to the idea of the watcher or
witness which, pioneered by W. H. Auden in the 1930s,
came up strongly in the work of Reg Butler and Lynn
Chadwick in the 1950s. The man or woman who

watches the skies has a particular emotional meaning for anyone who, from the Spanish Civil War onwards, has looked on the skies primarily as a potential source of catastrophe, and in carving this group Moore drew, whether consciously or not, on the stored memories of millions. This gives the group a distinct historical importance, but it does not of itself make it a major work of art. Judged purely as a three-dimensional invention the *Three Standing Figures* does not seem to me to rank very high among Moore's achievements. The swathed cylindrical figures have, in fact, something of that 'decorative and linear stylization' which Moore once pointed to in the post-Gudean period of Sumerian art.

Altogether this was a difficult period for Moore. On the one hand he needed to go on consolidating the private fancies which had welled up since 1939 and had had no chance of three-dimensional expression. On the other, people were looking to him for public utterances of the kind which had been forced upon him by history. He was getting the kind of acclaim and consecration which is usually accorded to Grand Old Men in their eighties: and official approval of this sort is designed as much to smother further progress as to favour a realistic appraisal of what has been done hitherto. New experiences were coming to him, nevertheless, on every hand. In 1946, for instance, his daughter was born: and the image of the family took on a new, leaping, unpredictable intensity. A journey to Greece in 1951 had almost as great an impact as the first journey to Italy, just twenty-five years earlier. Professionally speaking, the context of his work changed considerably with the arrival in the early 1950s of what came to be called 'the younger British sculptors'. Moore took on, in relation to them, the status of a senior master. The use of welded iron by Butler, Chadwick, and Adams emphasized the basic fullness and roundness of Moore's forms, just as the entry of a trumpet at the top of the orchestra will make the first 'cello sound deeper and richer. Everything in art was on the move.

64. *Reclining Figure*,
1949

In the circumstances it would have been inhuman if Moore had not manifested some variant of uncertainty at this time. (One sheet of drawings, dated 1948, is a kind of chart of alternatives, including as it does a naturalistic female nude and a naturalistic horse, side by side with preliminary sketches for the Internal and External Forms and the Helmet Heads of a year or two later.) Meanwhile, the Claydon *Madonna and Child* in Hornton stone was carved in 1948–9 after a small maquette of 1943; and as late as 1954–5 the Harlow *Family Group* was carved from a maquette of 1944. These were major works, in point of size, but in style they looked back and not forward. Somewhere within the Claydon group is the idea of internal and external form, but that idea is muffled in naturalistic detail and there is a certain clash of style between the Florentine graces of the Madonna's head and crown and the almost Mexican heaviness of her draped legs and very large feet.

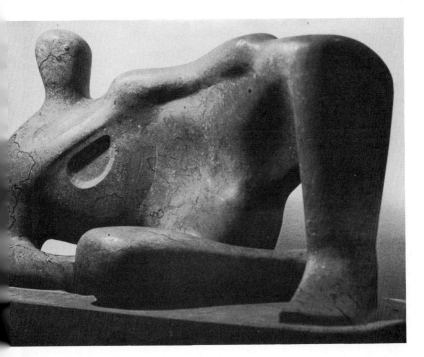

The Harlow group could be catalogued under the heading of 'Civic virtues, apotheosis of'; and although there are beautiful passages of naturalistic modelling here and there the general tone is rather sententious and the length of towelling which loops in and out of the parents' legs is not a device which would have satisfied Moore at any other time in his career.

Unluckily, we should have to go to the U.S.A. to see the piece which proves that Moore the all-risking poet was still very much alive. This is the Hornton stone *Reclining Figure* [64] of 1949. After many Reclining Figures in which a central hole was the dominant compositional feature here is one in which, on the contrary, the central area is filled in. Such is the modelling of that area that two complementary movements are set up: one begins below the heart and swings up and away to the left, while the other begins at the bottom of the right thigh and swings up and away to the right. The relationship, here, between the thing seen and the thing imagined is one of the most moving in all Moore's work, in that the spreading and subtly modulated area between heart and knees is continuously alive in terms both of human anatomy and of the landscape-analogy, the sublimations of moorland and bluff, which Moore keeps going at the same time. This is not one of Moore's largest carvings – it is only thirty inches long – but it is one in which social duty is laid aside and the imagination runs free to glorious effect.

Among the ideas mooted just before the outbreak of war and not yet allowed their full expression was one which appears in a watercolour-and-chalk drawing of 1939 and was worked up in three small sculptures a few months later. Moore had conceived of a small sculpture which would be both head and helmet, armour and living organism, internal and external form. Thus described, it might seem to have timely martial associations, but in point of fact the implications of the Helmet pieces are a good deal more complex. It is uncertain, for instance, whether the

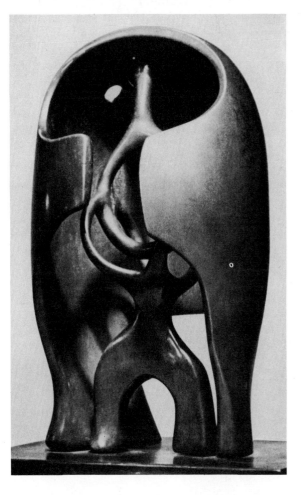

65. *The Helmet*, 1940

internal figure is protected or imprisoned by the
helmet itself: whether it has, in short, got into a
situation which it can no longer control. From the
way in which this idea went on battering for Moore's
attention until well into the 1960s we can assume that
it has a particular significance for him. It has to do,
above all, with envelopment. Within the fulfilled and
rounded form is its antithesis: a form that is angular,
irregular, uneasy, often forked and frantic. Nature

herself set the tone by making the skull one of the
most regular and predictable of known objects, and
the skull's contents so absolutely erratic and mysteri-
ous. Moore from the first gave his outer covering the
grand flawless outline of a Greek helmet: what sits
within is various enough for the findings of psychiatry.
Sometimes it suggests a Cycladic figure, sometimes a
shoe-tree. Sometimes it relates to prehistory, some-
times to an uncatalogued form of microphone. Once

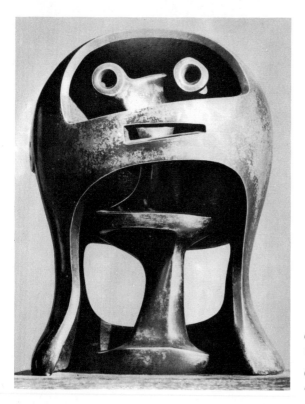

66. *Helmet Head no. 2,*
1950

67 (*opposite*). *Helmet Head
and Shoulders,* 1952

inside the outer covering it can never be seen com-
pletely: when not inside, it looks incomplete and
defenceless. The combined figures are, in short, nearer
to mother and child, or to mother and foetus, than to
any manual of warfare.

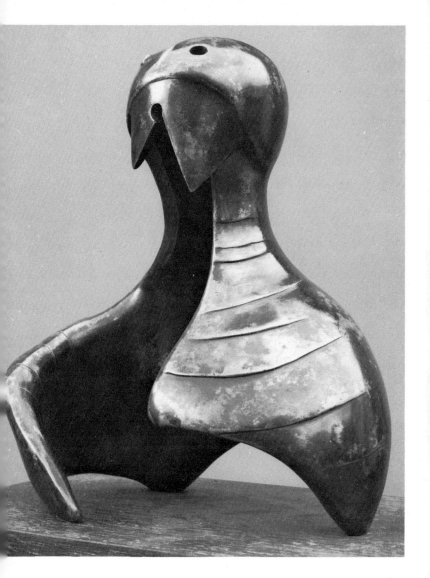

These remarks do not apply, however, to the open-work heads which were also produced in 1950. In these, helmet and head are undeniably one: and their oneness is the whole subject of the sculpture. (Moore's illustrations for Goethe's *Prometheus*, which appeared

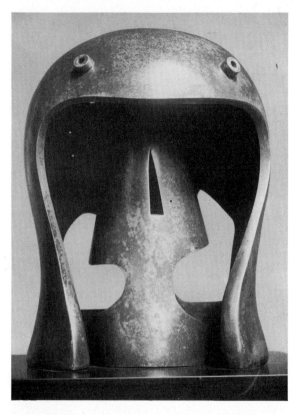

in 1950, have a lot in common with these openwork heads.) In 1951 Moore was inspired to push the helmet-and-head idea still further: a drawing of that year develops the notion, which in other hands would have had a directly erotic content, of an armoured female nude, in which it is hard to tell where the breastplate ends and the naked human breast takes over. The resulting bronze *Helmet Head and Shoulders* [67] was produced a year later and is one of the most purely elegant of Moore's small pieces.

The idea of the internal and external form was transferred, meanwhile, to an altogether grander and more ambitious context. As early as 1931 Moore had aimed, in the green Hornton stone *Composition* [18],

to 'get one form to stay alive inside another': and from 1951 he took the idea of the form half-protected, half-imprisoned by another form and developed it on the scale, and with many of the implications, of a full-length standing figure. Once again the most imposing of these sculptures, the 103-inch-high elmwood carving *Internal and External Forms* of 1953–4 [70, 71], is in the U.S.A. (at the Albright Art Gallery, Buffalo): and its dimensions are such that it is unlikely to revisit this country. But the theme is one that Moore used for a number of smaller pieces that were cast in bronze: as late as 1965 an edition of the *Upright Interior Form (Flower)* of 1951 was produced, and in general the idea obviously means a great deal to him. To the late Erich Neumann, whose *Henry Moore und der Archetyp des Weiblichen* Moore speaks of with friendly wariness and has steadfastly refused to read, the internal-and-external form was the culmination of all his work to date.

> *What we see here* [he wrote of the Albright piece], *is the mother bearing the still-unborn child within her and holding the born child again in her embrace. But this child is the dweller within the body, the psyche itself, for*

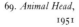

69. *Animal Head*, 1951

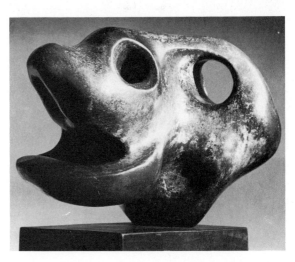

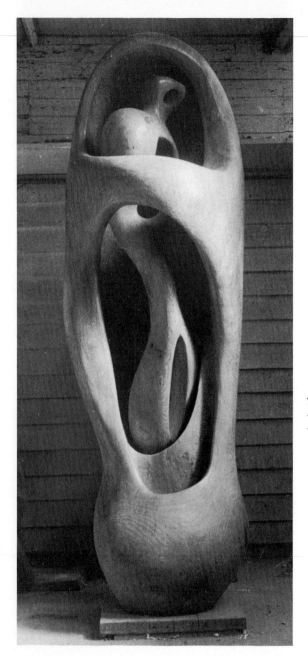

70 and 71.
*Internal and External
Forms*, 1953–4

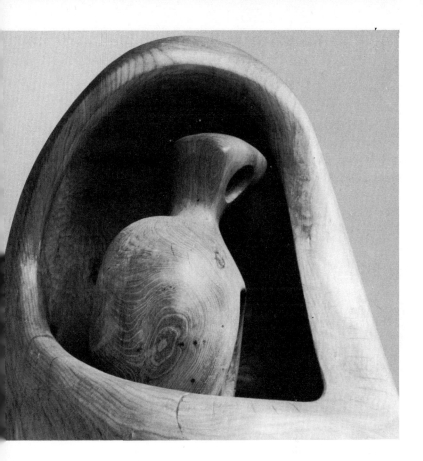

*which the body, like the world, is merely the circum-
ambient space that shelters or casts out. It is no accident
that this figure reminds us of those Egyptian sarcophagi
in the form of mummies, showing the mother goddess as
the sheltering womb that holds and contains the dead man
like a child again, as at the beginning. Mother of life,
mother of death, and all-embracing body-self, the arche-
typal mother of man's germinal ego consciousness – this
truly great sculpture of Moore's is all these in one.*

It is rude to contradict, and Moore's German
admirers have had a rough ride in England ever since
one of them asserted that, as an Englishman, Moore

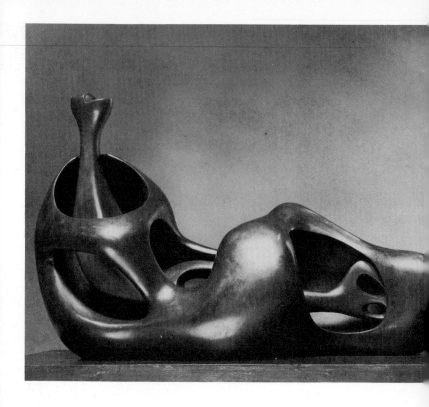

72. *Working Model for Reclining Figure (Internal and External Forms)*, 1951

was doubtless more familiar with Ossian than with Homer. Without disputing that the piece in question will bear Neumann's interpretation, we are entitled to remark that it is also rather like a hollow tree, that many such trees can be found on the borders of Moore's property in Hertfordshire, and that the lignum vitae *Composition* of 1933 is not far, in terms of sculptural idea, from the Albright piece. It is possible, in short, that Moore did not have anything like so portentous an ambition when he made the piece, and that it represents primarily a new and up-ended formal solution to a problem that he had often tackled in Reclining Figures. Laid flat, the huge piece would look like an early draft for part of the great *Reclining Mother and Child* of 1960–61 [121, 122]. Erect, it looks a little like an opened-out version of one of the cowled figures of the early 1930s. The internal form, with its bird-head and wasted nether limbs, certainly looks as if it needed protection, but the smoothness and benignity of the external form do not, in that case, look quite tough enough. For a landmark in Moore's *œuvre* I should, in fact, point rather to the small (twenty-one inches) working model [72] for a reclining figure which is also dated 1951. In this, the alliance of inner and outer forms seems to me altogether more cogent, and the upward thrust of the inquisitive turret-head is an inspired return to the idiom of the St Louis *Reclining Figure* of 1933. The outer form is visibly an *active* envelopment of the inner one: and the relationship between outer and inner forms is one of like with like and not, as in the Albright figure, one of antitheses. Moore is strongest, as I see it, when the internal-and-external theme relates to contrast between equal partners; and although I have no warrant for saying that he agrees, it is on record that when he planned a vulnerable, tuber-like form to go inside the *Reclining Figure (External Form)* of 1952–3 he eventually gave up the idea and published the external form as a piece on its own. This may have been partly because the vacant inner spaces set up some of the grandest echoes

in all Moore: but it was also, I suspect, because there was something basically abhorrent to him in the invalidish forms of the projected internal piece.

I have run on ahead, meanwhile, of another cardinal piece of Moore's development: the *Reclining Figure* [73] which was first shown at the Festival of Britain in 1951. This is more than life-size (ninety inches long) and it is Moore's most ambitious shot at making the spaces between the forms as important, and as various, as the forms themselves. It is, in fact, a parallel in Moore-terms to the welded iron figure or quasi-figure which was pioneered by Gonzalez, taken up by Butler in the early 1950s, and carried forward by Chillida ten years later. The bronze itself is used for a kind of drawing-in-the-air: the areas which it defines and leaves vacant are at least as much the subject of the sculpture as are the areas which it defines and fills in. The turret and the upraised knees remain from the 1930s, but the vacancies give the piece a monumentality which is not earthbound: Moore here commands the air. For the first time in his career, he had produced a piece of which no one drawing could give anything like the total effect: for there was no longer any 'principal view' or 'best view' from which that total effect could be summarized.

And the piece is one from which many later inspirations derived. Draped, it became the Time-Life figure of 1952–3. The *King and Queen* of 1952–3 [63], the *Sculptural Object* of 1960, and even the *Two-piece Reclining Figure* of 1961 [119, 120] – all can be traced eventually and in part to the 1951 figure. One final point: Moore offset the bone-smooth surface of the bronze with a network of fine raised lines that in some places run counter to the movement of the form and in other places emphasize it; and this, also, marks a watershed in his *œuvre* in that in almost all later pieces he goes for what he once called 'the elephant look' of bronze: the look half-way between leather and meat. The 1951 piece has, on the contrary, a fine-drawn calligraphical quality.

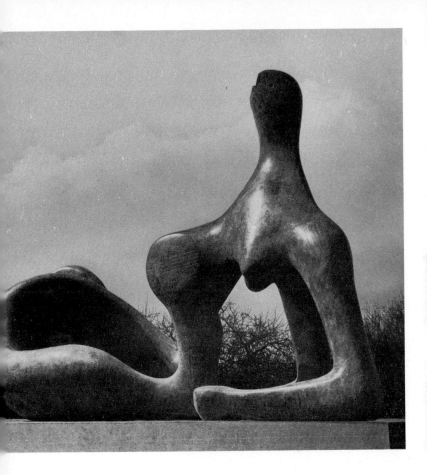

73. *Reclining Figure*, 1951

The year 1951 was also the occasion of Moore's first visit to Greece. This was occasioned by the arrival in Athens of the British Council's touring exhibition of his work, and it took him not only to Athens but to Mycenae, Corinth, Delphi, and elsewhere. Moore by that time was of course a very different human being and a vastly more evolved artist than the young man who had gone to Italy just twenty-five years earlier. There was no question, therefore, of a commotion comparable to that which marked the year 1926. There was no question, either, of his finding in

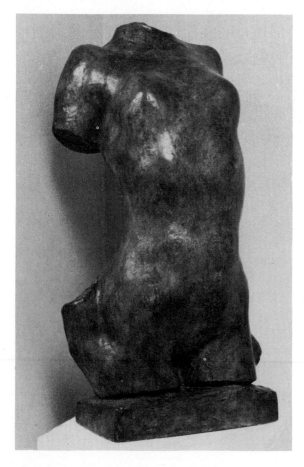

74. Auguste Rodin: *Torso of a Young Woman*, 1909

75 (*opposite*). *Draped Torso*, 1953

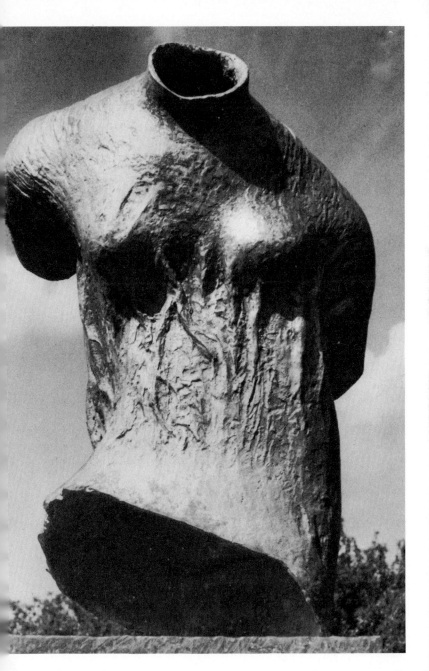

Greek art, whether Classical or pre-Classical, the kind of general authorization which he had found elsewhere. His is, as I have indicated, a northerly and a burrowing, underground *inside* orientation, for all the pleasure that he takes in seeing his work out of doors. His caves are northern caves and his promontories nearer to Flamborough Head than to the Argive coast.

Greece is Greece, and it would be a dull and trivial nature that did not respond to it. But when, two years later, Moore produced the *Draped Torso* [75] that could loosely be called Greekish we were reminded as much of Rodin's *Torso of a Young Woman* of 1909 [74] as of any particular Greek model. And the *Warrior with Shield* of 1953–4 [79] is, again, closer to Rodin's little *Study of a Seated Woman (Cybele)* of *c.* 1889 [80] than to any martial figure that Moore had seen in Greece. What are usually called Moore's Greekish figures do, in fact, seem to me to have a distinct air of the turn of the century about them. They are, too, among the earliest of the pieces in which his loyalty is given over entirely to bronze: and not only to bronze in general but to the quintessence of the material. I myself miss the multifarious interest of Moore's materials in the 1920s and 1930s. When Braque, for instance, came to Moore's studio just after the war, he was particularly taken with the speckled, grainy, subtly coloured aspect of the cast concrete *Mask* [14] of 1929, but there is no gainsaying the powerful role which bronze itself plays in the work of the 1950s and 1960s. And nothing could be less Greek than the broody, not to say sullen look of the material, with its hint of enormous burdens and romantic defiances.

The argument for Greece rests, in fact, on two things. One is the use of drapery in pieces like the Time-Life figure of 1952–3. The other is the choice of subjects vaguely related to those of Greek art, like the *Warrior with Shield* [79] and the brutalized *Falling Warrior* [84] of 1956–7. Moore himself dealt with the first when he wrote some notes on the Time-Life figure. The experience of the blanketed figures in the

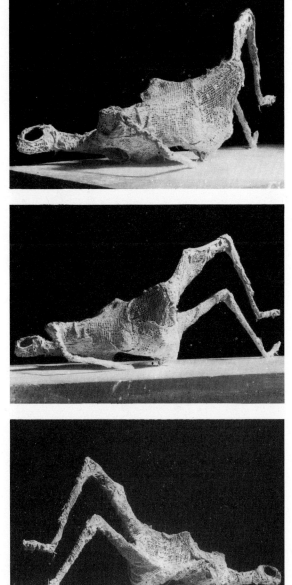

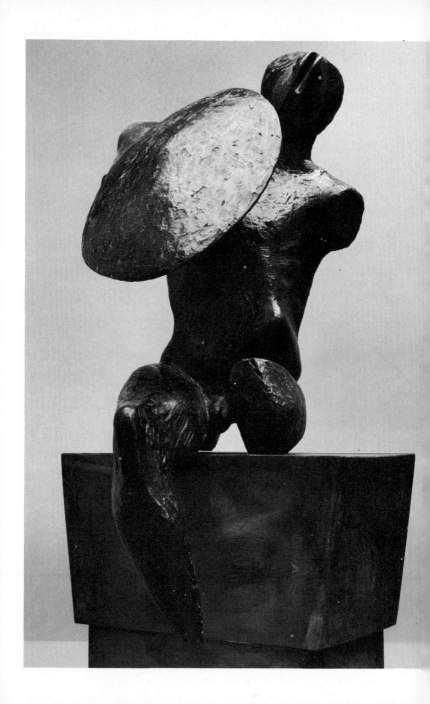

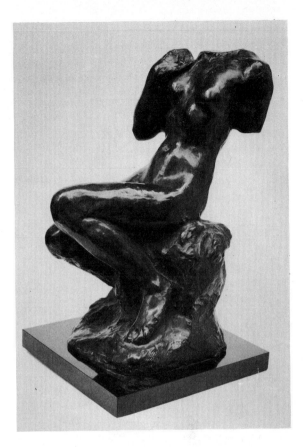

79 (*opposite*). *Warrior with Shield*, 1953–4

80. Auguste Rodin: *Study of a Seated Woman (Cybele)*, c. 1889

Shelter drawings had convinced him, he said, that he ought one day to experiment with the use of more naturalistic draperies: and 'my first visit to Greece in 1951 perhaps helped to strengthen this intention'.

Drapery [he went on] *can emphasize the tension in figure, for where the form pushes outwards, such as on the shoulders, the thighs, the breasts, etc., it can be pulled tight across the form (almost like a bandage), and by contrast with the crumpled slackness of the drapery which lies between the salient points, the pressure from inside is intensified. Also in my mind was to connect the*

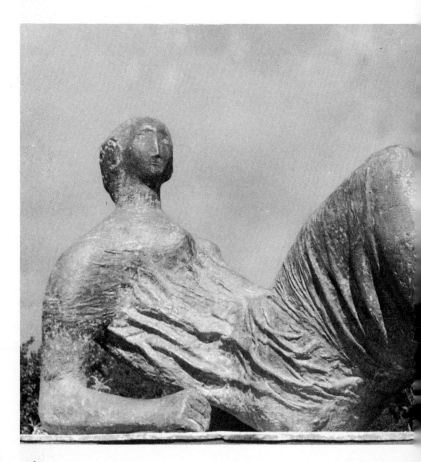

contrast of the sizes of folds, here small, fine, and delicate, in other places big and heavy, with the form of mountains, which are the crinkled skin of the earth. (The analogy, I think, comes out in close-up photographs taken of the drapery alone.)

81 (*below left*). *Draped Reclining Figure*, 1952–3

82. Johann Gottfried Schadow: *Prinzessinnengruppe*, 1797

Moore has never written a loose or an irrelevant word, and this particular text disposes altogether, in my view, of the idea that the draped statues owe anything substantial to Greek art. A sculptor like Johann Gottfried Schadow (1764–1850) used neo-Classical drapery to make an effect which related to his own

time, and not to that of the second century B.C. [82]: and Moore, likewise, uses it to romantic ends that would have been incomprehensible to the Greeks. The 'crinkled skin of the earth' was not something that they would have thought of as a metaphor for the folds of costume, but it was one of the quintessential metaphors for emotional states in the England of the 1940s and 1950s. Look at John Piper or Geoffrey Grigson on the derivations of British Romantic painting and you will find, over and over again, topographical references of this sort: drapery, for Moore, was another way, and a new one, of mediating between landscape and the human body.

The reference in his text to photography is also important to our understanding of his work, for Moore is a gifted photographer whose work in the medium constitutes a kind of authorized non-verbal commentary on his sculptures. It cannot be an accident that his photographs reach their level of maximum eloquence at just the period when his sculptures are ever more concerned with the specific character of bronze. Detail-photographs of the draped figures are, for that matter, one of the most rewarding of quasi-creative activities for anyone who can hold a camera at the appropriate range. There is almost no category of landscape, from glacier to moraine and from dry river-bed to precipitous scree, which cannot be counterfeited in this way. Nor are we talking of a shoddy 'dramatic' effect: the photograph looks *right,* no matter how we construe it, and the thing photographed retains its dignity.

Next to the Shelter drawings, the draped figures are among the most popular of all Moore's work. This is partly, I think, because people look to them for a certain generalized melancholy. The *Draped Torso* [75] of 1953 might, in point of fact, be that of an Olympic gold medallist after an unusually heavy workout. But a more common interpretation is in terms of picturesque decay: the human figure worn away by time, stands for civilization itself, too feeble by

now to do more than give an elegiac appearance to the facts of decline. Moore discourages this, and specifically says of the Time-Life figure that it is 'not in slack repose but, as it were, alerted'. Yet the sculpture, not the text, is what we are talking about in the end and to most observers the tone of the piece is given by the picturesque disarray of the draperies and – no other word will do – the elegiac beauty, suggestive of a great tradition gone sweet and soft, which they confer on the body as a whole. For Moore himself, on the other hand, one lesson of the Draped Figures was that the possibilities of bronze could be played up a great deal harder than they had been played hitherto. If we see the draped pieces, in this sense, as midway between the smoothness and roundness of the Internal-and-External Figures and the calculated rugosities of the two- and three-piece Reclining Figures of the early 1960s we shall have got the point: and the point is that the big late bronzes are adapted to a double perspective – that of the man who comes upon them from a distance, as he might glimpse a great ruin from the air, and that of the man who traverses them as a fly might traverse the Erechtheum.

From the so-called (though not by Moore) Greek period there remain the two Warriors and their related maquettes. Dr Neumann thought that the *Warrior with Shield* of 1953–4 [79] was 'the most devastating portrayal in all art of a suprapersonal castration complex'. 'It shows,' he went on, 'complete capitulation before the forces of destruction.' And although Neumann's book does not deal with the later *Falling Warrior* there is no doubt that these two do form a cryptic interlude in Moore's work, and one as to which no decisive explanation has yet come forward. There is undeniably something odd about the iconography of the two Warriors. Mistaken as it may be to feel that every doughty fighter must be a Hercules, it remains true that both Moore's warriors are conspicuously puny. The *Falling Warrior* [84] adopts, moreover, a pose that in another context might signify the extremes of

sexual fulfilment: and the fulfilment, what is more, of a beautiful woman. This element of sexual ambiguity heightens the strangeness which does not, in any case, have anything to do with Greece. Moore here seems to be close to Rodin – and to the Rodin who said, 'The sculpture of antiquity sought the logic of the human body. I seek its psychology.'

83. Auguste Rodin:
The Martyr, c. 1884

84 (*opposite*).
Falling Warrior, 1956–7

The Time-Life figure which I discussed above was commissioned from Moore in combination with a sculptured screen which was to be visible both from the street and from the open courtyard in which the reclining figure would be placed. In the event, the project was hampered by the regulations which forbid the erection of large and heavy objects immediately above the street. For this reason Moore was not able to carry out his original intention, which was that each of the four elements in the screen should be able to move independently, thus making an ensemble which would allow of regular variation. Nor did the final version turn out altogether happily, in that it had to be set so high above the street, and the street at that point is so narrow, that it is more or less invisible. Moore has in fact said privately that he would give a good deal to be able to take the screen away and make use of the ideas which are prisoners within it.

The progress of the project is, none the less, an immensely interesting episode in Moore's career, and the four maquettes in conjunction with the working model and full-scale version reveal a great deal about the movement of his thought. He had encouraged us to investigate the whole affair by publishing a characteristically undramatic account of the processes involved.

The first of the four maquettes [85] I rejected because I thought it too obvious and regular a repetition of the fenestration of the building. In the second maquette [86] I tried to vary this and make it less symmetrical, but in doing so the rhythms became too vertical. In the third maquette I tried to introduce a more horizontal rhythm but was dissatisfied with the monotony of the size of the forms. The fourth maquette [87] I thought was better and more varied, and so this became the definite maquette although a further working model produced other changes.

85 (*top*). *Time-Life Screen Maquette no. 1*, 1952

86. *Time-Life Screen Maquette no. 2*, 1952

87 (*top*). *Time-Life Screen Maquette no. 4*, 1952

88. *Time-Life Screen*, 1952

In point of fact, the maquettes represent a run-through of nearly everything that Moore had done before: a sounding-out of theme after theme. Careful scrutiny will reveal standing figures, reclining figures, animal heads, found and altered objects, re-invented torsos, and cryptic forms, half human being, half amphora, half sea-worn pebble. The space in which these are contained is the space of the pit-face drawings. The four final elements are pierced standing figures which have about them something of relief and something of free-standing figure: anatomy, in them, shades without warning into the geometrical relief-forms of the 1930s. And the screen looks forward, also, to many later pieces: to the huge standing reliefs, for instance, and to the pure sculptural inventions of the mid 1960s, to the Wall Reliefs of 1955, and to such isolated pieces as the *Mother and Child: Hollow* of 1959. Altogether, therefore, and even if the commission did not work out as freely and happily as had been hoped, the Time-Life screen is a capital work in Moore's career.

1954-63

It was inevitable that one day, when the moment was right, the long series of Henry Moore's Reclining Figures would find its vertical counterpart. The vertical figure, in one or another of its manifestations, is vital to Moore, as it is vital also to the whole history of sculpture – and, for that matter, to the English imagination. The English church-tower is one of the great products of our national imagination. Equally so, on a less exalted level, are the lighthouses and lookout-towers, so important to a sea-going and an island people. (I exclude, as being too obvious, the great repertory of upright figures and crosses which we share with the prehistory of all other ancient nations.)

To anyone as learned in the history of sculpture as is Henry Moore, the vertical figure is necessarily one of the great challenges. From the totems of the South Seas and the west coast of America down to the slender arrowy figures of Brancusi and Giacometti, much has been attempted. But much, even so, remains to be done, and we may be sure that Moore was storing ideas to this end for many years before he actually began work on the *Three Upright Motives* of 1955–6 [101]. Moore dates the initial impulse for these from the moment when he decided that a vertical figure, if anything, was needed to balance the horizontal lines of a new Olivetti building in Milan.

I visited the site [he wrote later], *and a lone Lombardy poplar growing behind the building convinced me that a vertical work would act as the correct counterfoil to the horizontal rhythm of the building . . . Back home in England I began the series of maquettes. I started by*

balancing different forms one above the other, with results rather like the North-West American totem-poles. But as I continued, the attempt gained more unity, and also perhaps more organic; and then one in particular [later to be named Glenkiln Cross] took on the shape of a crucifix: a kind of worn-down body and a cross merged into one.

'When I came,' Moore went on, 'to carry out some of these maquettes in their final size, three of them grouped themselves together and, in my mind, assumed the aspect of a crucifixion scene, as though framed in the sky above Golgotha.' *In my mind:* these are three vital words, in the context, for Moore rarely discusses the 'meaning' of his work, and in this parti-cular case what may seem to some an august identifi-cation may seem to others unnecessary and limiting. (Moore went on to say: 'I do not especially expect others to find this symbolism in the group.')

The idea of standing figures grouped in threes dates, in any case, from several years earlier, and the idea of the standing figure itself from nearly thirty years before. Disregarding the naturalistic figures of the early 1930s, one could point to the African wood torso of 1927 and a figure in beechwood from 1932 [22], in which the outline of the human body is re-duced to a significant swelling, here and there, and a commanding knob of form at those points where Moore wished to hold our interest especially tight. They are still, in essence, naturalistic pieces: Nature's order, and Nature's hierarchy, are preserved: but their naturalism is one on to which a new idiom could be grafted. By 1938, when Moore produced the little *Stringed Figure,* which is less than six inches high, that grafting had been completed.

The stringed piece is, in fact, a key work in Moore's development. The 'head' has, to begin with, the horn-or handle-like characteristic which recurs in several major post-war pieces. In the threefold jutting which occurs between the 'neck' and the urn-like base there

are foreshadowed the Upright Reliefs which are among the most enigmatic and disquieting of all Moore's works. In 1950, at a time when Authority hoped to have nothing but representational groups in perpetuity from a tamed and neo-conservative Moore, the *Double Standing Figure,* cast in bronze [90], announced a new, opened-out, linear approach to the figure, with flattened and triangular protrusions at shoulder height and slanted, rounded articulations at the waist. By comparison with the heavy-limbed human figures of a year or two before, these were animated wishbones, fleshless signals of a new idiom. In 1951 a drawing of three Standing Figures suggested that this idiom was getting beyond the schematic stage and might soon have a powerful emotional effect. Within a year a maquette, and within two years a group of three figures, twenty-eight inches high [96], proved this to be correct. All the spaces in the upper part of the body had now been filled in; and the stylization of heads and shoulders was considerably more abrupt, and more drastic, than in 1950. These forms had, in fact, a direct emotional impact which was stronger and more lasting than that of any of Moore's naturalistic heads. In the Northampton *Madonna and Child* [59], for instance, he had acquitted himself with honour in a task which, in the present state of sculpture, can be tackled by few artists of consequence. Individually and as a group the *Three Standing Motives* of 1953 derive from sources vastly more mysterious, and more personal to Moore, than the Madonnas and the Family Groups. They are recognizably human still, but drama of an inscrutable sort is in the air, and that drama resides as much in the attitudes struck by the figures as in the metamorphoses which they have undergone.

Moore by now was at a stage in his career when it is more profitable to pursue his key themes in their sequence than to examine his output year by year. Now that practically the whole of his work was being cast in bronze he could work on five or six ideas simul-

taneously, and it is more rational to follow the evolution of these ideas in turn than to jump from one to another in terms of the date on which each appears to have been completed. In the 1950s, for instance, the Vertical Figure pushed its way into all kinds of enterprises, even if sometimes it had to be pushed out again – as happened, for instance, when Moore was invited to prepare the sculptural screen for an upper floor of the Time-Life building in London.

This commission had a particular interest for Moore, and for ourselves, in that he had always been, and for that matter is still, very much in two minds as to the possibilities of a happy relationship between sculptor and architect. In 1961 he said flatly, in conversation, that he had never wanted to work for architecture.

Either the sculpture is on the architecture, in which case it's only a one-sided object, or else it has a background of architecture, in which case the architect's vision is likely to dominate. It was different in the Renaissance, when a sculptor might be able to make his own architecture for his own sculpture. What I want is for the sculptor to have his own complete, self-contained existence. The idea that architecture is 'the mother of the arts' has put sculptors into the position of being the architects' batmen. Architecture has never been the mother of the arts in that sense. All it has done is to house sculpture and painting: it gave the roof over the one, and provided a wall for the other, but the truth is that painting and sculpture existed long before architecture was ever heard of. In Palaeolithic times, after all, men lived in caves, or in trees, and yet painting and sculpture were already going strong.

Just how Moore went on from there, in this and other cases, will be seen later. The immediate point is that in the first two maquettes (1952) for the Time-Life screen [85, 86] Moore used vertical elements in which he tried out all kinds of possible new figure-forms. Both schemes were dropped, however, for architectural

reasons, and in the final draft the chunky, broad-based and partly transparent forms had a horizontal, as much as a vertical thrust, and all direct allusion to the human body was excluded.

The theme then seems to have gone underground until 1955, when it got going in a series of single figures, in a series of maquettes for a Wall Relief, and to a lesser extent in the large brick Wall Relief which was commissioned for the Bouwcentrum in Rotterdam. In none of these was it at all like the Vertical Figures of earlier days. The figure itself, as humanly constituted, had all but disappeared. Elements from it were arranged like an addition sum in mathematics. The top joint in each column did sometimes resemble the stylized Heads of 1953, or the Helmet Heads of a little earlier, and sometimes the bottom joint served as a pedestal. But fundamentally these were abstract arrangements that had a formal life of their own; a vigorous, versatile, all-purpose vitality that seemed to burst out of the columnar structure and set off all manner of associations. They were not so much reliefs, in the usual sense, as free-standing sculptures that seemed to have sunk into the body of the wall. Sometimes there was an echo of the 'fabulous animals' which he had set down in a sheet of drawings, and designated as such, the year before. Sometimes there were vegetable motives: a year or two earlier he had drawn a Reclining Figure of which the chest and belly were in the likeness of a pea-pod slit open up the middle. There were elements taken from machinery and from items of hardware: rings and screw-heads and graters. There were bone-forms and shell-forms imported entire with a freedom unknown since Moore's Surrealist days. There were complete fragments of a flattened architecture. There were reliefs in which the Vertical Figures stood bolt upright, side by side, like a guard of honour, and reliefs in which they seemed to have been battened down out of sight. The more radical and apparently disorganized (or perhaps merely anti-organized) look of these pieces brought Moore back to a position which he had earlier vacated:

that of a leader of the international *avant-garde*. A piece like the *Wall Relief Maquette no. 6* of 1955 [91] has the unconditional, take-it-or-leave-it quality that we associate with Moore in the 1930s: and we remember that, long before it was customary to accept such a point of view, Moore was saying (in 1937, to be exact) that 'if the work is to be more than a sculptural exercise, unexplainable jumps in the process of thought must occur'.

In these maquettes, the unity of the whole overrides the individuality of the parts. But when Moore came to make free-standing Vertical Figures, he at times fell back into a neo-humanistic idiom that was basically that of the little *Stringed Figure* of 1938: one or two even retained stringed forms on the outside of cylinder-like elements. Altered or 'perturbed' objects, in the Surrealist sense, alternated in these maquettes with sections that were like a human torso writ small or one of the pebbles worn through by water that had been among Moore's favourite found objects in the 1930s. There was a double problem to be solved: how to bring to the abstract idiom of the Wall Reliefs the unity and the meaningful articulation of pieces based on the human figure; and how to bring to that human figure the freedom and the audacity and the manifold reverberation of the abstract idiom. Each extreme had somehow to play up to the other and, by sacrificing a part of its independence, be enhanced. Looking, for instance, at the *Glenkiln Cross* [89] which acts as leader of the *Three Upright Motives*, we notice formal elements which go straight back to the African wood *Torso* of 1927. The smooth line from hip to shoulder is one of these; another, the stylized knob which stands for buttock and thigh. But in 1927 Moore would not have known how to produce the pedestal which merges almost imperceptibly into the body above it: nor would he have known how to wrench the top of the body in that extraordinary gesture which gives it a more-than-human thrust. The *Glenkiln Cross* is one of Moore's greatest achievements: the figure itself man-size, the

pedestal hardly smaller, and the combination of the two as arresting an image as has been created in the twentieth century. Moore likened it to the central image in the Crucifixion, when the three pieces were set up together outside the Kröller-Müller Museum in Otterlo; and, better than many a specifically religious work of art, it can bear the association. But it seems to me to lend itself equally well to an affirmative interpretation. And the combination of the three Motives does not seem to me necessarily to have anything to do with the Crucifixion. What to put next to the *Glenkiln Cross* was certainly a great problem, and one rendered all the harder by the distinct human affinities of the Cross. But Moore solved it by making the other two figures that much less human. In them, the idiom of the Wall Reliefs is carried out in three-dimensional terms; and although there is a suggestion of a naturalistic torso, and the barest implication of belly and pelvis and phallus and rump, the pieces do not come within calling distance of the *Glenkiln Cross* when it comes to the identification of their elements. It is as if Moore aimed, whether consciously or not, to regain the ambiguity which the *Glenkiln Cross* comes near to forfeiting. Seen together, the three sculptures do not (to me, at any rate) suggest a particular scene in history, august and hallowed as that scene may be. They suggest a gamut of feeling that runs from the tenderest of human implications to the mere brute survival of energies unconnected with our human designs. In doing this, they rejoin the central tradition of twentieth-century art: instead of illustrating what is already well known to us from other sources, they formulate what has not yet been put into words.

The *Three Upright Motives*, as set up at the Kröller-Müller Museum, consist of no. 1 (the *Glenkiln Cross*), no. 7 and no. 2 [101]. But there exist, in all, twelve Upright Motives, though only five got past the stage of the small maquette. Nos. 5 and 8 were cast at full scale (eighty-four and seventy-eight inches high, respectively) and they pursue the line of investigation repre-

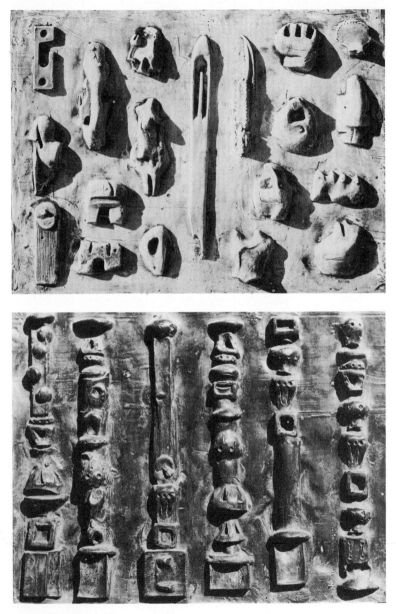

91 (*top*). *Wall Relief Maquette no. 6*, 1955

92. *Wall Relief Maquette no. 2*, 1955

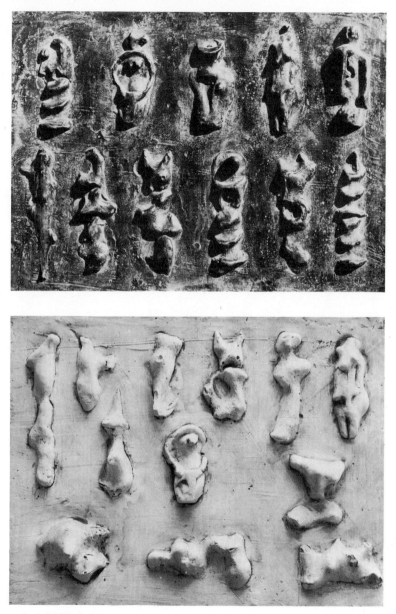

93 (*top*). *Wall Relief Maquette no. 3*, 1955

94. *Wall Relief Maquette no. 9*, 1955

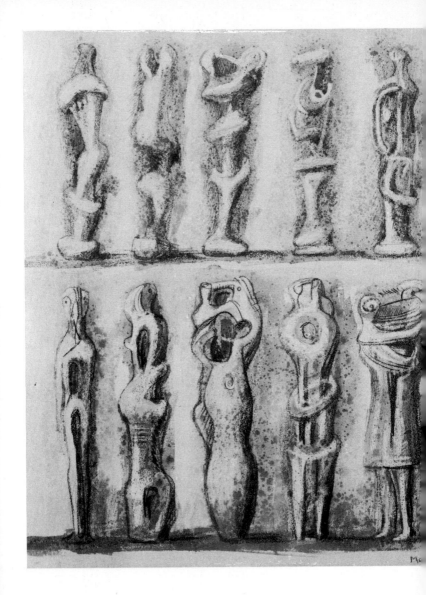

95. *Studies for Standing Figures*, 1951

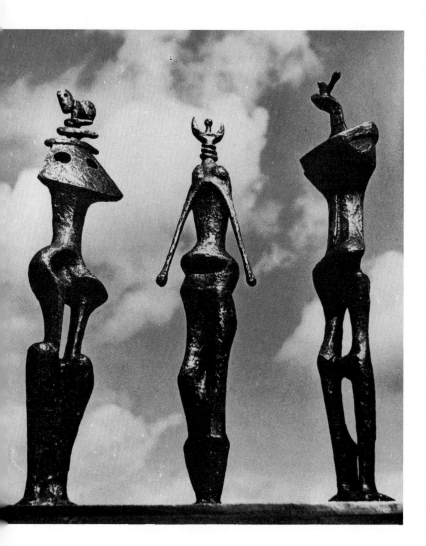

96. *Three Standing Figures*, 1953

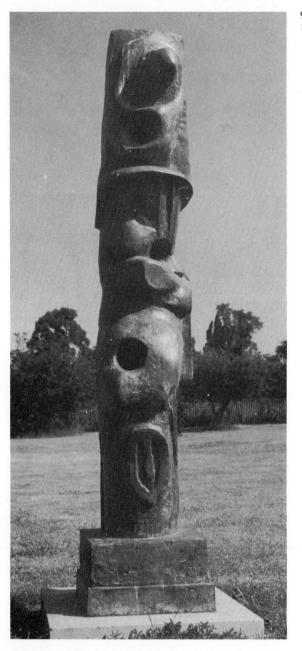

sented by no. 7 and no. 2. They do not, that is to say, exploit the human figure directly, but what looks at first sight like nozzle and slot could equally well bear an anatomical interpretation; and they attempt, also, to get away from the totem-pole principle, according to which isolated incidents can be piled one on top of another. They are recognizably striving towards a single coherent vertical form, even if they do not achieve it with the arresting immediacy of no. 1.

But, as happened with the Time-Life screen, the smaller maquettes have a lot to tell us about the auxiliary processes of Moore's imagination. No. 10, for instance, is basically a tower of bone- or stone-forms, such as we have all made at some time on a beach: Moore has in his studio the materials for a hundred such towers. No. 6 has a beautifully worked and ornamented pedestal, and the topmost section is basically an armless torso. No. 9 takes the head off the torso and puts a much heavier emphasis on the naturalistic shoulders and breasts. Somewhere along the line Moore tried out and then discarded the idea of a straightforward column with a human body at the top of it: eddying between this and the free association of the Wall Relief maquettes, he did not quite clinch the one triumphant image of sexual exuberance which is struggling to get out in the series of Upright Motives. But in the graver vein of the *Glenkiln Cross* he succeeded absolutely.

Shortly after completing the Upright Motives Moore began on a venture which, though forecast in a number of wartime drawings, was quite new in sculpture. Those works which resulted consist, fundamentally, of figures in an environment. Moore has always resented the sculptor's helplessness in this matter, and the fact that the client, or the client's architect, can nullify the sculptor's intention without the sculptor having any redress – and, in fact, without his ever knowing anything about it.

Of course [he once said], *one can't go on worrying about every piece one's done, and what's become of it, and*

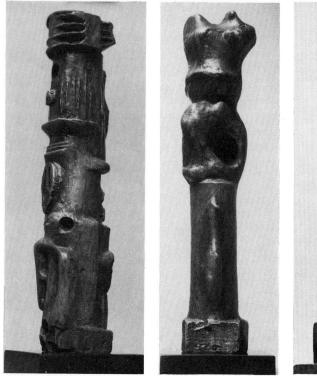

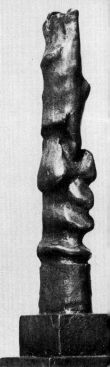

whether it's well or badly shown. One's life would just be a misery. But sculpture does need more care in its placing than paintings do. With a picture, the frame keeps you at a distance and the picture goes on living in its own world. But if a sculpture is placed against the light, if you come into a room for instance and see it against the window, you just see a silhouette with a glare round it. It can't mean anything. If a thing is three-dimensional and meant to have a sense of complete existence it won't do to back it up against a wall like a child that's been put in the corner.

98 (*left*). *Upright Motive Maquette no. 4*, 1955

99 (*centre*). *Upright Motive Maquette no. 9*, 1955

100 (*above*). *Upright Motive Maquette no. 7*, 1955

One way out of this is for the sculptor to be his own architect. Another is for the sculpture to carry its environment about with it: and this second solution is the basis of more than twenty pieces which Moore devised from 1956 onwards.

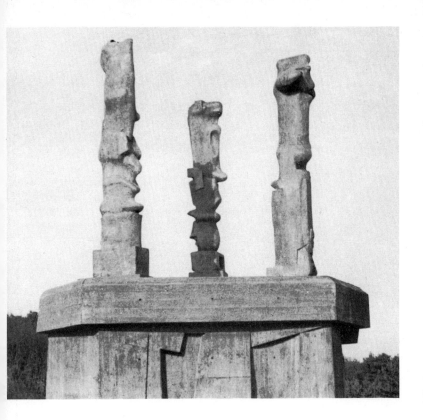

101. *Three Upright Motives* (including *Glenkiln Cross*), 1955–6

102. *Wall Relief Maquette no. 7*, 1955

In some cases the environment is no more than a bench: but a bench so massive as to give dignity to whoever sits on it. Sometimes steps, rounded or square, support a seated figure. Sometimes the bench has a high curved back, or stands at right angles to a pitted wall, and sometimes the back is opened out, so that contrast and echo are established as between the figures and their background. Once the seated figure is set against an enormous structure that is more flattened throne than wall, and once or twice the environmental motif is combined with a return to the Draped Figure: these are some of the most popular of all Moore's pieces. By 1958–9 Moore had abandoned the use of the naturalistic figure, in this context, and was experimenting with sets of three Motives (*presences* might be a better word) against a wall. The first of these [103] makes use of anatomical motifs: but no. 2, completed in 1959, dispenses not only with the benches and

pedestals of the earlier work but with all overt allusion to the human form. As with some of the Upright Motive maquettes, Moore has gone back to the animal-cum-mineral forms which abound in his studio, and the combination of these cryptic and sinister objects with a blind, prison-like wall is one of his most arresting

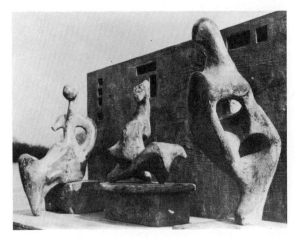

103. *Three Motives against Wall no. 1,* 1958–9

inventions. Moore himself has always refused, as I said earlier, to hitch himself to any of the great dramatists of the spoken or the lyric stage; but when we have studied the environmental series from beginning to end it seems natural that Wieland Wagner should have drawn upon Moore's imagery, as he avowedly did, for his production of *The Ring* at Bayreuth in 1965. (Victor Gollancz reported on this as follows: 'The dominant influence, as Herr Wieland acknowledged, is Henry Moore. I would mention in particular the spiky back-cloth for *Siegfried*, Act II; the crater-pitted castle in *Gotterdämmerung*; and above all the immensely power-ful picture for *Die Walküre*, Act II, with its great holes, and its clash of verticals and horizontals jutting out in a sort of steel-blue shale.')

We have no warrant whatever for regarding Moore's as a Wagnerian genius, but in two respects his art does at moments run parallel to Wagner's. In both, the idea

of landscape appears as something august and terrible, while architecture is pre-eminently a department of admonition. Moore produced his most elaborate essay of this kind in *The Wall: Background for Sculpture*, 1962. At first this looks like a piece of latter-day land-scaping: something that Batty Langley might have produced if he had read Kafka. But if we look again, Bayreuth does seem the right place. Even more re-markable in its way is the *Large Torso: Arch* of 1962–3 [104]: architecture here *is* the human body. Actually to walk through this piece is a curious experience. On one level, it offers the total involvement for which many of Moore's larger pieces seem to call. On another, it is a gesture of defiance towards architecture, as if the artist were saying that in several thousand years the idea of the triumphal arch had not been more solemnly ex-emplified than in this sculpture, which owes as much to the charnel-house as to Vitruvius.

104. *Large Torso: Arch*, 19◆

Moore is comparable to Wagner also in his command of animal forms which, without belonging to established mythology, could take their place in it as if by right. (And not of animal forms only, for that matter: who better than Moore could devise the magic helmet in *Rheingold*, or Mime's forge, or Brunnhilde's rock, or the Ring itself?) Over and over again in the 1950s and 1960s Moore has invented animal-forms which belong to no known bestiary and yet are quintessentially plau-sible. We can't give a name to them, but we accept the fact of their existence. Moore's art is at its most power-ful, as I see it, when these evocations overlap with human presences. A piece like the *Three-quarter Figure* of 1961 [105], or even more so the *Three-part Object* of 1960 [106], is a reminder of unsubdued forces within us. These owe allegiance not to one particular creature – lion, hyena, tiger, jackal, elephant, vulture – that we could name with respect or abhorrence, but to an anony-mous residue, a mindless persistence and blind in-genuity that we have not yet classified. Even the *Slow Form (Tortoise)* of 1962 [107], which for once has a title precise enough even for the zoo, has characteristics that

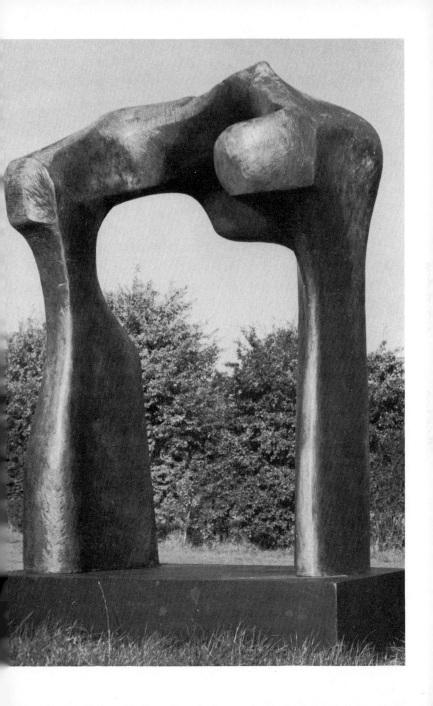

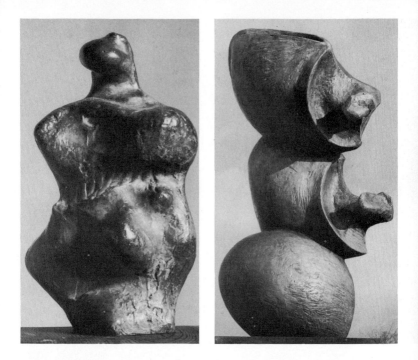

would baffle Buffon. And as for the *Three-part Object*,
even Moore himself has always refused to say, or per-
haps to investigate, what it is really about.

105 (*left*). *Three-quarter Figure*, 1961

106 (*above*). *Three-part Object*, 1960

It has a sort of animal/vegetable mixture [he once said].
*It's not human, but neither is it animal or vegetable. Well,
I just don't know how it came about. I don't know how a
piece like that begins. I just begin in the morning with a
bit of plaster or a bit of clay and a form comes about. Either
it has some interest, and keeps it, or it doesn't. If it has, I
go on without having to know, or trying to know, exactly
what it means. I wish in a way that I could be even freer
than I am from the tie of having to know exactly what it
means, so that I could take a form and develop it and
carry it further without ever having to have an 'expla-
nation'.*

And there is no doubt that it is the anarchical imagi-
nation that has kept Moore's art from ever settling

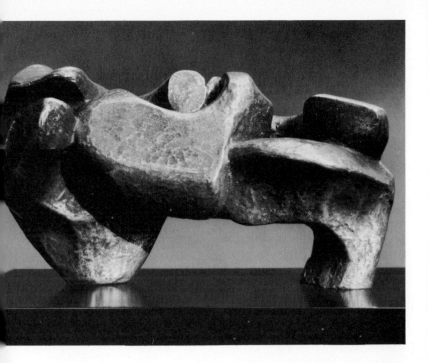

107. *Slow Form*
(*Tortoise*), 1962

down. Something in him keeps up the long steady swing between the sweet reasonableness of the Rocking-chair piece of 1950 and the snouted, misshapen, dwarfish creatures that stand for the night-side of an artist whom people associate, on the whole quite rightly, with the broad and open light of day. Our generation has outgrown the idea of monsters – which is one reason why naturalistic Wagnerian production had to come to a halt – but there are also monsters that we have not yet grown up to: and Moore is one of the men who can make them.

The element of the unsubdued imagination runs right through Moore's work in the 1950s and 1960s. Public bodies are not very fond of it, because it leads to work which does not correspond to any established image of Moore. People who commission a sculpture like to get 'the same again, only more so', and I don't doubt that sighs of relief were heard when it became

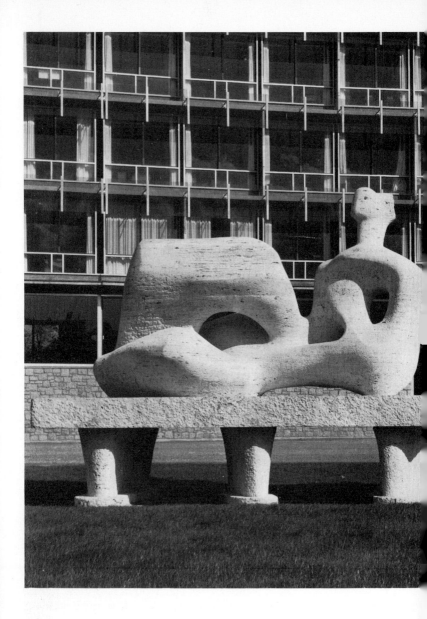

108. *Reclining Figure,* 1957

known in the mid 1950s that for the new UNESCO building in Paris Moore had chosen to do a reclining figure. The motif of the reclining figure has, in fact, been treated with a signal ruthlessness throughout Moore's career. But there is a basic majesty about the idea of a huge woman lying down that is in itself reassuring: and there was reassurance also in the news that Moore was going to Carrara for his material. Italy has the effect, broadly speaking, of domesticating the subversive element in Moore's art. Carving is a long, slow, steady, ruminative process that rules out, almost by definition, the darting and insubordinate insights which find outlet in his small bronzes. Everything pointed, therefore, to the emergence of something that could be related in general terms to the ultimate object of UNESCO's activities: exalted relaxation, that is to say.

Moore does not, of course, subscribe to the view that because a figure is lying down it is necessarily going to enjoy itself. 'Alerted' was his adjective for the state of mind of the Time-Life figure, and a generalized vigilance, an anxiety just held in check, is the note of many of the pre-war Reclining Figures. He regards the subject, moreover, as one capable of every imaginable nuance of expression.

Sometimes an artist has a set theme that he takes over and over again – Cézanne and his bathers are a case in point – and the theme frees him to try out all sorts of things that he doesn't quite know or isn't quite sure of. With me, the reclining figure offers that kind of chance. The subject is settled for one, one knows it and likes it, and therefore one's free to make a new form-idea within that subject that may be completely different from any other idea that one's ever had. The subject-matter frees one, and yet it gives what one does a continuity . . .

The UNESCO figure [108] is the largest (200 inches in length) of Moore's carvings, and it is in a material – Roman Travertine marble – that means a great deal to him. The block came from a quarry that Michelangelo

had used; and, quite apart from the idea of continuity which this represented, Moore was stirred by the exceptional scale of the quarrying operations – the blocks as big as a house that were manoeuvred down the mountain-side, and the strange involuntary poetry of the photographs in the quarry-master's office.

There was one huge block – as big as this room turned on end and twice as high – and a ladder with a man perched on the top of it, and in one corner a man's bowler hat, a hat of about 1900, I should think, and this hat and the ladder and the man at the top of it combined to give one a sense of almost unbelievable scale and reminded me of the kind of things that I could try to get out of the block . . .

When we last looked at undraped Reclining Figures in this book, two main tendencies were asserting themselves. One is the sense of drawing in the air that comes out strongest in the figure of 1951 [73]: here the empty spaces are as important as the thing drawn in bronze. The other is the sense of enclosed space that comes out in the reclining Internal and External figure of 1951. Here, too, the empty spaces are as important as the forms which surround and define them, but the psychological situation is a great deal more complex: whether the interior is prison or sanctuary, womb or detested cage, is a question that the artist leaves open. It remained in abeyance while Moore worked on the Time-Life draped figure, and at the time of the warriors, the *King and Queen*, and the Harlow *Family Group*, it just didn't arise: conceivably the tensions which it provoked were too great to be managed at the moment and had to go underground.

It was unlikely, in any case, and for several reasons, that problems of this sort would be tackled in the UNESCO figure. Everyone is entitled to his opinion of the activities of UNESCO, but its foundation was pre-eminently a constructive, not to say an optimistic gesture; and one which took for granted the perfecti-

bility of the post-war world. Time may have blown upon this notion, but it remains one to which the externalization of private dramas, no matter how universal, would be inappropriate. The problem of the UNESCO figure was, in short, the problem of how to make a Promised-Land figure without resorting to Promised-Land art. Erich Neumann put this in more scientific terms when he spoke of Moore's having helped, with his Reclining Figures, to 'activate a feminine archetype' which would offset the 'one-sided patriarchal culture' which characterizes the Western world in the twentieth century. 'The birth of the feminine archetype in modern man,' he said, 'signifies at the same time the development of human related-ness, of his social capacity, and the growing conscious-ness of the unity of mankind on earth.' Herbert Read was on the right lines, surely, when he quoted this passage and said that Moore's Reclining Figure, thus interpreted, ideally symbolized the aims of UNESCO.

During the period of cogitation Moore experi-mented with a large number of subjects that were loosely related to the UNESCO problem: Mothers and Children, Family groups, single figures seated or standing in front of a wall, and so on. Some of these were later cast in bronze, but none of them, in the end, would have done for his purpose. For one thing, the sculpture had to stand against a background of fene-stration which looks mathematical in a scale-model but in life tends to be fussy and chaotic. The light on the windows themselves, and on the lattices of support and balcony, gets glary and irritable if the weather is at all fine. The green of the surrounding grass must also be taken into account.

All this put bronze out of account and made out of the question, also, a piece that depended on intimacy and nuance. (The visitor is not allowed to approach within twenty or thirty yards of the sculpture.) White marble and plain statement were the thing: white marble to combat the fuss and glare of the building itself, plain statement to serve as a mascot for activities

which begin as a department of a holy war and all too often end as a department of international tax-free bureaucracy. The bronze *Working Model* for the UNESCO figure is an affair of dramatic shadows, of light glimpsed through darkness, of great louring fell-like hollows and heights: a northerly piece, if ever there was one. Transposed into Roman Travertine marble, those same tunnels take on the likeness of a road cut through the southern flank of the Alps, and those same clefts and overhanging bluffs the likeness of a cavern by the sea in Homer. The upward thrust of leg and shoulder is balanced by delicate black horizontal markings in the marble. The striations on the back of the head, which look in the bronze like the marks of hard weathering, look in the marble like incisions in material blanched by salt winds and Aegean sunshine. This dexterous alliance of north and south is one of the happiest features of a piece which has just the weight, and just the quality of 'pull', to detach it cleanly and for ever from its background. The UNESCO figure has never had the Press it deserves – French critics in particular and French opinion in general can never bear to give credit to British art – but to me it seems to be the right answer to an impossible question.

That answer was given, as I indicated, in terms of Moore's public manner. Nothing in the piece could be said to contest the central tenet of UNESCO: that if human nature is given the right opportunities it will get better and better. Moore himself is steadfast and affectionate in private relations and has something of the constructive optimism of the schoolmasters from whom he learned so much at the start of his life. But, as Proust points out in *Against Sainte-Beuve*, the self which produces a work of art is a different self altogether from the self which comes out in life. Nothing is more instructive, in this context, than to compare the maquettes which Moore produced in 1956–7, when he was trying out one idea after another for the UNESCO piece, with the related works which he pro-

duced in 1957–8, when the UNESCO problem was out of the way. The earlier group is pacific in tone and naturalistic in idiom: somewhere within each of them is the idea of the Good Family, the Good Mother, the Good Individual, and the Good Society. The attitudes of the individual figures are those of the sage counsellor, the well-trained son or daughter, the husband and wife caught at a moment of quiet communion. But once duty had been done, and been seen to be done, the tusky and unregenerate side of Moore's art made itself felt again.

It made itself felt, what is more, in precisely the terms of the UNESCO maquettes. The wall was there, and the standing or seated figures, and the bench that might have served for some village parliament. But in the *Three Motives against Wall no. 1* [103] of 1958 the three figures were in retreat from humanity, and in the *Three Motives against Wall no. 2* of 1959 they had lost touch with it altogether. There could be no clearer illustration of the tendency of Moore's imagination, when left to itself, to veer away from the classical approach of European humanism and tack towards the demonic forces implicit in the animal and vegetable kingdoms, in the millennial workings of boulder and rock-face, and in the idioms of non-European art. In the *Three Motives no. 1* the figure on the left is perceptibly the cousin of the seated figures in the UNESCO maquettes; the central figure derives from the found objects of the 1930s but is still recognizably human in its derivation, and the figure on the right is like a reclining figure up-ended and poised in the attitude of a dinosaur in an Edwardian boys' magazine. Each has its podium, and together they look like first, second, and third in a space-fiction Olympiad, with electronic national anthems somewhere unheard. But in the *Three Motives no. 2* the podiums have been whipped away and the three anonymous, unnameable forms are just *there*: no explanation comes to hand. Anyone who has watched a space-fiction serial will know that the most difficult thing is to carry conviction

with an invented form that does not somewhere rely upon human or mechanical affinities. Moore has achieved, here, what the novelist and scenarist fall down on: the invention of forms which impress themselves immediately as definable personalities and yet do not appeal to already existing categories of experience. And they carry conviction as a group, moreover: there really is a relationship between them as individuals, and as members of a group, and between them and their environment. The scene is the scene, unchanged, of many of Moore's wartime drawings; but another race now inhabits it.

Moore was to tack back again towards a world of legible anatomies. In 1960 the *Two Seated Girls against Wall,* and in the same year the *Seated Figure: Arms Outstretched,* have a freedom of reference which can be traced to the *Three Motives against Wall nos. 1 and 2.* But the basic advantage of absolute autonomy – the right, that is to say, to push forward independently of all sentimental allusion to the heroic art of the past – was never quite forfeited again. Moore began, also, to make private images on a public scale. By casting these in bronze, and in editions of six or more, he was able to gain for them a wider currency than had been possible with the unique pieces of the 1930s and 1940s. It soon came about, in fact, that public collections overseas thought of Moore primarily in terms of the large bronzes of the 1950s and 1960s; and he could have gone on with the big neo-Classical draped figures in much the same way as Maillol went on with his full-breasted and full-bottomed peasant girls. They were as acceptable to the San Francisco Longshoremen's Union, which wanted to commission a bronze, as to the Trustees of Yale University Art Gallery. Basically these are undemanding pieces which give enormous pleasure: the *Draped Seated Woman* of 1957–8 [111] has, for instance, a vespertinal look, a ripeness like that of Richard Strauss's 'Four Last Songs': with its contemporary the *Draped Reclining Woman* [109, 112] it induces a feeling of unfocused

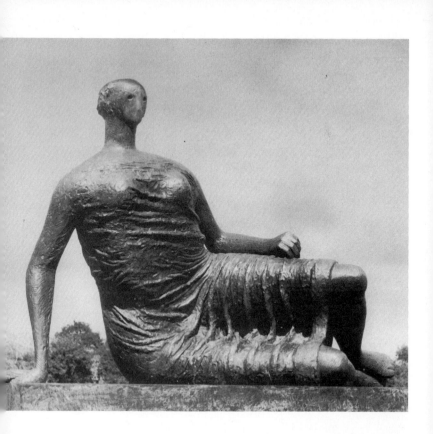

109 (*above*). *Draped Reclining Woman*, 1957–8

110. Rafael Donner: *The River Ybbs*

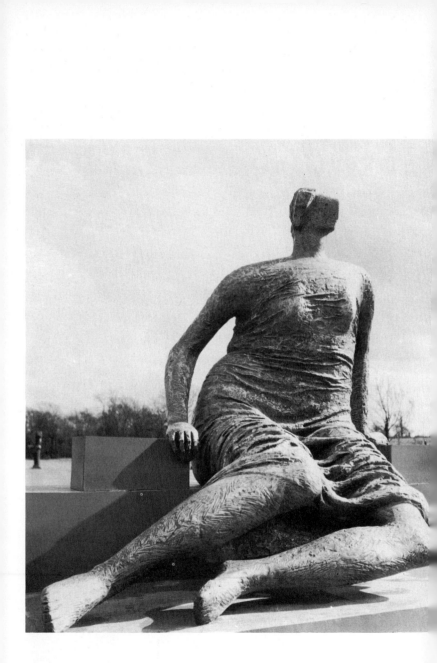

111. *Draped Seated Woman*, 1957

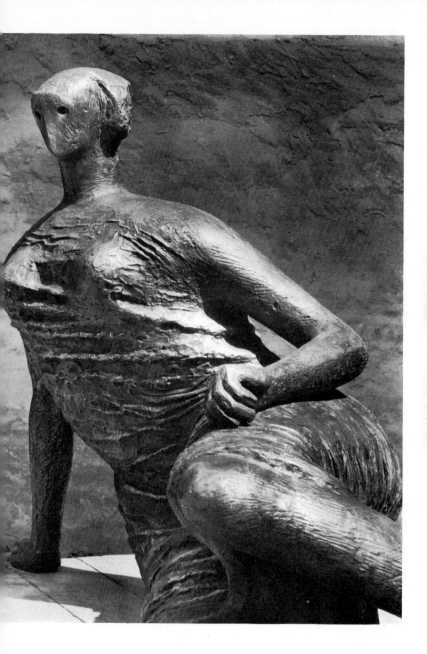

112. *Draped Reclining Woman* (detail), 1957–8

regret, and anyone who has seen either piece in the open, in an environment of dark trees and falling water, will know that as symbols of withdrawal they would be difficult to excel.

But withdrawal is not a characteristic of Moore, any more than passivity is a characteristic of his major figures. Moore's women at their best abrogate to themselves the masculine qualities of power, determination, authority, and endurance, and they become, as Michelangelo said of Vittoria Colonna, '*un uomo in una donna, anzi uno dio*'. When he had got free of the UNESCO commission he gave the tender side of his nature free rein in the two Draped Figures; but these arose directly from trial runs for the UNESCO figure and from the momentum of Moore's efforts in that direction: nothing was more reasonable than that Moore should make use of material which, though unsuited to the UNESCO building, has given intense satisfaction elsewhere. But, as happened with the *Three Motives against Wall,* the tough side of his nature broke out with all the more ferocity for having been so long kept out of sight: 1959–61 was to be a period of exceptional activity on that account.

There had been portents of a return to the woman-as-superman theme. In 1956 an eight-foot-long Reclining Figure in bronze had come as near as Moore had ever come to the exaggerations of Expressionism: movement and attitude were heightened for expressive effect and the figure seemed to be heaving itself out of the mould, just as in the Reclining Figures of the 1920s the female animal gazed out at us as if to say that she was trapped as much by the fatality of the block as by any external predicament. In the *Upright Figure* in elmwood of 1956–60 [113, 114], which went to the Guggenheim Museum before it was ever shown in England, this theme was up-ended and the figure seems to be struggling as much to get free of the wall as to climb up it. In both cases the idiom itself was unusually cautious for Moore, as if he were for once not quite certain how far to push the idea. By 1959

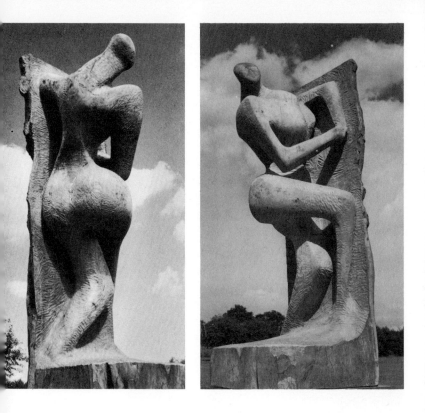

113 and 114. *Upright Figure*, 1956–60

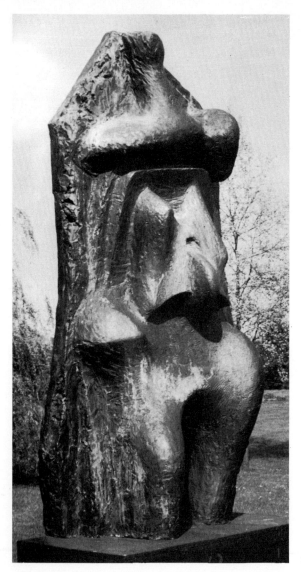

115. *Relief no. 1*, 1959

every doubt had vanished: 'all the way' was the
answer. In the monumental *Relief no. 1* [115] the
human body is seen as something robust as a rhino:
with something, in fact, of a rhino's armoured hide,

and something of its power to trample and thrust when and where we least expect it. To imagine what movements might aptly be forthcoming from this tremendous creature we should turn rather to Wilhelm Reich on the orgasm than to any manual of the classical dance. Old-style aestheticizing, and considerations of 'beauty' and 'ugliness' are meaningless in the context of this relief. It is, understandably, one of the least popular of his pieces: and nothing could give more conclusive proof of Moore's vitality as an artist than his ability to produce a commandingly powerful work which almost nobody likes.

Moore turned his mind, at the same time, to the renewal of the Reclining Figure. He had come to maturity at a time when there was still something startling and provocative in the idea of the kinship between human forms and those of vegetable or mineral origin. Moore raided landscape, also, for certain qualities of roundness and smoothness. And he used materials, at that stage, which were predominantly sleek: for all the toughness of the ideas behind them, there is an inexpugnable elegance about many of the pre-war carvings. The sinews remained fine, no matter how rugged was the artist's intention. But ever since the Upright Motives of 1955 Moore had dropped this fineness of sinew, had got out of the drawing-room, one might say, and into – what? The sacrificial pen? A forbidden temple? Or the Pantheon of some race heavier in limb, and more resistant in spirit, than our own?

The two- and three-piece Reclining Figures of 1959–62 are the pieces which count in this context. Throughout the period in question Moore was at work, also, on the elmwood *Reclining Figure* [116] which he began in 1959 and finished only five years later; and this very beautiful piece is relevant to the others in so far as, in contrast to them, it relies on the continuous line. Looking at it, we can gaze in perpetuity: never is the eye brought up short. This is a consolidatory work, related back to the Onslow Ford figure of just before

the war [44]; but it has a steady, unbroken coherence, a regular persistent exploration of a given idea, which are the more striking in contrast to the two- and three-piece Reclining Figures. For these are portraits of Upheaval; and their architecture is an architecture of survival and not, as in many earlier Reclining Figures, of consolidation. What they stand for, fundamentally, is the ability of the human body to survive and dominate, no matter how catastrophic its surroundings. Fragmentary and ruinous as is the condition of these huge carcasses, their aspect is not one of collapse. Never are they merely inert. On the contrary: the upraised leg in *Two-piece Reclining Figure no. 1* [117] is probably the most dynamic incident in all Moore's work: nor has the watchtower of the head ever been more regally poised.

In most of the Reclining Figures with which sculpture has endowed us, certain areas sustain our interest at a greater level of intensity than others. But in these large later figures by Moore no one part, and no one view, is more compelling than the others. They are works that must be toured, not quizzed; lived in, not visited; read from end to end, and not encapsulated. The student must see their seasons round before he can claim to know them. For the ferocity of their inspiration they are paralleled by the *Three Upright Motives* of 1955–6 [101]. Each of those totem-like figures has a single climax, to which the eye is led: all is coherent, one-minded, taut. But in the two-piece Reclining Figures Moore can afford to let our attention wander at will: what does not come in with one tide will come in with the next.

The tidal image is not chosen at random. If these pieces have any one single secondary significance, it is that of an eroded coast. Photography brings this out better than words; but if Walter Pater were to come back to earth and see one of these figures he would not say of it, as he said of the *Mona Lisa*, that she was 'older than the rocks among which she sits': he would see that she *was* those rocks. Rock and woman are one,

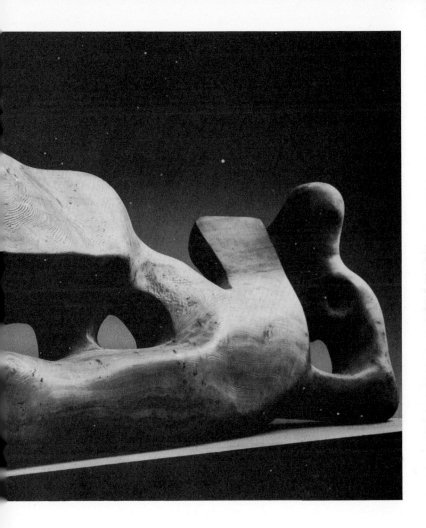

116. *Reclining Figure,* 1959–64

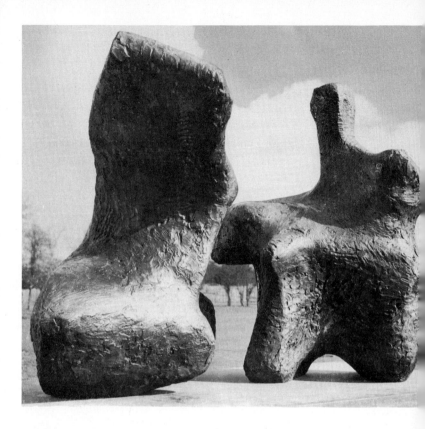

117. *Two-piece Reclining Figure no. 1*, 1959

in these pieces: it is as if the famous cliff-structure near Étretat, which played so large a part in French late nineteenth-century painting, had become a metaphor for the human body. To this effect the special nature of bronze contributes: in fact I doubt if the dogged, sullen quality of a very large bronze cast has ever been used more cunningly. Bronze has, as much as alabaster, its load of connotations from the past. (This is one of the reasons why it has been rejected with such absolute scorn by many sculptors of the younger generation.) And the problem for a sculptor is to get those connotations to work for him and not against him. The observer must not say, 'That's very good, but after all Rodin did it better.' Nor, at this stage in the history of art, is the weight and bulk of bronze anything but a handicap: '*Aere perennius* my foot!' would be our generation's reply to Horace if he ever got off that Sabine farm. What counted as plus for so long now counts as minus: bronze is, in fact, in the situation that the nineteenth-century cathedral organ was in before Messiaen came along to write for it.

Messiaen redeemed that organ by taking the characteristics which had put people off and pushing them so far that he came out, as it were, on the other side. And Moore does something of the same in the two- and three-piece Reclining Figures. What people dislike in bronze is the mandatory solemnity, the trombone-voice that says, 'Hats off! This is Art.' Bronze-casting is believed, too, to produce something that is a translation, if not a blurred approximation, of the original sculptural idea. This may be true, or it may be a misreading of the caster's role, and a misreading, also, of the sculptor's ability to allow for these approximations and, even, to exploit them as each cast comes back from the founder. But, whether right or wrong, it is the reason, or a large part of the reason, why young artists have turned to materials which are light, and can be coloured at will, and have nothing to do with high art.

What Moore did, in these large figures, can be studied in photographs; and very imposing some of his own photographs are. We see at once how, so far from smoothing away the working-marks of the original plaster, Moore has emphasized them in the finished bronze. The basic texture of these pieces is not 'expressive' in the way that a bronze by Rodin or Matisse or Giacometti is expressive. Moore is intent, on the contrary, on keeping 'expressiveness' at a distance. This is not because he disapproves of it (no one is more loyal to bronze) but because he does not want the observer to slip into aestheticizing.

Photographs can show this, as I say. But nothing substitutes for the experience of walking all round these pieces. The *Two-piece Reclining Figure no. 2* [118] is, for instance, one of the most prized possessions of the Scottish National Gallery of Modern Art in Edinburgh. Placed on the lawn at the top of the Royal Botanical Garden, with a view that stretches across Princes Street, across the New Town, and away to the mountains beyond, it makes an astonishing effect. For once the mountains in the piece and the mountains in 'real life' are allowed to harmonize. We realize all over again that what Moore has produced is an imaginary landscape that happens to relate at every point to the human body, to human emotional states, and to aspects of human experience. We wonder afresh at the mysterious three-way tunnels – impossible, these, to photograph – which characterize both halves of the piece. Edinburgh weather, so impulsive and imperious, so rich in short-term incident, is somehow called to order by a piece that maintains its own tempo and simply will not be hurried into registering every whim of the elements. And in all this the basic unit of expression is that of the marks made on a rock-face by the climber's axe, or on a coal-face by the miner's pick: Moore nowhere relies on the traditional idiom of plaster transmuted into bronze.

Moore originally hit on the two-piece idea when he found that a clean break somewhere in the middle

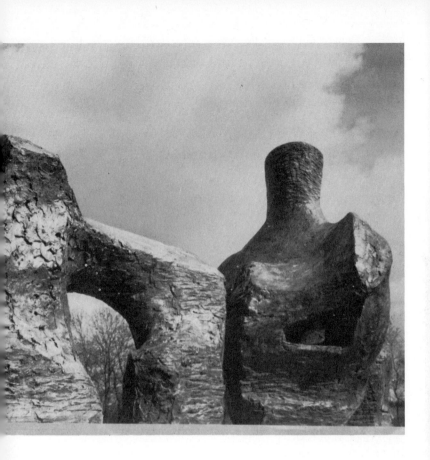

118. *Two-piece Reclining Figure no. 2, 1960*

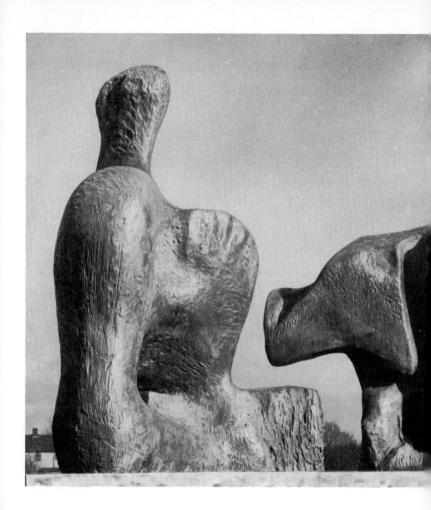

119 and 120. *Two-piece Reclining Figure no. 3*, 1961

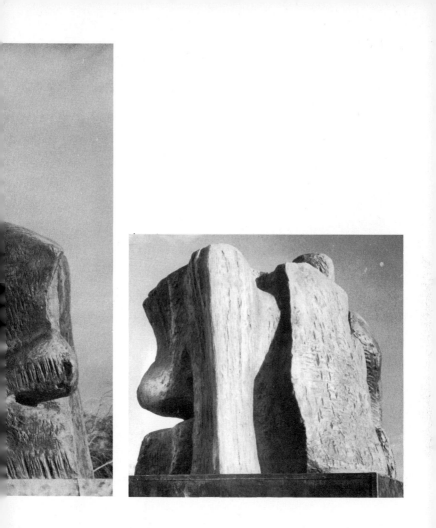

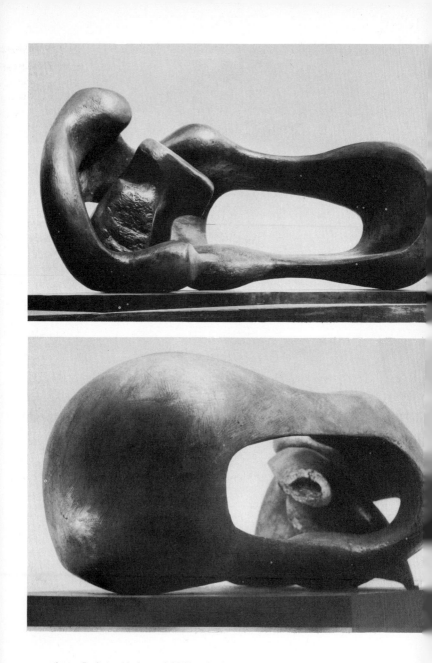

121 and 122. *Reclining Mother and Child*, 1960–61

opened up possibilities of tension and antithesis, statement and counter-statement, which simply could not be explored within a single form. The reader can judge of this for himself by imagining the two-piece Reclining Figures with the central gap filled in: the sculpture at once becomes unintelligible. Here again, no photograph can convey the impact of the empty space as it reveals itself when we walk round either end of the figure. Somewhere within that impact is the idea of irreparable separation and loss which is fundamental to all human experience; and art's highest function is fulfilled when we look again and realize that the two pieces have an intense and living relationship, as separate entities, which would be dulled and rendered inert if they were to be joined together.

The idea of the divided piece was not, of course, a new one. Moore did, as we have seen, make several sculptures in two, three, and four pieces in the 1930s. What was new was the scale of the works: the fact that it was as much a bodily as a merely ocular experience to get to grips with them. New, also, was the texture: working on so large a scale, Moore could afford to reject the smoothness of the 1930s, and in fact to lose the image altogether, in the confidence that the overall design was grand enough to pull the observer through. Clearly it was only a matter of time before he made a figure in three pieces, as well as in two; and in 1962 he did produce a small maquette that broke new ground, even if it did tread it rather uncertainly. In style this was midway between the landscape idea of the big two-piece Reclining Figures (the legs and feet, for instance) and the 1930-ish object-of-art (the head and shoulders). It was highly polished, also, and in between the two pieces I have characterized there was a third element that derived from the bone-forms of earlier years. But when the large *Three-piece Reclining Figure* of 1961–2 [124] came along it was in the landscape-idiom of the large two-piece Reclining Figures: like them, it made a great effect of monumentality by rejecting the means which normally conduce to monu-

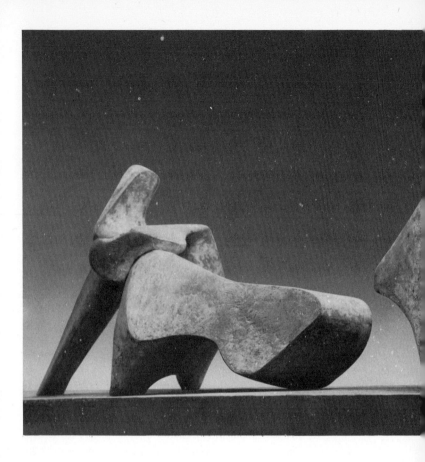

123. *Three-piece Reclining Figure no. 2: Bridge Prop*, 1963

mentality. It did not, that is to say, rely on the rhetoric of familiar forms; nor did it aim at any one obvious climax. If anything, the forms were even more closely related to cliff-face and mountain-side than were those of the four earlier figures. Human anatomy, recognizably the point of departure for the two-piece Reclining Figures, was getting farther and farther away: and *The Wall* of 1962 was getting nearer. It was difficult to see that this particular line of effort could be pushed further, more especially as the idiom was one which relied to a certain extent on the sensations of surprise and disorientation with which we felt our way round the first two or three pieces. One could put this very briefly and crudely by saying that in the 1930s Moore made the point that human beings could look like boulders; in the late 1950s he made the point that boulders could look like human beings; and at the beginning of the 1960s he was beginning to make the point that boulders look like boulders: very imposing and finely-worked boulders, but boulders none the less. Something of the pull of opposites was being lost, although the scenic element – the sensations brought into being when an observer walked slowly right round the piece – was grander than ever.

Another artist might, in these circumstances, have run aground in a welter of picturesque landscaping. Cliffs ever more horrendous, caverns ever more serpentine, bluffs ever more meaningfully knobbed and pocked, might have taken the place of genuine inspiration: it would have been like starting with *Oedipus at Colonus* and ending up with the Gothick novel. But already with the *Two-piece Reclining Figure no. 3* of 1961 [119, 120], there were portents of a new evolution. The butt-end of that piece was a matter not of landscaping, but of thrust paralleled, surely, in architecture and, even more, in engineering. Ever since Le Corbusier pioneered the idea of a city of stilts, architecture has meditated the notion of great masses lifted clear of the ground. The bridge, in particular, is a form of construction in which the late nine-

teenth and twentieth centuries have excelled: a form, also, which more than most architectural inventions approximates to sculpture. So it seems only natural that the last Reclining Figure in this book should derive in large part from engineering forms. The *Three-piece Reclining Figure no. 2: Bridge Prop* of 1963 [123] differs from the earlier two- and three-piece figures in that its forms are sharply defined, owe nothing to the poetry of near-dereliction, and present the human body in terms that look forward to a heroic, or at any rate to a serviceable future, instead of looking back to a past in which to have come through was in itself an achievement. The Bridge Prop figure is, in fact, a raid upon the preserves of post-war architecture. In eschewing so firmly the pathos of the earlier multiple figures, and in choosing forms which had a minimum of direct emotional appeal, Moore once again broke free from the successes of his immediate past. Younger sculptors think it very grand and daring to make use of ready-made industrial sections, but Moore's achievement in the Bridge Prop piece is that he invented sections which have the same look of functional efficiency and are yet unmistakably his own. We should not be surprised if we went into a ship-chandler's, or into a repair shop underneath the Forth Bridge, and found any one of the three components of this sculpture lying around ready for some specific use: and yet, when put together, they make a metaphor for an exceptionally powerful and resourceful human being. What happened with the draped figures has happened once again: Moore has broken free in good time.

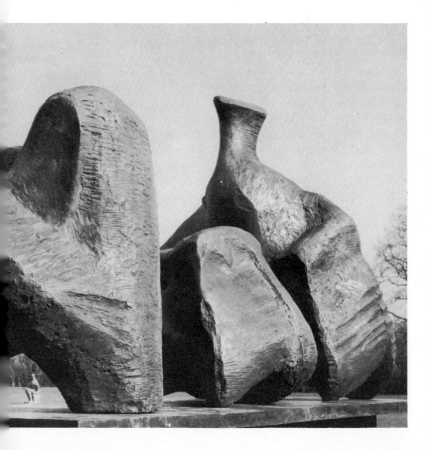

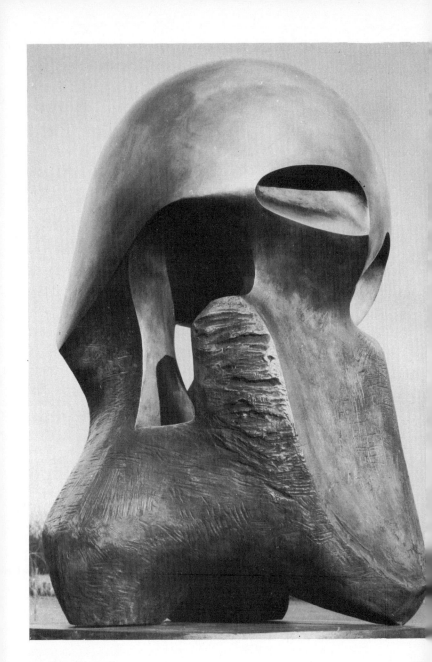

125. *Atom Piece*, 1964

Since 1963

Moore in the 1960s explored a great many ideas, and he left himself free to take them up and put them down as suits him best. For instance the natural pair and pendant to the Bridge Prop piece of 1963 is the *Two-piece: Pipe* [126], where the nonchalant pose of the bridge prop is transposed in erotic terms. But the *Two-piece: Pipe* is dated 1966. Equally, the bronze of 1959 called *Mother and Child: Hollow* harks back to the vigils and alarms of 1929–30; the *Two Torso (Maquette)* of 1962 is a late homage to Rodin; and the *Thin Standing Figure* of 1965 is the kind of delicately characterized piece which relates rather to sixteenth-century Italian bronzes than to any 'coherent' account of Moore's evolution. Other pieces of the 1960s are late variants of themes which keep coming back and back into Moore's awareness: the *Helmet Heads* (no. 4, 1963, and no. 5 (Giraffe), 1966) [130, 131] and the little *Reclining Interior Oval*, 1965 [132].

Pieces like these keep the sculptor's private imagination alive. But Moore in the 1960s was continually being honoured (or plagued, according to one's point of view) by requests for major public statements. It is not always easy on such occasions to distinguish between the job which might fulfil the ambition of a lifetime and the job which fundamentally represents a disguised philistinism on the part of those who suggest it. Large-scale commissions are subject to all manner of small disappointments. (At the Lincoln Center in New York, for instance, the level of the water round the huge Moore *Reclining Figure* is rarely or never as the artist intended.) Yet there are challenges which a man of spirit will find it difficult to refuse: one such

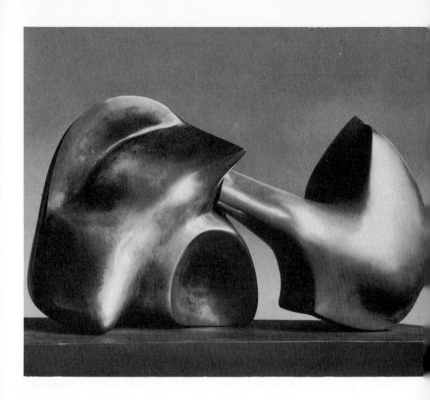

126. *Two-piece Sculpture no. 7: Pipe,* 1966

was the invitation from the Lincoln Center, and another the commission from Chicago for a piece which would commemorate the work done there on atomic physics.

In the Lincoln Center piece, Moore took the opportunity of completing once and for all the experience which had begun with the two-piece Reclining Figures of 1959–60. As time went on, and Moore himself was able to stand aside from these works, their sources became more and more clear. Moore has spoken of two paintings which contributed to them – Seurat's *Bec du Hoc* in the National Gallery, and Monet's *Cliffs at Étretat, 1883* in the Metropolitan Museum – by their evocation of natural forms hollowed out or up-ended; he has also been reminded of the Adle Rock, not far from his birthplace, which he first saw in 1908 or thereabouts and had harboured in his imagination ever since. I also think, though I have no warrant for saying so, that something in the present state of the Elgin Marbles may have made a contribution. Group after group in the British Museum survives

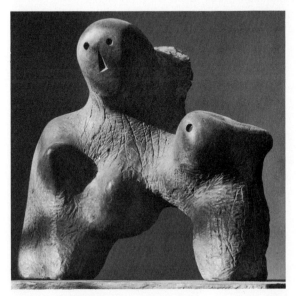

127. *Mother and Child : Arch*, 1959

in fragmented and eroded shape, with an unintended vacancy where once the forms were in close and majestic communication. But that very break in the forms turns out to have an expressiveness of its own; and this expressiveness recurs, as it seems to me, in Moore's two- and three-piece Reclining Figures. That the Elgin Marbles should one day serve as metaphors for survival was certainly no part of Pheidias' intention; nor did Moore plan to provide the pleasure-bound New Yorker with a spurious antiquity. Big works of art are big enough to stand up to all manner of interpretations – if this were not so, the free-thinker would feel uneasy at *The Magic Flute* – and they are not at all diminished if we happen to stumble on one of the elements which went to their making. We do not think less of *The Polish Rider* because Rembrandt may have had in mind a generalized image of the *miles Christianus* and could have filched his composition from a reversed version of the knight in Dürer's *Knight, Death, and Devil*. Rembrandt's artistic personality was strong enough to make these borrowings into something of his own. Similarly – and without making comparisons which Moore would be the first to discard – the Lincoln Center piece is strong enough to digest both Pheidias *and* the Adle, both Monet's *Cliffs at Étretat and* the experience of Étretat itself, and doubtless a great many other ingredients among everything that Moore has experienced. The cantilever-like thrust of the torso is, in particular, one of his most forceful images.

The *Atom Piece* [125] is something different again. Initially, Moore was not attracted by the idea of celebrating an activity which in many of its aspects has brought us little but foreboding. Memorials as such seem to him an outmoded use for sculpture, and this particular subject did not prompt him to change his mind. But when he came to think about it at length he found that a certain specific form did suggest itself, and that this form was relevant both to the set subject and to his own inmost preoccupations. So he went ahead:

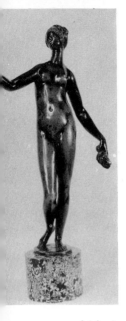

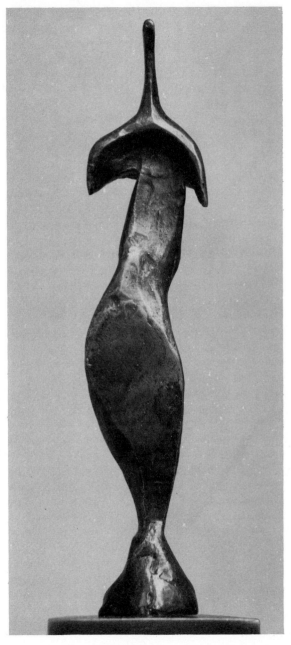

128 (*above*).
Danese Cattaneo:
Allegory of Vanity,
or The Negro Venus

129. *Thin*
Standing Figure, 1965

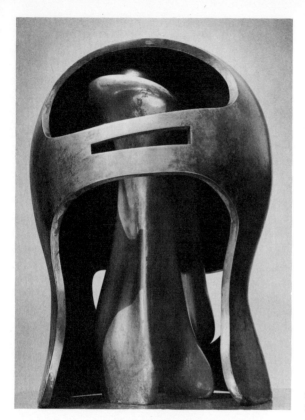

130. *Helmet Head no. 5,*
1966

and the piece which resulted is an amalgam of many
congruent ideas – among them the profile of the human
cranium, the outline of the mushroom-cloud, the
notion of the armoured head as it is often found in
Moore's work, and the idea of the inward-outward
form which is at once fortress and prison. There was
also a tension quite new in Moore's work: that between
the rugosities natural to bronze and the suavity of
marble. This tension manifests itself as between the
upper part of the piece – the bald, seamless cranium –
and the pocked and weathered-looking base.

I have no warrant for my opinion, but I suspect that
this polarity derives from the fact that in recent years

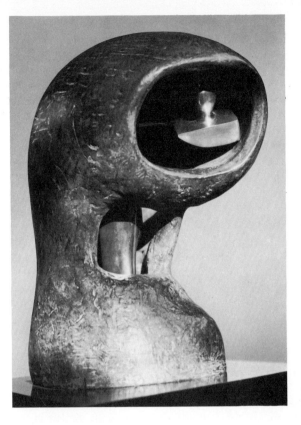

131. *Helmet Head no. 4,*
1963

Moore has renewed his contacts with the world of direct carving. Not long after he was awarded the Feltrinelli Prize in 1963, Moore went house-hunting in Italy. He settled in the end for a little house in the flatlands just north of Forte dei Marmi. From his garden he can look up to the Carrara Mountains, and in particular to the quarries now worked by Messrs Henraux. These lie in the stretch of mountain in which Michelangelo is said to have gone in search of stone, and the topmost workings are to this day as impressive a scene as can be found anywhere in Italy. One would have, in fact, to go to Delphi itself to find somewhere more directly suggestive of the home of the gods. Not

only are the mountains themselves irresistibly grand, with their shifting cloudscapes and sudden daunting fits of ill-humour, but the enormous concealed caverns of marble form a scene to silence even the most reckless among us. It is as if we were whisked back, literally, to the Stone Age: man and matter are confronted, and the raw materials of art present themselves as nowhere else.

It is one of the fatalities of an inept society that these materials are put mostly to uses quite unworthy of them. But an artist with Moore's sensitivity to material could not in such circumstances fail to fall in love all over again with the potentialities of stone. It was a year or two before he actually got down to direct carving again; but I do not believe that it was coincidence that led him, from 1962 onwards, to concentrate more and more on surfaces that were smooth and unbroken and edges that were sharp and clean.

This shift of interest had a double source. After a long period in which bronze casts dominated his imagination Moore was quite ready for their anti-thesis. He found this in another lifelong preoccupation: bones. 'Since my student days,' he wrote in 1962, 'I have liked the shape of bones and have drawn them, studied them in the Natural History Museum, found them on sea-shores and saved them out of the stew-pot.' It also happens that part of his garden in the country once belonged to a butcher, and that old bones are constantly being turned up there. Moore's interest in bones goes, moreover, far beyond the fact that their forms are suggestive.

There are [he says] *many structural and sculptural principles to be learned from bones, e.g. that in spite of their lightness they have great strength. Some bones, such as the breast-bones of birds, have the lightweight fineness of a knife-blade . . . In 1961 I used this knife-edged thinness throughout a whole figure, the* Standing Figure: Knife-edge [134].

Moore himself has suggested that there may be something of the Louvre *Victory of Samothrace* in this

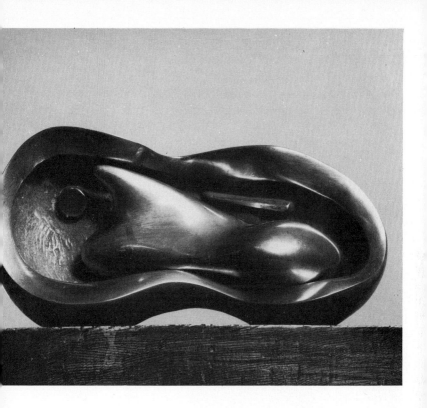

132. *Reclining Interior Oval*, 1965

133. *Reclining Figure* (working model for Lincoln Center sculpture), 1963

134 (*opposite*). *Standing Figure: Knife-edge*, 1961

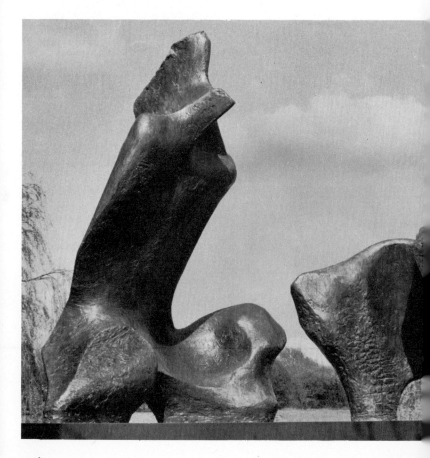

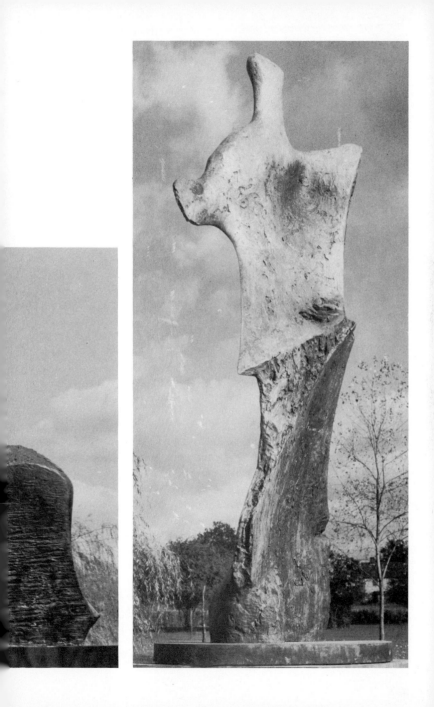

figure; this gives it a place midway in the transition from those larger pieces for which an august cousinage can be claimed to the late carvings which for the most part defy such analysis. We believe in bones as a prime source of the *Standing Figure Knife-edge*, and we can see their influence on a piece like the *Knife-edge two-piece*, 1962 [135]; but in the later piece there is already, I think, a distinct allusion to the experience of the stone-yard. Anyone who has spent a morning at Henraux's will have noticed that by lunch-time there is something compelling about the cutting and slicing, as such, of the stone. It matters hardly at all that the ends are those of everyday funerary sculpture: what matters is the means. This applies as much to the hammer and chisel which have one man's arm behind them as it does to the redoubtable, screeching, invincible powered saw. The unambiguous light also plays a part in persuading us that this is a language in which everything is brought out into the open. The sonorous equivocations of bronze are forgotten as we stand in awe before material that has come down from the throne-room of the gods and can never be totally degraded.

Perhaps one should also bear in mind the fact that a great many supremely beautiful pieces of sculpture lie within an hour's drive of Forte dei Marmi, and that very nearly all of these are carvings in marble or stone. Past and present pull, therefore, in the same direction; and it seems to me that pieces like the *Knife-edge Sculpture* of 1962 or the *Divided Head* of 1963 [148] are really stone carvings that just happen to have been simulated in plaster and cast in bronze. Nearer to the art of the master-mason than to that of the bronze-founder, they augur a new phase in Moore's work; and that phase was carried forward in the piece known as

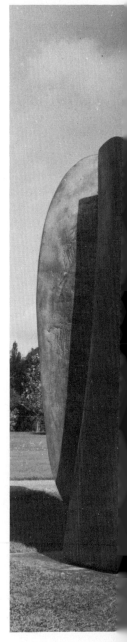

135. *Knife-edge two-piece, 1962-5*

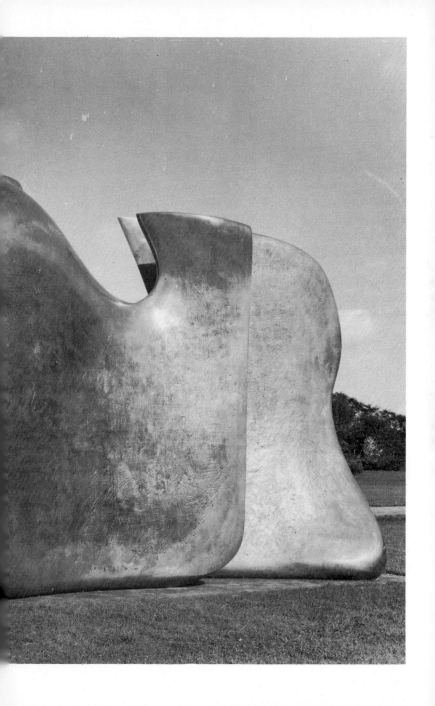

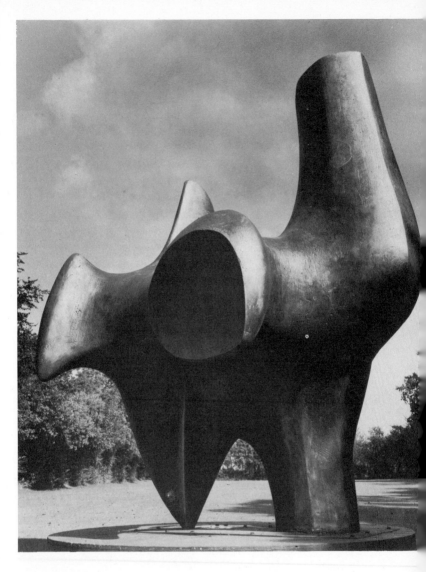

136. *The Archer*, 1964–5

The Archer (1964–5) [136] which underwent a number
of metamorphoses but is likewise in essentials an idea-
for-stone. By this I mean that the forms are smooth,
precise, and regular: an unbroken line leads from one
to another. There are no hidden areas, no points at

136. *The Archer*, 1964–5

which the eye is led so far and no farther. Nor is there the pull to and fro between inner and outer surfaces which marks the big bronze two- and three-piece sculptures: in fact, there *are* no inner surfaces. *The Archer* is the antithesis of all the pierced pieces which Moore had been making for close on thirty years. And, for all its huge bulk (the big bronze version is almost eleven feet high), it gives no feeling of heaviness: it has a slow, easy, turning-and-circling movement which suggests that if it cared it could execute an immensely dignified somersault and land, the right way up, on its

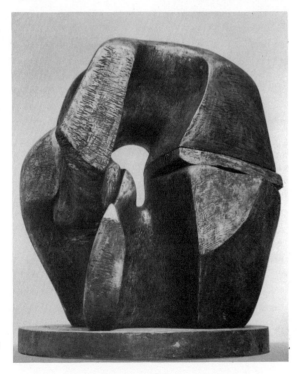

137. *Working Model for Locking Piece*, 1962

two feet: the one broad and flat, the other delicate and pointed.

With the exception of the grim-faced *Locking Piece* of 1962 [137], most of the sculptures of the mid 1960s had something of this quality. They looked as if their

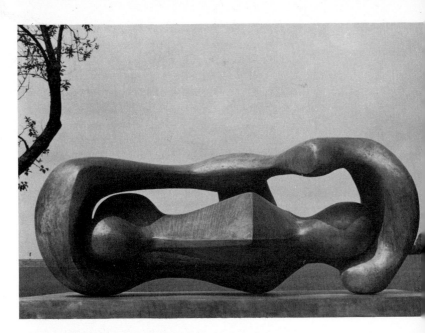

138 and 139. *Reclining Connected Forms*, 1969

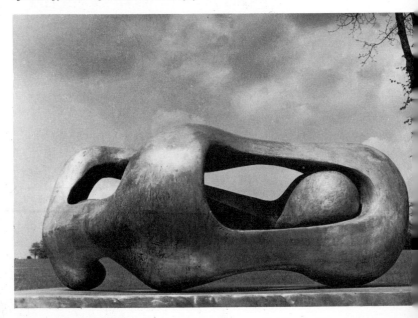

basic forms had been decided with hammer and chisel, even if whole groups of documentary photographs exist to prove that they were built up with splodges of white plaster on an armature of what looks like cheesecloth and rough-hewn pencils. Sometimes the delicate stance of *The Archer* was uppermost: this was the case, for instance, in the *Three-way Piece no. 1: Points* of 1964 [147]. At other times, as in the *Divided Head* (1963) [148] and *Moon Head* (1964), bronze was made to do things which made it look like marble, even if in reality neither piece would have been practicable as a carving. Moore had not made a direct carving since the long haul of the elmwood *Reclining Figure* [116]. His is in large degree a tactile imagination; in England he likes above all to keep a dozen ideas going at once, either in the sketchbook or with rapid manipulations in plaster. But in the 1960s the sketchbook serves him less well: the ideas behind a piece like *The Archer* simply cannot be drawn; its spatial existence is altogether complex. So there are no preliminary drawings for *The Archer*: the work exists from start to finish in three dimensions.

At Much Hadham the preliminary explorations go forward in plaster in a curious cupboard-like room heated by an electric fire not much bigger than a jumbo postcard. In Forte dei Marmi, quite other habits were formed. An abundance of fine stone is constantly to hand, and Henraux's often import exotic rarities in the way of business. The tradition of fine hard craftsmanship is immensely alive in the workshops. Altogether it is stone-country, and stone-manipulator's country, and everything about it represents a challenge to a sculptor who for years communicated above all in stone. Moore began, therefore, to carve in stone all over again, and in the summer of 1967 a group of these new carvings was put on show in London.

They were of many kinds. There was nothing uniform or repetitive about them. *Three Rings* [149] was what it sounds like: a meaningful arrangement of three designs in Rosa Aurora marble for a ring for Mary

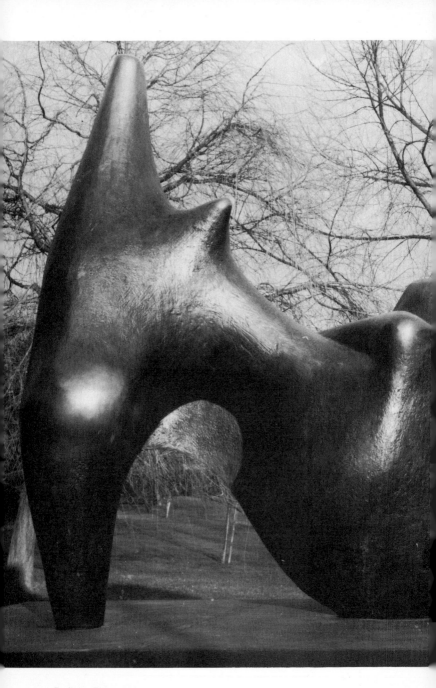

140. *Reclining Figure*, 1969–70

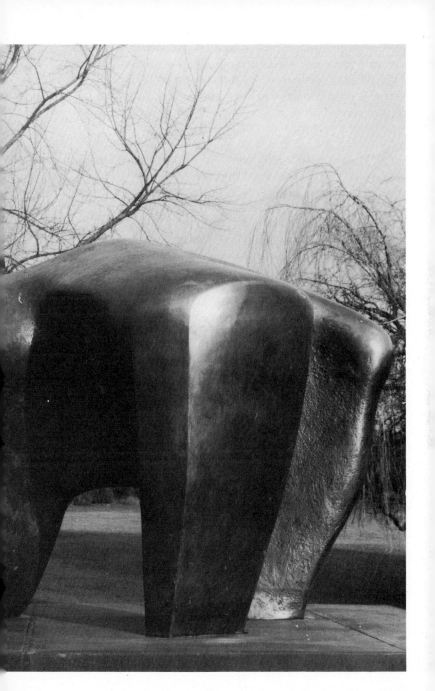

Moore. *Two Forms* [150] was in the great succession of Moore's erotic sculptures: a mating-dance momentarily arrested. *Upright Form (Knife-edge)* [151] and the white marble *Reclining Form* [152] were late variants of themes which had obsessed Moore for forty years; but they were variants of a particularly subtle and purified sort, in which nothing was left to the happy accidents of casting and the piece worked continuously throughout 360 degrees. Nor was it only the white radiance of the material which gave the pieces their immaterial look. The *Reclining Form* seemed, for instance, barely to rest on the ground. They were pieces, also, which resisted interpretation: no one could say, 'These are about survival', as they could of the big two- and three-piece bronzes. The unconscious had kept its rights intact.

An exception to this was the white marble *Torso* [157]. This was as near as Moore had come for twenty years to a straight naturalistic carving. When one thinks of the metaphors for strenuosity with which Moore has so often concerned himself, there is something positively angelic about the ease, the delicacy, and the unerring judgement which went into this study of the human female back. (There is also, of course, an unconcealed sexual scrutiny from which the angels are traditionally exempt.)

Common to all these pieces was a fine-drawn, uninflated quality. Everything lay under the hand. We were back to the proto-Moore of the late 1920s and early 1930s, for whom a sculpture was something that could be spanned by a man's arms. Working close in to the stone, Moore could allow himself a degree of finesse that is not possible in bronze.

Many of the pieces had, also, an open, relaxed quality: they were not at all 'busy'. This came out again, and even more strongly, in the large *Double Oval* [158] which he prepared in plaster at Much Hadham in the spring of 1967. Intended for the Chase Manhattan Bank in New York, this had a beautiful, slow, even pulse. It was, moreover, the first of Moore's

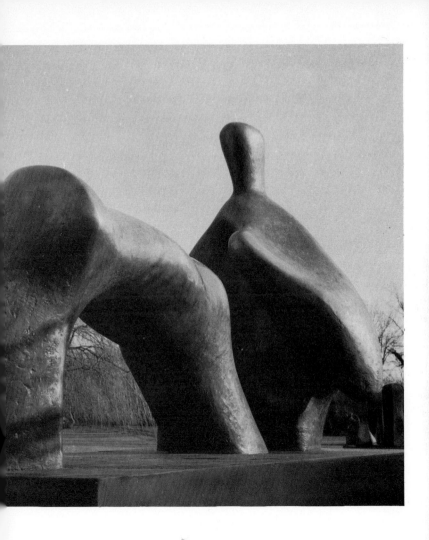

141. *Reclining Figure: Arch Leg*, 1969–70

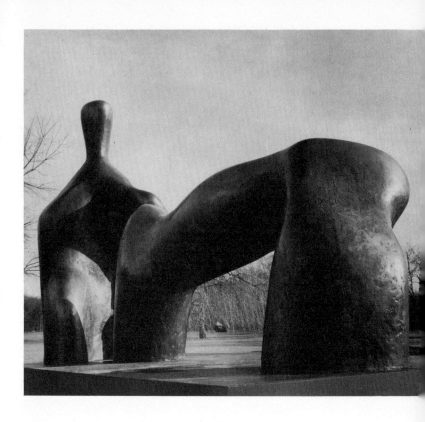

142. *Reclining Figure: Arch Leg*, 1969–70

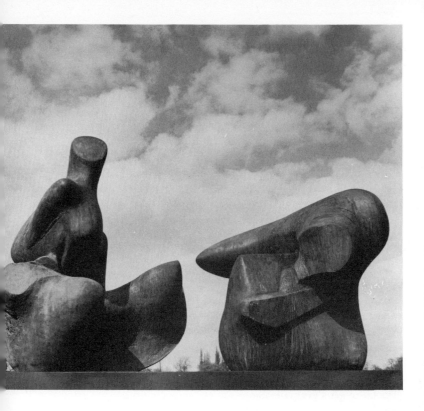

143. *Two-piece Reclining Figure: Points*, 1969–70

major pieces which was expressly designed to be walked through. There were none of the secret, undersized tunnels which, in earlier pieces, could trap an intruder: a smiling openness took their place. Moore was, once again, on the move. This applies as much to pieces which investigated new and enigmatic ideas (like the *Working Model for Animal Form* (1969–71) [144]) as to the major works which were in effect a resuscitation of lifelong preoccupations: prime examples of this second tendency include the *Reclining Connected Forms* (1969) [138, 139] and the eleven-foot-long *Reclining Figure* (1969–70) [140].

All this came at a time of some difficulty for Moore's reputation. Injustice always results if an artist gets more talked about than looked at. This has been Moore's fate with older people for ten years or more, and it has also been his fate with younger people. Older people still think it rather daring to 'accept' Henry Moore; younger people consider that the repudiation of Moore is a part of growing up, and a part on no account to be omitted. Meanwhile the work – which is what really matters – is not looked at.

There is, of course, a great deal of it. It is almost as difficult to get a grasp of Moore's work, in its totality, as it is to get a grasp of Rodin's. Moore has his anthology pieces, the way Britten has his 'Young Person's Guide' and Auden has 'Out on the lawn I lie in bed': too often, acquaintance with these does duty for a more comprehensive understanding. Criticism of Moore tends to be reverential on the one hand, vituperative on the other. People who have grown up, and grown old, with his work incline to identify with it to such an extent that an attack upon Moore is an attack upon themselves. For young people Moore is, by contrast, a fabled obstruction: if only he and his reputation could be got out of the way! Moore, in this context, is to art what Churchill was to public affairs: the big figure who divides the generations as Moses divided the Red Sea.

This being so, it is only natural that a good deal of attention was given in the 1960s to a kind of sculpture

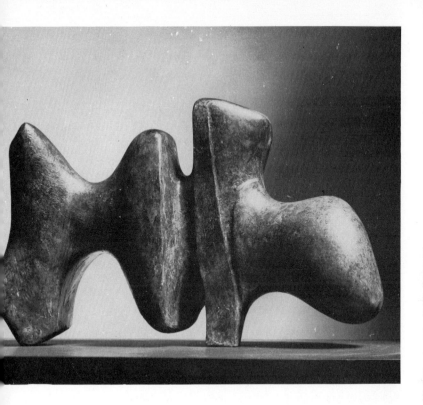

144. *Working Model for Animal Form*, 1969–71

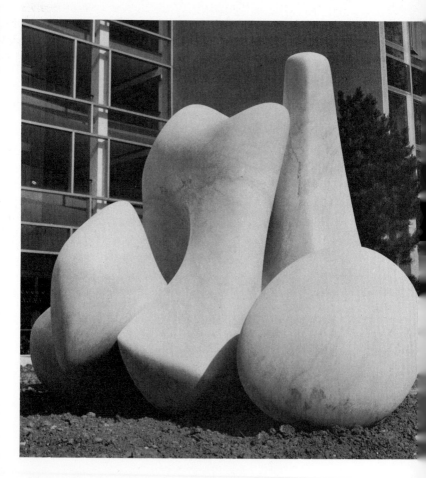

which presents, in effect, a reversed image of every-
thing that Moore has striven for. That sculpture was,
broadly speaking, spare, non-allusive, metallic or made
of new-minted plastic materials, often brightly col-
oured, and in intention distinct from everything that
sculpture had meant to the patrons of an earlier day.

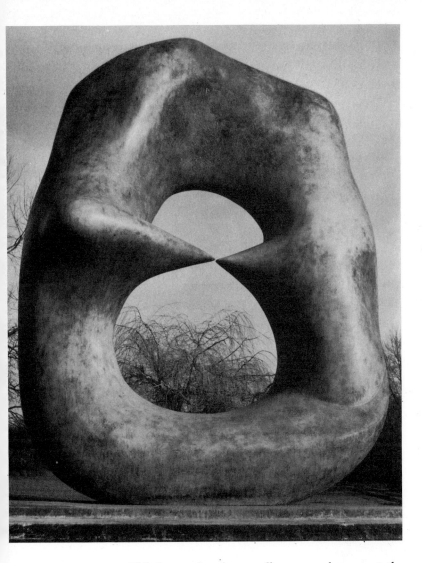

This is not the place to discuss to what extent the sculptors in question succeeded in their aims; but it is legitimate to say that older people are often as blind to the merits of Caro and his colleagues as younger people are blind to the merits of Moore. What matters here is the extent to which the history of British

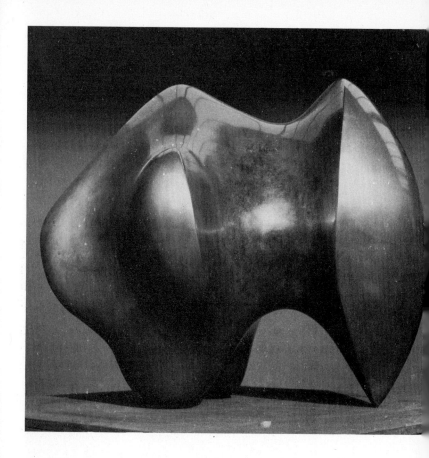

147. *Working Model for Three-way Piece no. 1 : Points,* 1964

sculpture was shaped in the 1950s and 60s by the necessity of finding an alternative to Moore.

I myself find this all the more natural in that Moore himself has so often been affected by that necessity. It will by now, I hope, be clear that there are many Moores, and that some of them are as much antitheses as alternatives. Between the architecture of disquiet

148. *Divided Head*, 1963

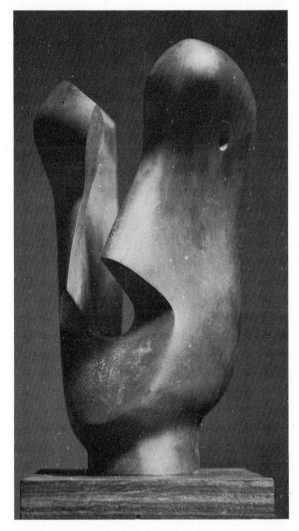

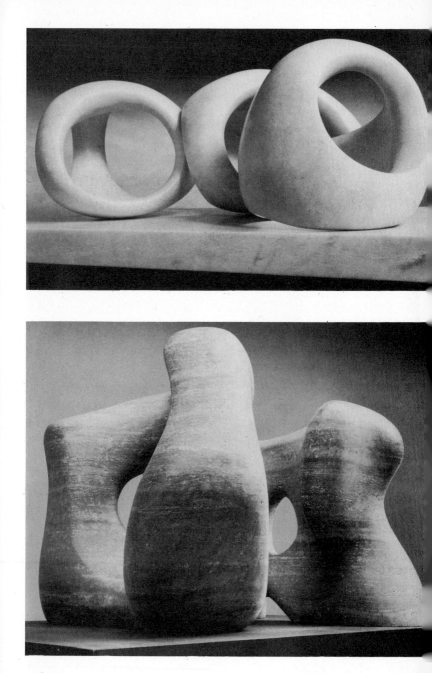

149 (*opposite*). *Three Rings*, 1966

150 (*opposite below*). *Two Forms*, 1966

151 (*below*). *Upright Form*, 1966

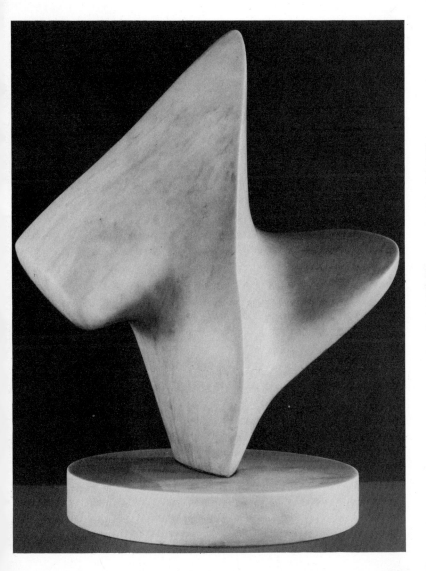

and the architecture of consolation there is, for instance, an obvious polarity: and one which Moore has taken care to preserve. Moore has played continually on the great primary oppositions: horizontal/vertical, open/shut, hollow/solid, animal/mineral, tough/tender, passive/active. He has drawn upon a vast range of secondary allusion, much of it ambiguous; but he has never tried to smother the extremes of his nature. Each has been given its turn: tough and tender have equal rights.

Every reader of art literature is wary of the great crashing 'definitive judgement'. Huge claims do not impress posterity, any more than the lifelong resident in the Hotel des Grands Hommes is necessarily material for the Pantheon. We none of us know to what extent we are the captives of our environment. In particular, we cannot be sure to what extent our responses are to universal qualities, and to what extent they relate to particular and ephemeral needs. The bigger the achievement, the more mysterious the forces involved: the relationship between Cézanne and analytical cubism is, for instance, a long way from its final codification. Edmund Wilson once said that 'No two people read the same book', and he might equally well have said that no one person reads the same book twice: there is a continual readjustment, not only between different people and 'the same book', but among the elements within any one person which respond to that book. *Middlemarch* is not the same at fifty as it was at eighteen, and this is all the more true of recent works of art with which one has been associated for the whole of one's adult life.

And there is, finally, the question of under- and over-exposure. All successful artists have to cope with this today. Before 1939 it was not so: it was possible, for instance, for Picasso's *Demoiselles d' Avignon* to be finished in 1907 and first put on show thirty years later. Brancusi, likewise, was able to work away with minimal interference from the outer world. Bonnard's studio was full of marvellous canvases which it never occurred

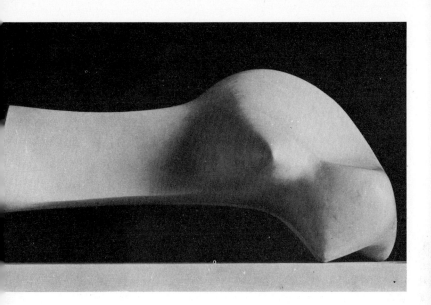

152. *Reclining Form*, 1966

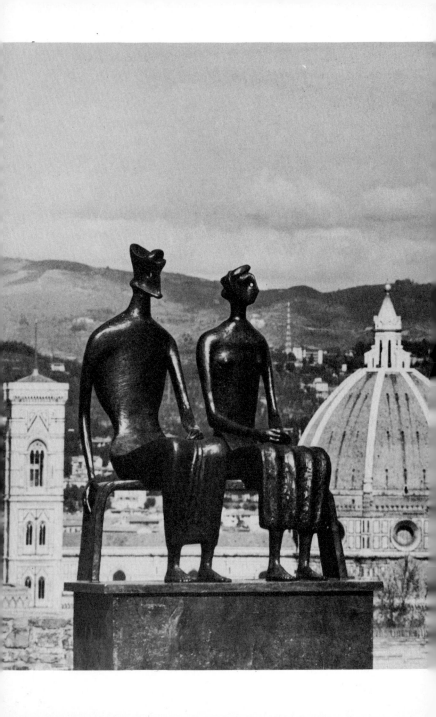

to him to publicize. The fatuity of public-relations procedures played no part in serious art-life. It was possible, equally, for an artist like Henri Laurens to live and die in near-poverty. But, on balance, European art-life was the better for the atmosphere of near-secrecy in which the bigger painters and sculptors went about their work, just as it was the better for the fact that ambassadorial duties were left to ambassadors and the artist was not paraded round Europe under official auspices one year and left for dead the next.

Moore has lived through both periods. He has been in Paris, for instance, as an all-but-anonymous visitor who had to count every centime; and he has been there as the fêted ornament of a series of governmental occasions. He has been in Florence as a student on a travelling scholarship; he was there in 1972 as the hero of an enormous exhibition, much of it in the open air, which was held at the Belvedere, within sight of some of the noblest of all human constructions. When things got to the point at which he could hardly go to the theatre without being followed by a camera-team and a *New Yorker* profile-writer, some people thought that the old, ruminative, and private Moore had gone down in a welter of promotional devices. These were conditions in which it would be very easy for an artist to turn into a one-man souvenir-shop.

There is a very great utility, when those conditions prevail, in an exhibition of the rigorously-selected and carefully-argued kind which David Sylvester devised for the Tate Gallery on the occasion of Moore's seventieth birthday in 1968. Art needs a certain privacy; when there is quite so much of it about, and when speculation among pseudo-collectors is quite so flagrant, it is very difficult indeed to get back to the primal responses, the unprompted and disinterested delight in the thing seen for the first time, which

153. *King and Queen* in Florence Exhibition, 1972

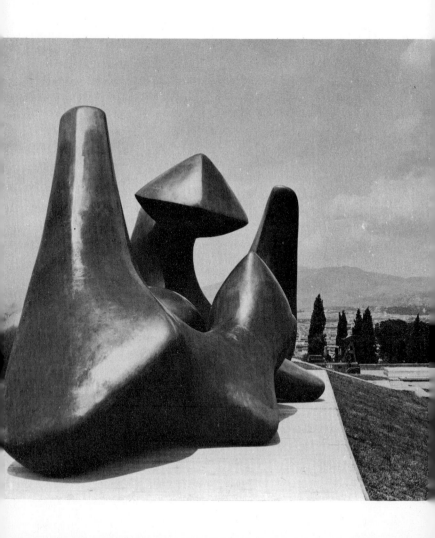

Moore inspired in the 1930s and early 1940s. A lesser man could have been completely swamped by the adulation which has lately surrounded Moore: and that adulation has provoked, in others, feelings as petty as they are malignant.

In May 1972 Henry Moore was crowned in Florence, almost as Petrarch was once crowned in Rome: not literally, but in the ways that matter. It was a very great compliment: so great, one might have thought, as to invite catastrophe. For what the Florentine authorities and the British Council had in mind was not the discreet admission of one or two pieces to some out-of-the-way corner of the city, but a retrospective exhibition of sculptures and drawings that would fill the whole of the Forte di Belvedere and overflow on to the star-shaped battlements that yield one of the finest of all views of Florence.

It could have been a piece of tasteless effrontery: one that left the work looking diminished and out of place. If it had quite the opposite effect, several reasons can be adduced. One is the particular historical position of Florence. Florence is, of course, a place in which a great deal of art was made. But it is also a place in which it was made a very long time ago. The museums and galleries of Florence operate on the far side of a gap of time which has the effect of removing new art from the area of analogy: still more so, from the area of competition.

There is, also, the particular character of the Forte di Belvedere. It is a true fortress: compact and sober, it makes a gaunt eye-music, both inside and out, which subdues itself to whatever business is in hand. Though no more than a stiff seven-minute walk from the Ponte Vecchio, it seems a world away from the narrow streets of the city below. It has a Shakespearean resonance: far better than real-life Elsinore, it could provide ideal exteriors for Act I, Scene one, of *Hamlet*. Where the Uffizi and the Bargello are places in which the past is deep-frozen, the Belvedere has no visible souvenirs to come between us and its present-day existence. It is a

tough, spare building which gives a great deal and takes nothing away.

People think of it, quite rightly, as dominating Florence. The panorama is well worth the climb, even when the Belvedere itself is shut. But what people don't always realize, when they hurry to the parapets that overhang the Arno, is that the majestic turning motion of the battlements continues through 360 degrees. More than half of that circle has to do with a country-side that has changed remarkably little since the Renaissance: the same olive-trees, the same winding, dusty, high-walled lanes, the same unpretentious farm-buildings. One can look down on all that from the Belvedere and fancy oneself in the open countryside. Florence is oriented towards art – nowhere more so – but it is also oriented towards Nature, and towards man: a sense of human scale is omnipresent, even if it is occasionally used to awe and to overpower.

Thinking of all this, and looking at the annotations on some of the drawings of the early and middle 1930s in the show, many visitors came round to thinking more than ever that the Forte di Belvedere was just the place for Moore. What it offered was not a hallowed, 'fine-art' setting. It was an opportunity to mingle with nature, and to adjust to a distant prospect of great architecture, and to merge with a timeless human environment. Much of what Moore had written in his sketchbooks of the 1930s read like a notional pro-gramme for Florence in the summer of 1972: 'Make some drawings from architecture or wonders of the past and turn them into figures,' or 'Sculpted head and mountain top as one single form,' or 'Do drawings of setting for a figure.' And just in case this could read like the search for a willed monumentality – or for rhetorical statements predicated only on the past – the notes on the next page may well contradict it: 'See torso photos by Brassai,' for instance, 'for full solidity.'

The drawings in question were shown high up in the Belvedere, in bare rooms shaded from the sun. They had the effect of a private diary now released under the

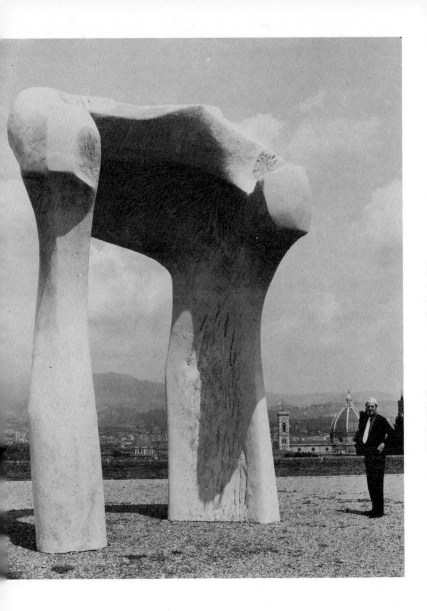

155. *Large Arch* in Florence, with the artist, 1972

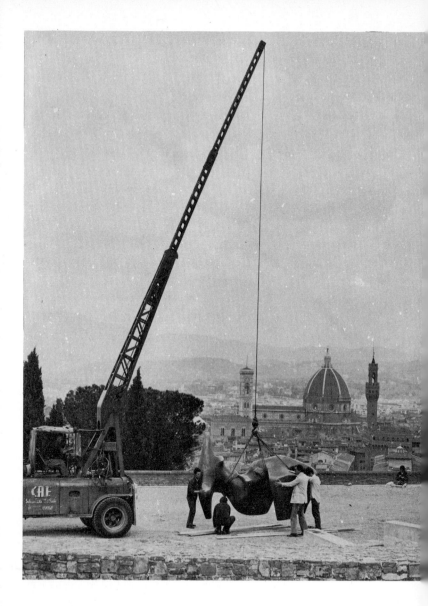

156. Placing the bronze *Reclining Figure*, 1969–70, at the Florence Exhibition, 1972

'thirty year rule'; and, like many of the papers thus made available at the Record Office, they annihilated time. We were back in the 1930s: in that uneasy decade when the future of art seemed the least of humanity's problems and many of those who stand highest in twentieth-century art seemed not to be functioning at quite their full strength. (This was a mistaken impression, in some cases, but the mistake was not made plain till later.) Moore's programme was massive in scale and compound in inspiration: Michelangelo and Brassai, Surrealism and Greek temples, Picasso and the Adle Rock – all were involved in it. It is a kind of inspiration not much in favour today, when the ruling doctrine is that put forward by Clement Greenberg in the 1950s: that 'it seems to be a law of modernism – thus one that applies to almost all art that remains truly alive in our time – that the conventions not essential to the viability of a medium be discarded as soon as they are recognized.' Certainly it could have led to work that would now look arty and over-allusive. But it didn't: abstract pieces like the *Locking Piece* turned out to merge with the Tuscan landscape without even a preliminary tension. As for the long series of human types which Moore has created without ever intending to do so, they also were perfectly at home: above all, the warrior-Venus in whom are combined the ideals of endurance, protectiveness, combativity and a heavy-limbed physical beauty. There just wasn't anything to worry about; the case for a compound inspiration was perfectly put.

It was, of course, put in the context of a particular generation. It was a generation with very firm beliefs: some of them current among younger people, some of them not. Moore believes, for instance, in the sanctity of very hard work; in fixed loyalties in the private sphere; in a certain plainness and stubbornness of statement, whether in words or in the work; and in the possibility of a steady general improvement in human affairs. It was possible to feel, when walking into the spare, high-ceilinged room where the great elmwood

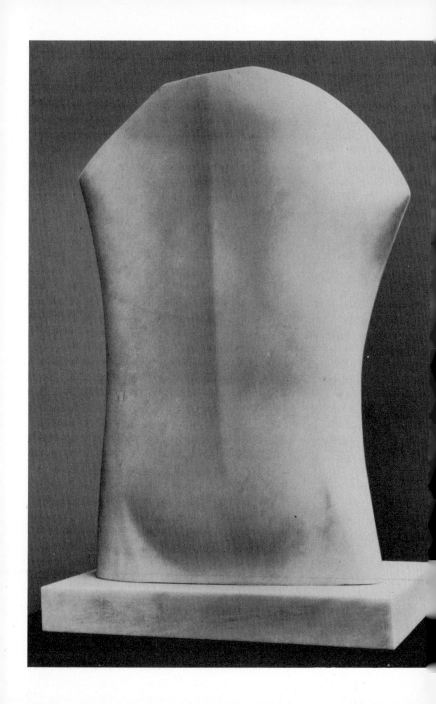

Reclining Figure of 1959–64 [116] was shown on its own, that the ideals of a whole generation of Englishmen were lying in state on the slab. History had taken them over, but it had not made light of them.

With age the senior artist does, of course, inspire a kind of collective involvement which has nothing to do with the quality of his current work. When Voltaire's *Irène* was put on in Paris in 1778, and Voltaire himself went to see it, the plaudits were not for the play but for all that Voltaire had meant to his century. It could be the same with Henry Moore; but it isn't. The *Reclining Figure* and the white *Torso* of 1966 [157] have somehow got clear of adulation. They have an element of unhurrying privacy which reminds us of the days when Moore didn't know where the next bit of stone was coming from. They stand for the quintessential Moore: not the 'seventy-year-old smiling public man' of whom Yeats might have written, but the one who has lived all his life a private adventure.

There are other Moores, as everyone knows: and, in particular, there is the Moore who more than once became the keeper of Everyman's conscience. He did this in the Shelter drawings, and he did it when in 1945 the idea of a stable family life re-entered the realm of practicality, and he did it in the *Atom Piece*. He also did it, indirectly, in the late Reclining Figures which suggest that there is, after all, an alternative to pettiness and self-destruction. In all these, the element of public service is somewhere latent: this is not a fashionable impulse, in matters of art, and it is one that usually leads only to rhetorical commonplace. But there is in Henry Moore a broad streak of the nineteenth-century radical, and this has not been at all contaminated by two decades of worldly success. Art for him is a single-handed matter, but it does not exclude the generous meaningful gesture which reminds us that things can be changed for the better and that it is our duty to bring that about.

But if a certain dogged optimism is the mark of Moore's activity on the public front, quite other quali-

ties distinguish the Moore who has dived over and over again below the level of conscious awareness. It is by his readiness to let the demons loose that we recognize this Moore: less metaphorically, we realize that in the mid 1930s, long before the imagery of the 'divided self' was formulated by R.D.Laing, Moore was probing the extent to which an individual personality could be divided, and split off, and set against itself, and yet retain its identity. On this private Moore, much work has still to be done: in the light, above all, of the revised concept of the unconscious which was pioneered by Anton Ehrenzweig in his *The Hidden Order of Art*. Ehrenzweig looked to Moore primarily for his evocations of the 'Great Mother'; later students may prefer to study other and more cryptic aspects of Moore's work. The private Moore has kept his secrets: their deciphering must wait for another time, and another man, and a different book.

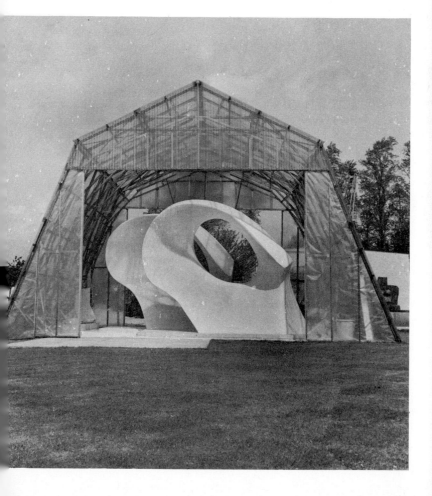

Bibliography

The bibliography of Henry Moore is by now so voluminous that it could well make up a book on its own. What follows is a brief, personal and doubtless partial choice of items which contain essential information (or, in some cases, enrich our understanding by the quality of their insights).

Henry Moore's own writings have been collected by Philip James in *Henry Moore on Sculpture* (Macdonald). Since that excellent anthology was published, Moore has contributed a foreword to Michael Ayrton's *Giovanni Pisano* (Thames & Hudson, 1969).

Among monographs, Herbert Read's *Henry Moore, Sculptor* (Zwemmer, 1934) was the earliest. Geoffrey Grigson's *Henry Moore* (Penguin, 1943) was followed in 1944 by Vol. 1 of the Lund Humphries series *Henry Moore, Sculpture and Drawings*. This volume, now in its 4th (1957) edition, was edited by David Sylvester. Further volumes in the series have been edited by Alan Bowness: Vol. 2 in 1955 (2nd edition 1965), and Vol. 3 in 1965; Vol. 4 is in preparation. The Museum of Modern Art's retrospective of 1946 had an excellent catalogue with text by James Johnson Sweeney. Non-English monographs include those by G. C. Argan (de Silva, Turin, 1948), Werner Hofmann (Fischer, Frankfurt, 1959), and J. P. Hodin (De Lange, Amsterdam, 1956, Eng. trans. Zwemmer, 1958). Erich Neumann's *The Archetypal World of Henry Moore* (Routledge, 1959) and Will Grohmann's *The Art of Henry Moore* (Thames & Hudson, 1960) should also be noted. Herbert Read's *Henry Moore* (Thames & Hudson, 1965), Donald Hall's *The Life and Work of a Great Sculptor: Henry Moore* (Gollancz, 1966), John

Hedgecoe's remarkable photographic record (Nelson, 1968) and Robert Melville's compendious *Henry Moore, Sculpture and Drawings* (Thames & Hudson, 1970) date from the years of maximum celebrity. David Mitchinson's *Henry Moore: Unpublished Drawings* (Pozzo, Turin, 1971) is a genuine contribution to knowledge. Ionel Jianou's *Henry Moore* (Meridiane, Bucharest, 1971) is a late-comer not to be despised.

Among books illustrated by Moore one or two rarities should be sought out: Edward Sackville West's *The Rescue* (London, 1944), *Shelter Sketchbook* (Poetry, London, 1945), Jacquetta Hawkes's *A Land* (Cresset, London, 1951), and Moore's own *Heads, Figures and Ideas* (Rainbird, London, 1958).

Exhibition-catalogues worth consulting include: Buchholz Gallery, New York, 1943 (text by Kenneth Clark); Tate Gallery, 1951 (text by David Sylvester); Kröller-Müller Museum, Otterlo, 1968 (text by A. M. Hammacher); Tate Gallery, London, 1968 (text by David Sylvester); Forte di Belvedere, Florence, 1972 (texts edited and lists of works annotated by Giovanni Caradente).

List of Illustrations

24. *Composition*. African wonderstone, $17\frac{1}{2}$ in. 1932. Tate Gallery, London

25. *Reclining Figure*. Corsehill stone, length $24\frac{1}{2}$ in. 1934–5. Mrs Irina Moore

26. *Figure*. Corsehill stone, 30 in. 1933. Carlo Ponti, Rome

27. *Figure*. Travertine marble, 16 in. 1933. H. Cady Wells, Santa Fé, New Mexico

28. Salvador Dali: *The Birth of Liquid Desires*. Oil on canvas, 37 in. × 44 in. 1932. Mrs Peggy Guggenheim Collection

29. H. Henrici: *Algebraic Formula*. 1876. Science Museum, London

30. *Carving*. Brown Hornton stone, 20 in. 1936. Private collection

31. *Four-piece Composition: Reclining Figure*. Cumberland alabaster, 20 in. 1934. Miss Martha Jackson, New York

32. Paul Nash: *Earth Home*. Oil on canvas, 28 in. × 36 in. 1935. Charles Kearley, Havant, Hampshire

33. *Carving*. Blue Ancaster stone, 16 in. 1934. Carlo Ponti, Rome

34. *Carving*. Travertine marble, 18 in. 1936. Mrs Irina Moore

35. *Reclining Figure*. Hoptonwood stone, length 33 in. 1937. Miss Lois Orswell, Narragansett, Rhode Island

36. *Two Forms*. Ironstone, $7\frac{1}{4}$ in. 1934. Marlborough Fine Art

37. *Sculpture*. White marble, 22 in. 1935. Art Institute of Chicago

38. *Four Forms*. African wonderstone, 22 in. 1936. Henry Hope Collection

39. *Head*. Elmwood and string, 8 in. 1938. Marlborough Fine Art, New York

40. *Stringed Figure*. Lignum vitae and string, 14 in. 1938. G. Burt Collection

41. *Reclining Figure*. Elmwood, 42 in. 1936. City Art Gallery, Wakefield

42. *Stringed Reclining Figure*. Bronze, length 11 in. 1939. Private collection

43. *Recumbent Figure*. Green Hornton stone, length 55 in. 1938. Tate Gallery, London

44. *Reclining Figure*. Elmwood, length 6 ft. 9 in. 1939. Detroit Institute of Arts

45. *Reclining Figure*. Lead, length 14 in. 1938. Museum of Modern Art, New York

46. *Reclining Figure*. Carved reinforced concrete, length 43 in. 1932. CAM Collection, St Louis

47. *Seated Woman: Drawing from life*. Wash, 22 in. × 15 in. 1928. Mrs Irina Moore

48. *Figures in a Cave*. Chalk and wash, 15 in. × 22 in. 1936. Artist's collection

49. *Page from Shelter Sketchbook*. Chalk, pen and watercolour. 1941. Mrs Irina Moore

50. *Tilbury Shelter. Page from Shelter Sketchbook*. Chalk, pen and watercolour. 1941. Mrs Irina Moore

51. *Morning after an Air-Raid. Page from Shelter Sketchbook.* Chalk, pen and watercolour. 1941. Mrs Irina Moore

52. *At the Coal-Face.* Chalk, pen and watercolour, 13 in. × 22 in. 1942. Whitworth Art Gallery, Manchester

53. *Figures in a Setting.* Pen, chalk and watercolour, 18 in. × 22 in. 1942. Artist's collection

54. *Figures in a Setting.* Pen, crayon and watercolour, 19 in. × 22¾ in. 1942. Fogg Art Museum, Harvard University

55. *Sculpture in Landscape.* Pen and watercolour, 15 in. × 22 in. 1940. Museum of Fine Arts, Santa Barbara, California

56. *Girl Reading to a Woman Holding a Child.* Pen, chalk and watercolour. 1946. Lady Walston, Cambridge

57. *Crowd Looking at a Tied-Up Object.* Pen, chalk wash and watercolour, 17 in. × 22 in. 1942. Lord Clark of Saltwood

58. *Drawing.* Pen and wash. 1942. Private collection

59. *Madonna and Child.* Hornton stone, 59 in. 1943–4. Church of St Matthew, Northampton

60. *Memorial Figure.* Hornton stone, 56 in. 1945–6. Dartington Hall, Devon

61. *Reclining Figure and Pink Rocks.* Gouache, chalk and pen, 22 in. × 16½ in. 1942. Albright-Knox Art Gallery, Buffalo

62. *Reclining Figure.* Elmwood, 75 in. 1945–6. Fischer Fine Art Ltd, London

63. *King and Queen.* Bronze, 64½ in. 1952–3. Sir William Keswick, Glenkiln, Scotland

64. *Reclining Figure.* Hornton stone, 30 in. 1949. R. Sturgis Ingersoll, Philadelphia

65. *The Helmet.* Lead, 12 in. 1940. Sir Roland Penrose, London

66. *Helmet Head no. 2.* Bronze, 14 in. 1950. National Gallery of New South Wales, Sydney

67. *Helmet Head and Shoulders.* Bronze, 6½ in. 1952. Private collection

68. *Helmet Head no. 1.* Bronze, 13½ in. 1950. Tate Gallery, London

69. *Animal Head.* Bronze, 12 in. 1951. Peter Pears Collection

70 and 71. *Internal and External Forms.* Elmwood, 8 ft. 7 in. 1953–4. Albright-Knox Art Gallery, Buffalo

72. *Working Model for Reclining Figure (Internal and External Forms).* Bronze, length 21 in. 1951. Kunsthalle, Mannheim

73. *Reclining Figure.* Bronze, length 7 ft. 6 in. 1951. Arts Council of Great Britain, London

74. Auguste Rodin: *Torso of a Young Woman.* Bronze, 33¼ in. 1909 (cast). Roland, Browse and Delbanco, London

75. *Draped Torso.* Bronze, 35 in. 1953. Ferens Art Gallery, Hull

76, 77 and 78. *Falling Warrior* (first stage). Plaster, length 50 in. 1956. Destroyed

79. *Warrior with Shield.* Bronze, 60 in. 1953–4. Birmingham City Art Gallery

80. Auguste Rodin: *Study of a Seated Woman (Cybele).* Bronze,

$19\frac{3}{4}$ in. c. 1889. Wasserman Family Collection, Massachusetts (photo Barney Burstein)

81. *Draped Reclining Figure.* Plaster for Bronze, length 62 in. 1952–3. Artist's collection

82. Johann Gottfried Schadow: *Prinzessinnengruppe.* 1797. Staatliche Museum, Berlin

83. Auguste Rodin: *The Martyr.* Bronze, c. 1884. Metropolitan Museum of Art, New York. Gift of Watson Dickerman, 1913

84. *Falling Warrior.* Bronze, 58 in. 1956–7. Walker Art Gallery, Liverpool

85. *Time-Life Screen Maquette no. 1.* Bronze, 7 in. × 13 in. 1952. Private collection

86. *Time-Life Screen Maquette no. 2.* Bronze, 7 in. × 13 in. 1952. Private collection

87. *Time-Life Screen Maquette no. 4.* Bronze, 7 in. × 13 in. 1952. Private collection

88. *Time-Life Screen.* Portland stone, 26 ft. 6 in. × 10 ft. 1952. Time-Life Building, London

89. *Glenkiln Cross.* Bronze, edition of six, 7 ft. 3 in. 1955–6. Sir William Keswick, Glenkiln, Scotland

90. *Double Standing Figure.* Bronze, 7 ft. 3 in. 1950. Vassar College, New York

91. *Wall Relief Maquette no. 6.* Plaster for bronze, $18\frac{1}{2}$ in. × $13\frac{1}{2}$ in. 1955. Private collection

92. *Wall Relief Maquette no. 2.* Bronze, $17\frac{1}{2}$ in. × 13 in. 1955. Private collection

93. *Wall Relief Maquette no. 3.* Bronze, $14\frac{1}{2}$ in. × $20\frac{1}{2}$ in. 1955. Private collection

94. *Wall Relief Maquette no. 9.* Bronze, $18\frac{1}{2}$ in. × $13\frac{1}{2}$ in. 1955. Private collection

95. *Studies for Standing Figures.* Pencil, chalk and wash, $23\frac{1}{4}$ in. × $19\frac{1}{4}$ in. 1951. Dr Andrew Revai, Pallas Gallery

96. *Three Standing Figures.* Bronze, $28\frac{1}{2}$ in. 1953. Kunsthalle, Hamburg

97. *Upright Motive no. 5.* Bronze, 7 ft. 1956. Private collection

98. *Upright Motive Maquette no. 4.* Bronze, $11\frac{1}{2}$ in. 1955. Private collection

99. *Upright Motive Maquette no. 9.* Bronze, 10 in. 1955. Private collection

100. *Upright Motive Maquette no. 7.* Bronze, $12\frac{1}{2}$ in. 1955. Private collection

101. *Three Upright Motives* (including *Glenkiln Cross*). Bronze, 10 ft. 6 in. 1955–6. Kröller-Müller Museum, Otterlo; Amon Carter, Fort Worth, Texas

102. *Wall Relief Maquette no. 7.* Plaster, $18\frac{1}{2}$ in. × $13\frac{1}{2}$ in. 1955. Artist's collection

103. *Three Motives against Wall no. 1.* Bronze 42 in. × $18\frac{1}{2}$ in. 1958–9. Victoria and Albert Museum, London

104. *Large Torso: Arch.* Bronze, 6 ft. 9½ in. × 4 ft. 2 in. 1962. Museum of Modern Art, New York

105. *Three-quarter Figure.* Bronze, height 15 in. 1961. Private collection

106. *Three-part Object.* Bronze, edition of nine, 48½ in. 1960. Private collection

107. *Slow Form (Tortoise).* Bronze, length 8½ in. 1962. Private collection

108. *Reclining Figure.* Roman Travertine, 17 ft. 1957. UNESCO Building, Paris

109. *Draped Reclining Woman.* Bronze, height 53 in., length 82 in. 1957–8. Sir Robert and Lady Sainsbury, London

110. Rafael Donner: *The River Ybbs.* Barockmuseum, Vienna

111. *Draped Seated Woman.* Bronze, 73 in. 1957. National Gallery of Victoria, Melbourne

112. *Draped Reclining Woman* (detail). Bronze, height 53 in., length 82 in. 1957–8. Sir Robert and Lady Sainsbury, London

113 and 114. *Upright Figure.* Elmwood, 9 ft. 3 in. 1956–60. Solomon R. Guggenheim Museum, New York

115. *Relief no. 1.* Bronze, 7 ft. 4 in. 1959. Private collection

116. *Reclining Figure.* Elmwood, length 7 ft. 6 in. 1959–64. Mrs Irina Moore

117. *Two-piece Reclining Figure no. 1.* Bronze, length 76 in., height 51 in. 1959. Albright-Knox Art Gallery, Buffalo

118. *Two-piece Reclining Figure no. 2.* Bronze, length 102 in., height 51 in. 1960. Tate Gallery, London

119 and 120. *Two-piece Reclining Figure no. 3.* Bronze, length 94 in., height 59 in. 1961. City of Gothenburg, Sweden

121 and 122. *Reclining Mother and Child.* Bronze, length 86 in. 1960–61. Walker Art Center, Minneapolis

123. *Three-piece Reclining Figure no. 2: Bridge Prop.* Bronze, length 99 in. 1963. City Art Gallery and Museum, Leeds

124. *Three-piece Reclining Figure no. 1.* Bronze, length 114 in., height 59 in. 1961–2. National Bank of Canada, Montreal

125. *Atom Piece.* Bronze, height 48 in. 1964. Private collection

126. *Two-piece Sculpture no. 7: Pipe.* Bronze, length 37 in. 1966. Whitworth Art Gallery, Manchester

127. *Mother and Child: Arch.* Bronze, 19½ in. 1959. Private collection.

128. Danese Cattaneo: *Allegory of Vanity, or The Negro Venus.* Bronze. Private Collection François Heim, Paris

129. *Thin Standing Figure.* Plaster, 7½ in. high with base. 1965 (cast in 1968). Private collection

130. *Helmet Head no. 5.* Bronze, 16½ in. 1966. Private collection

131. *Helmet Head no. 4.* Bronze, edition of six, 18¾ in. 1963. Private collection

132. *Reclining Interior Oval.* Bronze, 8 in. 1965. Private collection

133. *Reclining Figure* (working model for Lincoln Center sculp-

ture). Bronze, length 14 ft., height 9 ft. 1963. Mr and Mrs Albert List, New York

134. *Standing Figure: Knife-edge*. Bronze, height 112 in. 1961. Perini-San Francisco Associates, San Francisco

135. *Knife-edge two-piece*. Bronze, length 12 ft., height 9 ft. 1962–5. City of Westminster

136. *The Archer*. Bronze, length 10 ft. 8 in. 1964–5. Nathan Phillips Square, Toronto

137. *Working Model for Locking Piece*. Bronze, height 42 in. 1962. Lehmbruck Museum, Duisburg

138 and 139. *Reclining Connected Forms*. Bronze, edition of nine, length 84 in. 1969. University of Adelaide, South Australia

140. *Reclining Figure*. Bronze, edition of six, length 11 ft. 3 in. 1969–70. Tel Aviv Museum, Israel

141 and 142. *Reclining Figure: Arch Leg*. Bronze, edition of six, length 14 ft. 6 in. 1969–70. Hakone Museum, Japan

143. *Two-piece Reclining Figure: Points*. Bronze, edition of seven, length 12 ft. approx. 1969–70. Pinakothek, Munich.

144. *Working Model for Animal Form*. Bronze, edition of nine, length 26 in. 1969–71. Private collection

145. *Interlocking Two-piece Sculpture*. White marble, length 124 in. 1968–70. Roche Foundation, Basle

146. *Oval with Points*. Bronze, edition of six, height 10 ft. $10\frac{1}{2}$ in. 1968–70. Princeton University, USA

147. *Working Model for Three-way Piece no. 1: Points*. Bronze, height 25 in. 1964. Private collection

148. *Divided Head*. Bronze, $13\frac{3}{4}$ in. 1963. Kunsthaus, Zürich

149. *Three Rings*. Rosa Aurora marble, length $39\frac{1}{2}$ in. 1966. Mr and Mrs Gordon Bunshaft, New York

150. *Two Forms*. Red Soraya Travertine marble, 59 in. 1966. Private collection

151. *Upright Form*. White marble, height 26 in. 1966. Private collection

152. *Reclining Form*. White marble, length 43 in. 1966. Private collection

153. *King and Queen* in Florence Exhibition, 1972 (Foto Marchiori)

154. *Three-piece Vertebrae* in Florence Exhibition, 1972 (Foto Marchiori)

155. *Large Arch* in Florence, with the artist, 1972 (Foto Marchiori)

156. Placing the bronze *Reclining Figure* 1969–70 at the Florence Exhibition, 1972 (Foto Marchiori)

157. *Torso*. White marble, height 31 in. 1966. Private collection, Zürich

158. *Double Oval* (in shelter). Plaster, approx. 14 ft. 1967. Artist's collection

Index

Page numbers in *italics* refer to illustrations